IMAGES
of Sports

THE LITTLE
LEAGUE®BASEBALL
WORLD SERIES

IMAGES
of Sports

THE LITTLE
LEAGUE® BASEBALL
WORLD SERIES

Robin Van Auken

ARCADIA
PUBLISHING

Copyright © 2002 by Robin Van Auken
ISBN 978-1-5316-0654-1

Published by Arcadia Publishing
Charleston, South Carolina

Library of Congress Catalog Card Number: 2002102041

For all general information contact Arcadia Publishing at:
Telephone 843-853-2070
Fax 843-853-0044
E-mail sales@arcadiapublishing.com
For customer service and orders:
Toll-Free 1-888-313-2665

Visit us on the Internet at www.arcadiapublishing.com

CONTENTS

ACKNOWLEDGMENTS

Baseball is a cherished rite of childhood. This philosophy continues to be the cornerstone of Little League Baseball, which began as a daydream of one man more than 60 years ago in Williamsport, Pennsylvania.

This book is possible because of the many volunteers and their dedication to Little League, including Carl Stotz, founder of Little League Baseball; Harold "Major" Gehron and Jimmy Gehron, Carl's inspiration; Grayce, Karen, and Monya Stotz, Carl's family; George and Bert Bebble, managers of the second and third Little League teams; Jack Lundy for believing in and supporting Carl; Oliver Fawcett, Allen "Sonny" Yearick, William "Mac" McCloskey, Bert Haag, Frank Rizzo, Howard Gair, Vance Gair, and Terry Gramling, volunteers at Original Little League; and John Lindemuth, Peter J. McGovern, Dr. Creighton J. Hale, Beverly Gray Hale, Lance Van Auken, and Stephen D. Keener.

Special recognition also should be given to the photographers who recorded this slice of Americana. They include Putsee Vannucci, Raymond G. Wenzel, Russ Tinsley, Chris Stutz, and Craig W. Smith. Photographs are courtesy of Little League Baseball and of Karen Stotz Myers, from the Carl E. Stotz Collection. Maria Pepe and Kathryn Massar made other photographic contributions. Special thanks go to Louis Hunsinger Jr. and Kate A. Griffith for their editorial assistance.

INTRODUCTION

Little League Baseball is found in more than 100 countries and, at the height of the season, Little League is played on 12,000 fields in the United States alone. An estimated 360,000 children play on a typical day. The next day, 360,000 more children play.

A microcosm of American culture, Little League has a history filled with stories of good fortune as well as adversity. In 1947, when the first Little League Baseball World Series (then called the Little League National Tournament) was played, only 17 leagues existed. All were in Pennsylvania, except one, which hailed from Hammonton, New Jersey. Although not much of a national series, the world soon noticed the budding baseball program.

Adults were enchanted and girls buzzed around the adolescent ballplayers, a youthful mirror of the Major Leagues. Soon, Williamsport, Pennsylvania, the former lumber center boasting to be the home of more millionaires per capita than any other city, had a new identity: home of the annual Little League World Series.

In addition to coverage by newspapers, radio, and television, journalists were eager to report on the young athletes and descended upon the baseball complex.

Williamsport's Community Trade Association was proud of its river city, quaint and adorned with Victorian mansions of a bygone era, and its dynamic boys' baseball program. City officials opened their arms to the series and organized parades and dinners. They shuttled series participants to and from hotels, invited dignitaries (most often their favorite baseball players), and reveled in the glory brought to them by Carl Stotz and his cadre of loyal volunteers.

Visitors to the series have included baseball notables Cy Young, Connie Mack, Jackie Robinson, Mickey Mantle, Tom Seaver, Jim Palmer, Nolan Ryan, and Orel Hershiser, as well as George Bush (a few months before he became vice president), his son Pres. George W. Bush, Vice Pres. Dan Quayle, and Sen. Bill Bradley. Entertainers, actors, and best-selling authors are also attracted to the series, and visits have been made by Kevin Costner, Tom Selleck, Kenny Rogers, and John Grisham. Grisham even penned a screenplay, directed by Hugh Wilson, about the Little League World Series. The movie *Mickey* is about an overage Little Leaguer who deceives all by pitching in the World Series. The story is eerily reminiscent of the much publicized fraud perpetrated by a Bronx, New York league in 2001.

Founded in 1939 (granted a federal charter on July 16, 1964), Little League maintains its mission "to promote, develop, supervise, and voluntarily assist in all lawful ways, the interest of those who will participate in Little League Baseball."

One

BASEBALL FOR ALL BOYS

Visitors to the Little League Baseball World Series generally find their way across the West Branch of the Susquehanna River and into Williamsport, Pennsylvania. There, baseball fans wander down West Fourth Street to the birthplace of Little League.

Original League, the birthplace of Little League Baseball, is a living-history museum. Jim and Pennie Vanderlin and Jim and Karen Stotz Myers have lovingly restored it, with generous support from the community and Original League volunteers. During the annual series, Original League sponsors an open house. Volunteers raise the green plywood awnings of the concession stand and sell hot dogs and sodas while exhibition games are played on the two fields. Karen, the youngest daughter of founder Carl Stotz, often helps at the concession stand or gives tours of the small, one-room museum.

Time stands still at Original League. The outfield fence is still 180 feet, so the smaller boys and girls can hit home runs. It is the way Carl Stotz envisioned it, and to some, it is Little League in its purest form.

Stotz often played catch with his two nephews, Harold "Major" Gehron and Jimmy Gehron. Avid baseball fans, they would listen to legendary radio announcer Sol Wolf broadcast the games at Bowman Field, home of the Williamsport Grays, a Class A Eastern League team.

One afternoon in 1938, Stotz tripped over the stems of a lilac bush and sat down on his back porch to rub the bruise. The boys continued to toss the ball in the air, imitating the sportscaster's commentary. Stotz said it was at that moment he envisioned a baseball league exclusively for boys.

"Sol's broadcasts of the games up at Bowman Field were so exciting, so interesting to those little boys. After they heard him announce a game, they would go in their back yard and play catch and make the same statements he did. To Sol, the bases were never loaded—the ducks were on the pond. The batter never walked—he drew an Annie Oakley," said Stotz. "Now this next thing is hard to explain unless you have experienced it yourself sometime in your life, where all at once something comes to you that they call a flashback. . . . There it is in one scene. Immediately passed before me the conditions under which I played baseball. And that's when I said to them, 'How would you like to play on a regular team, with uniforms, a new ball for every game and bats you could really swing?' And they said, 'Who would we play? Will people come to watch us? Do you think a band would ever come to play?'"

People came, bands played, and Little League continues to enchant and entertain adults, even presidents, with its everyday lessons in character, courage, and loyalty.

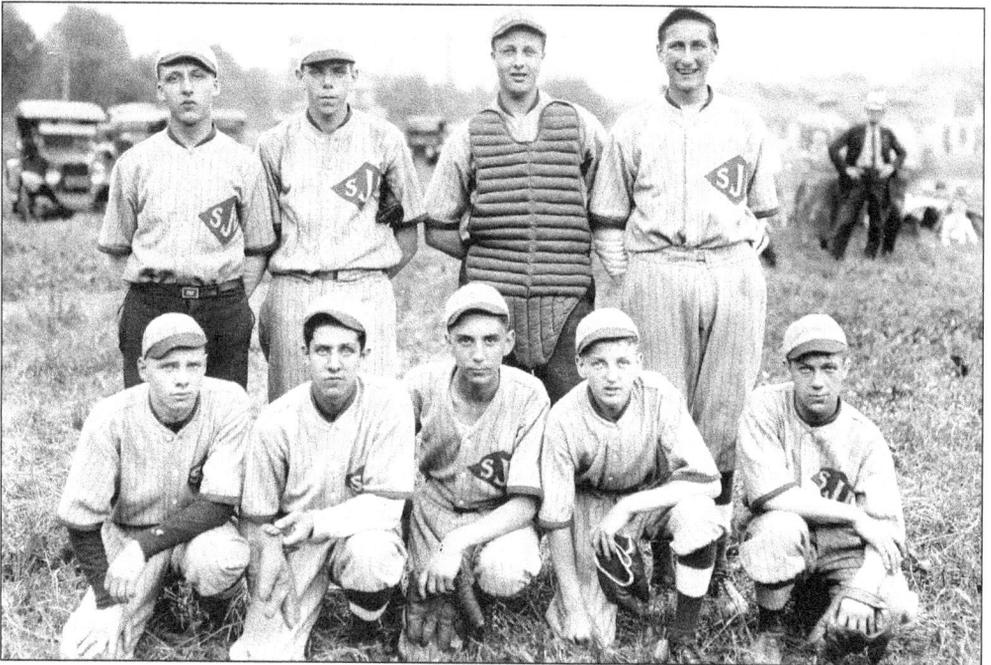

As a 13-year-old in Williamsport in 1923, Carl Stotz (front row, fourth from left) played baseball for St. John's Lutheran in the Sunday School League.

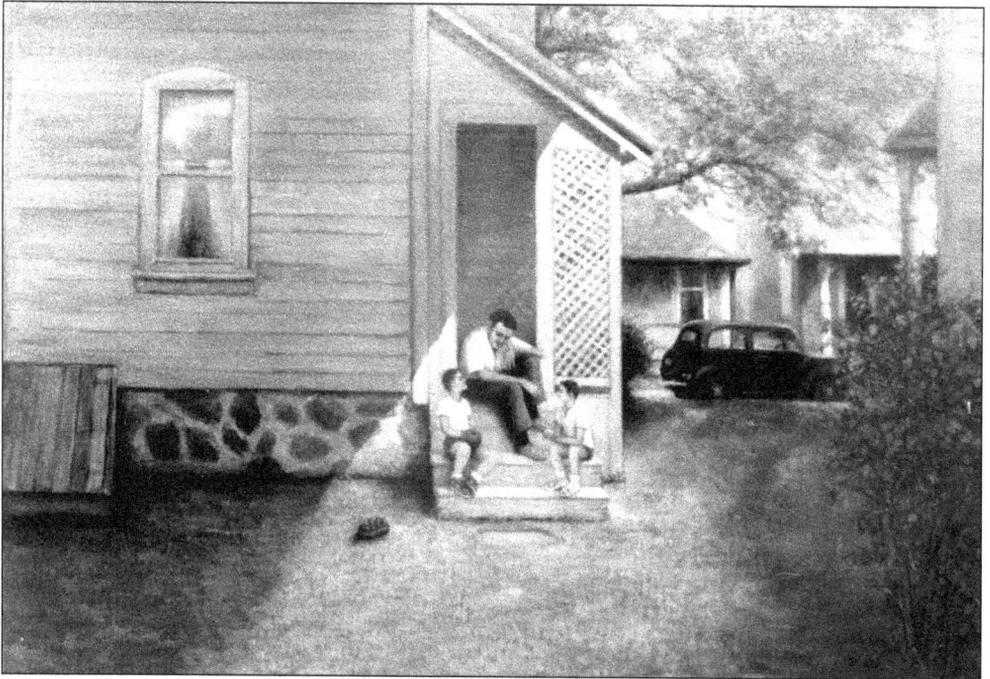

The young father of two girls (Monya Lee and Karen), Stotz often played baseball in his backyard with nephews Harold "Major" Gehron and Jimmy Gehron. This painting depicts the moment when Stotz, nursing his ankle from a nasty bump with a lilac bush, was inspired to begin a baseball program for boys.

The actual lilac bush over which Stotz tripped the day he dreamed of Little League is on display at Original League. He would later recount the story of how Major and Jimmy Gehron were playing ball in his backyard and he had a vision: "And that's when I said to them, 'How would you like to play on a regular team, with uniforms, a new ball for every game and bats you could really swing?'"

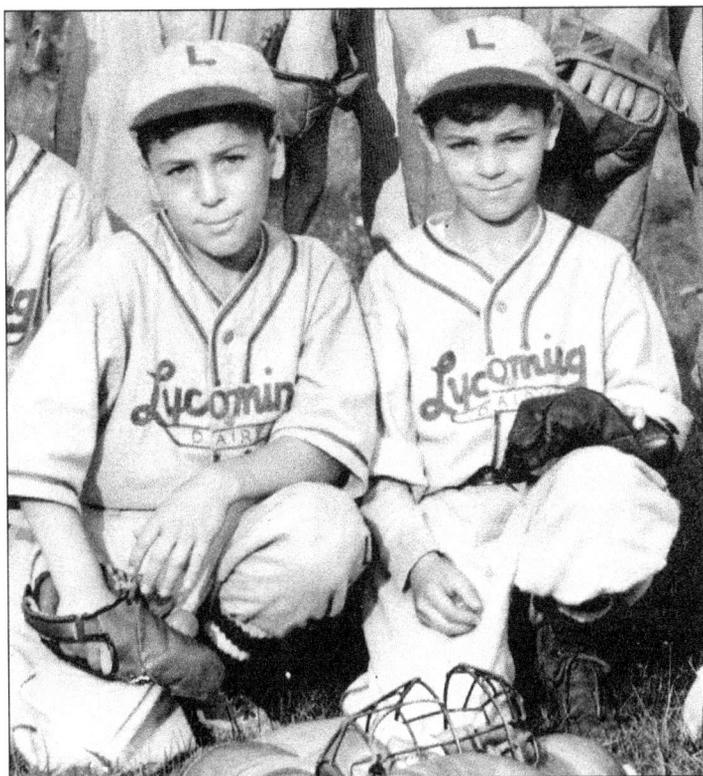

Major and Jimmy Gehron helped Stotz gather neighborhood children during the summer and devise the first rules and field dimensions for his planned boys' baseball program. For Stotz's first experimental workouts in 1938, the players ranged from ages 6 to 11. As the league coalesced, however, age guidelines were narrowed to ages 9 through 12.

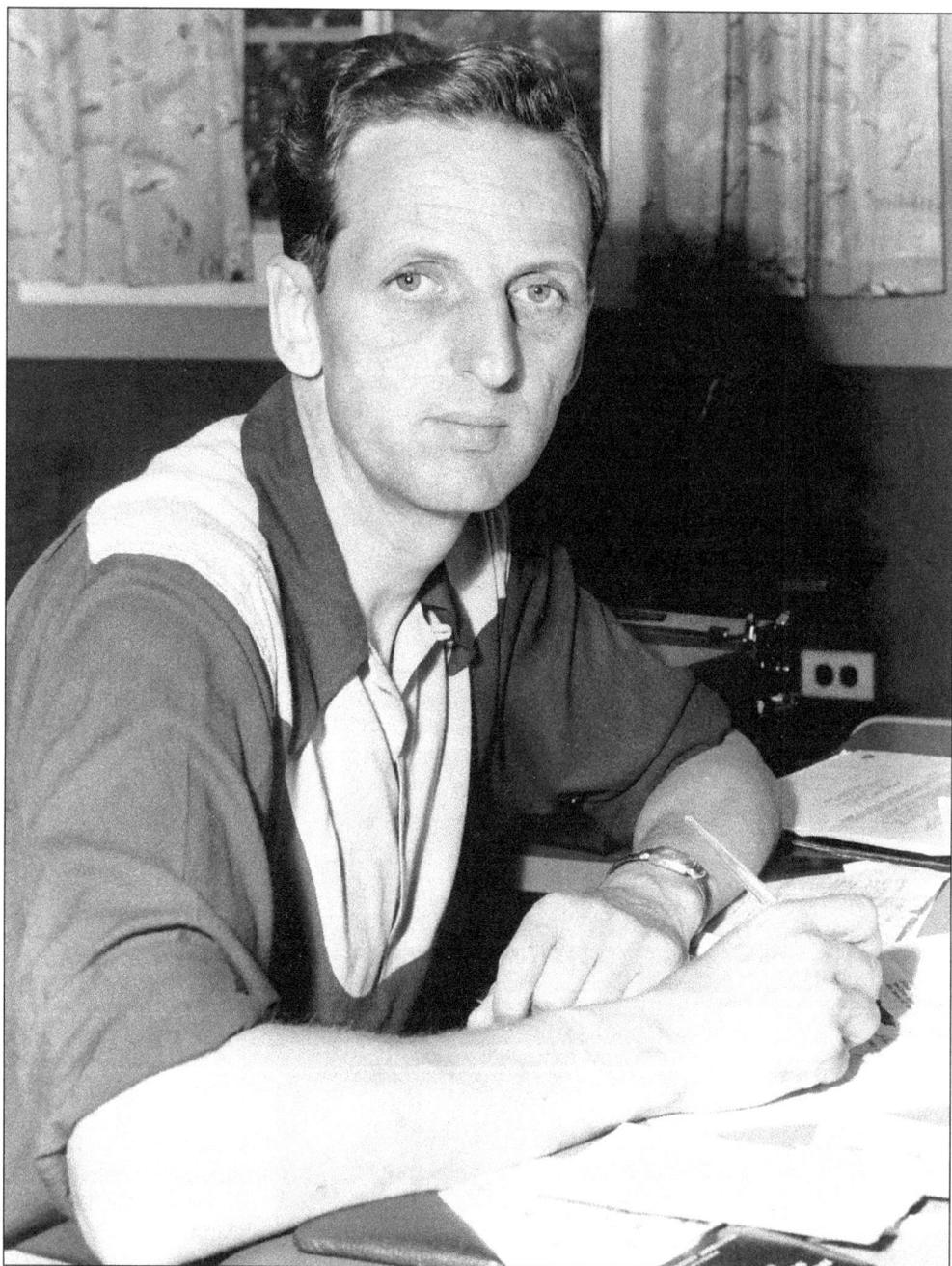

Carl Stotz works on Little League receipts in 1947. He kept his promise and created Little League Baseball. He approached local businesses for team sponsors and was rejected 56 times before securing Lycoming Dairy, Jumbo Pretzel, and Lundy Lumber. He formed three teams on a $30 donation, sufficient to purchase uniforms for each of the players. He enlisted help from other community members.

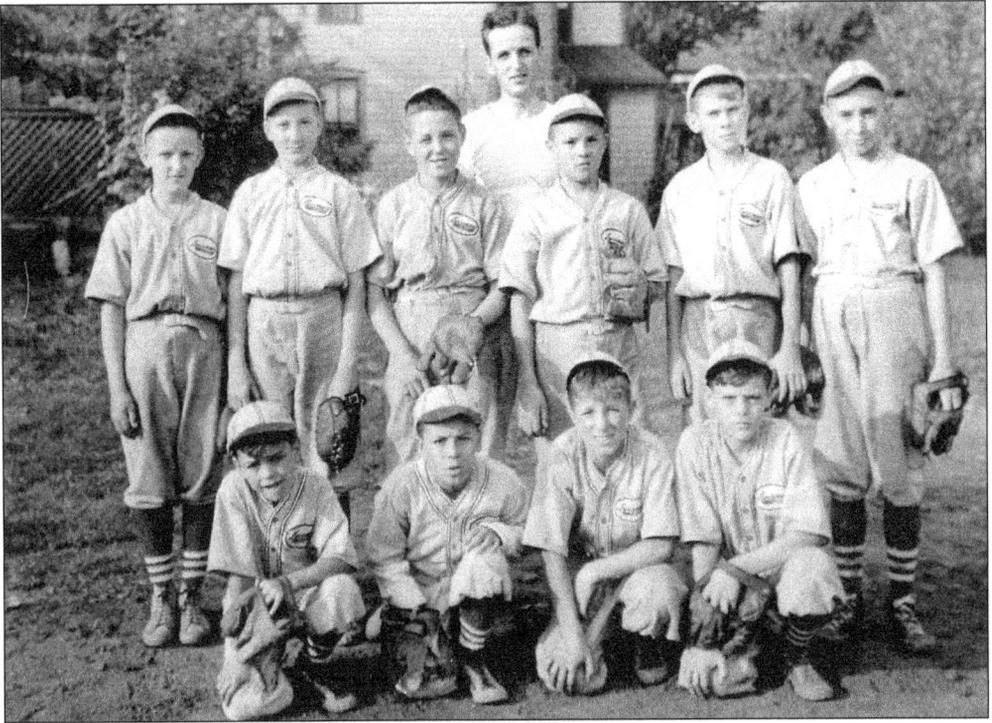

Carl Stotz (back row) was the manager of the Lycoming Dairy team, which included his nephews Major and Jimmy Gehron, and Allen "Sonny" Yearick (front row, second from the left). Yearick was the first Little Leaguer to sign a professional baseball contract (Boston Braves). The first three managers were Stotz and brothers George and Bert Bebble.

Stotz's employer, Jack Lundy of Lundy Lumber, became the league's third sponsor in 1939. To this day, Lundy Lumber sponsors a baseball team at Original League. Lundy also served on Little League Baseball's international board of directors until his retirement in 2000.

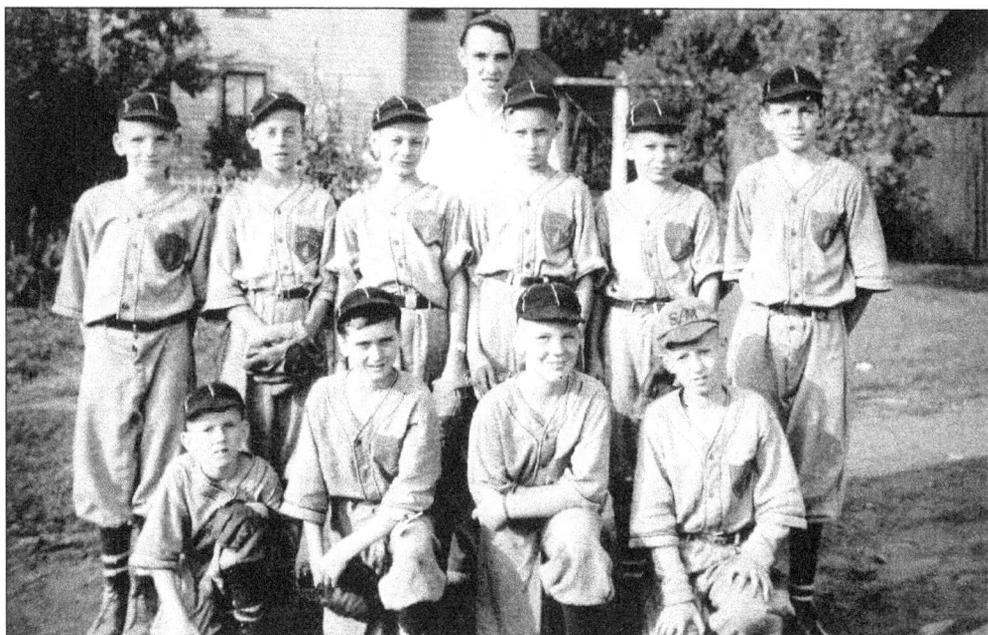

George Bebble (back row) managed the Lundy Lumber team. One of the first adult volunteers—George's wife, Annabelle—worked with Carl Stotz's wife, Grayce, at a hosiery mill. Annabelle Bebble suggested that Carl Stotz invite George, since he liked baseball and played in the Sunday School League. George recommended his brother Bert Bebble to manage the third team.

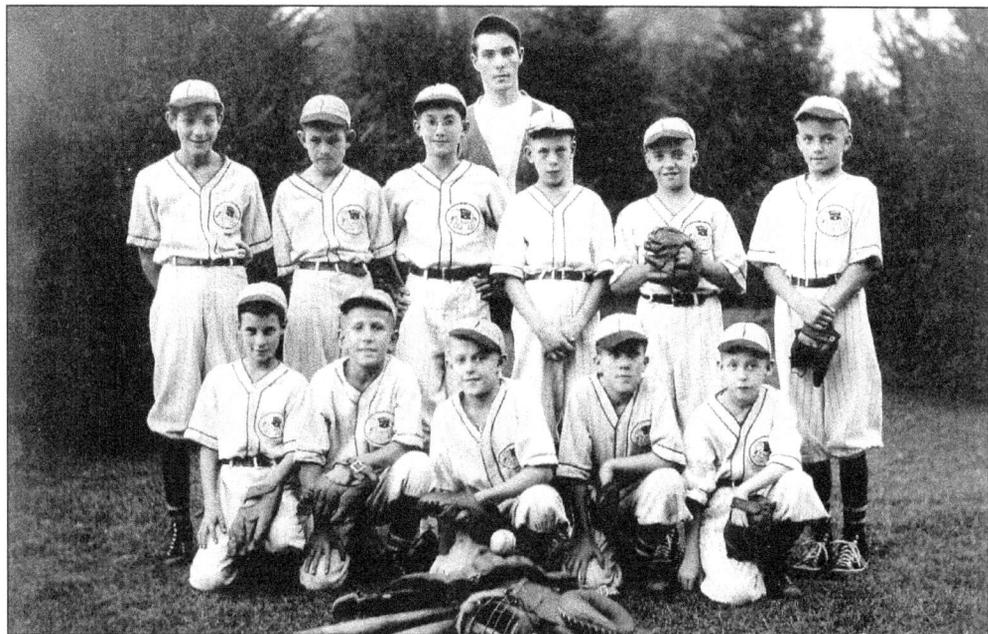

Bert Bebble (back row) managed the Jumbo Pretzel team. The league's first year ended with a five-game championship series. Lycoming Dairy was the first-half champion against Lundy Lumber, the second-half champion. Carl Stotz arranged the schedule in halves, allowing for a slow-starting team to improve and vie for the title.

An overgrown lot owned by the Williamsport Textile Company sat at the corner of Memorial Avenue and Demorest Street in Williamsport. Carl Stotz, George and Bert Bebble, and other volunteers cleared the land and created the program's first baseball diamond, Demorest Field.

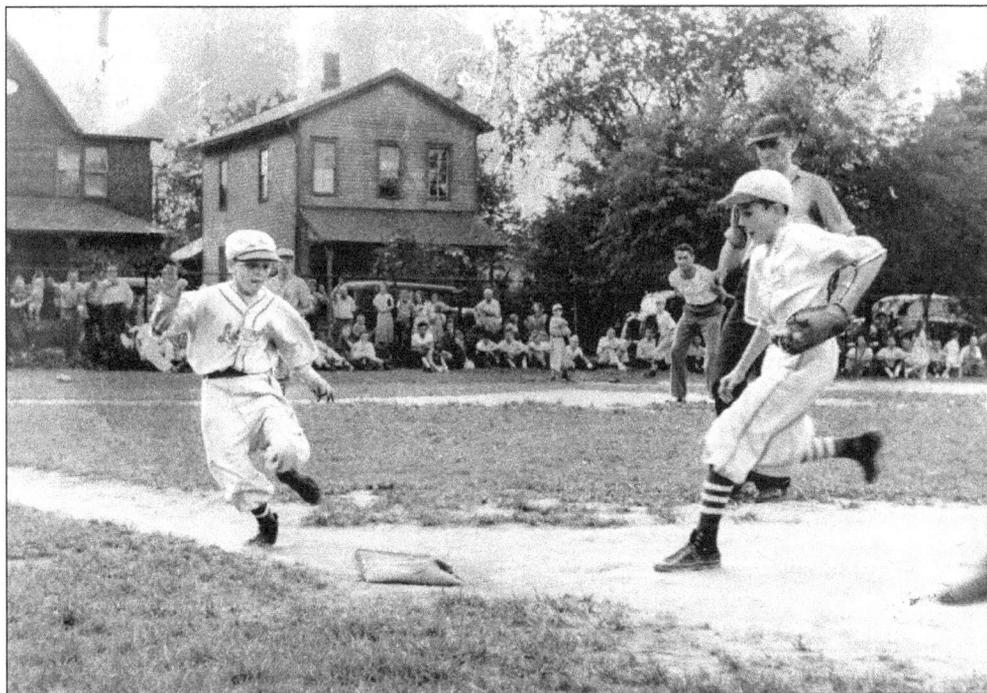

Demorest Field was used for two years until the league moved to Memorial Field in 1942. The program expanded to include a fourth team, Richardson Buick, in 1940. With more boys joining, it became evident that not every one of them could be selected. From these ranks, a farm league, the Morning League, was established.

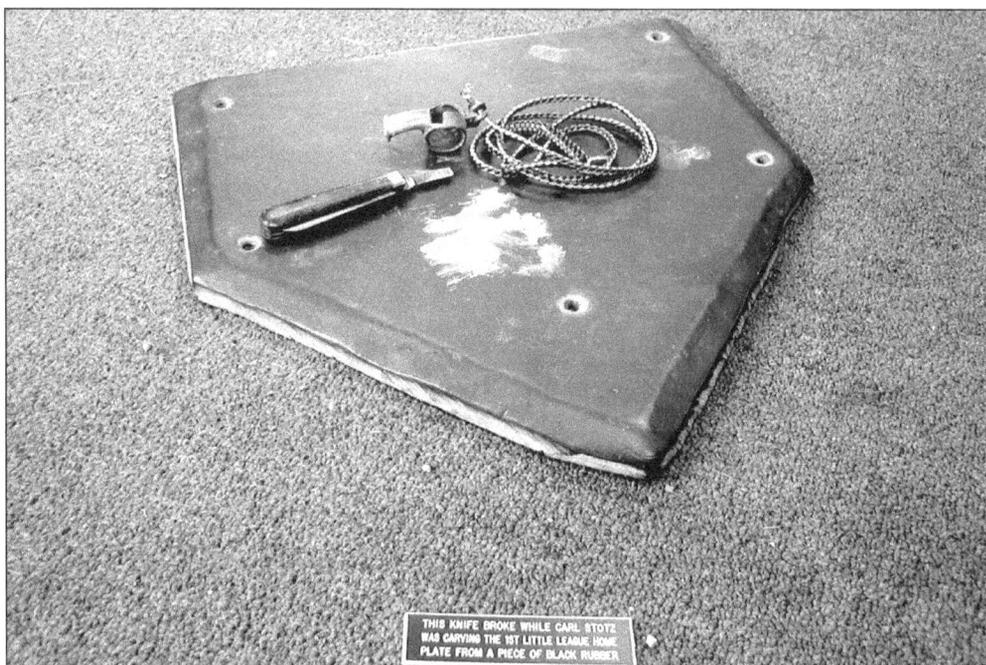

The first home plate was carved out of a large piece of rubber and painted white. Carl Stotz preserved the knife he used to carve home plate and the whistle he used during the first Little League tryouts. These items are all on display at Original League.

LUNDYS TAKE OPENER IN "LITTLE LEAGUE"

Lundy staged two big innings to defeat Dairy in the "Little League" opener last evening. In a game filled with excitement for both fans and players, Sipe, hurling for Lundys, held the Lycoming batters in check and was in danger at no time during the game. Not until the third inning after Gehron relieved Miller in the box were the Dairy boys able to quiet the bats of Lundys' sluggers and from that point on the game developed into a close contest.

The score:

Lycoming Dairy 1 0 0 3 3 1— 8
Lundy Lumber 7 8 4 2 2 0—23

Thursday evening Jumbo will meet Dairy and determine whether stage-fright prevented the Dairy boys from playing a better brand of ball.

The first Little League game, played on June 6, 1939, was reported in the *Williamsport Sun*, along with a line score. The little boys were given major-league consideration by the daily newspaper's sports department.

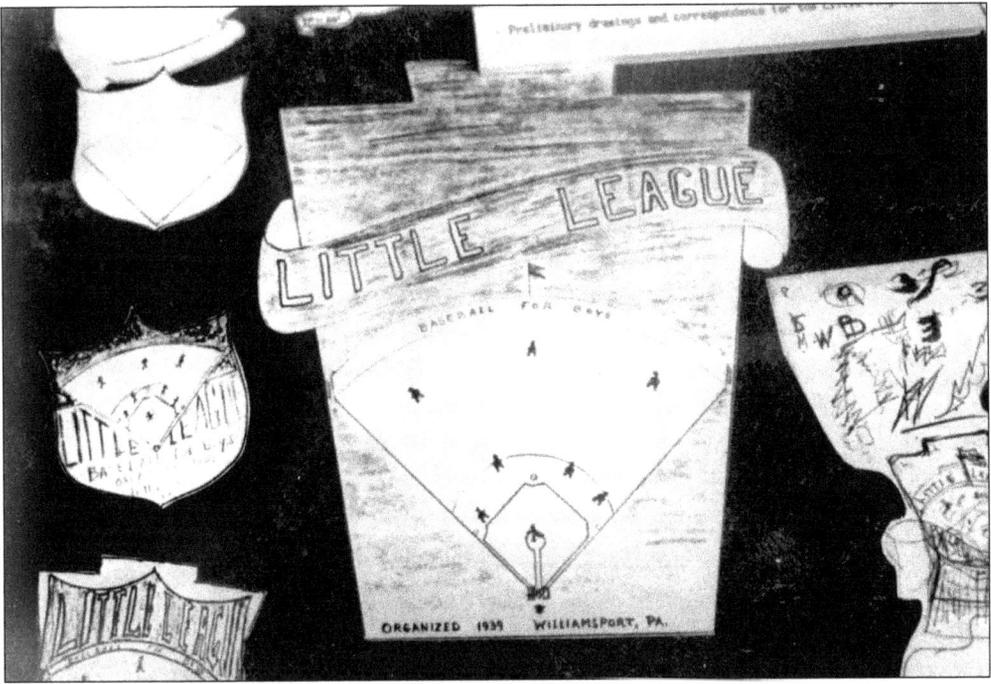

Carl Stotz enjoyed the attention his boys' baseball program attracted, and he worked on its identity. The name Junior League was already taken, so newspaper editors suggested Little League. Stotz's drawings of rejected emblems are part of the Stotz family's archives. Little Leaguers still wear the keystone patch he designed.

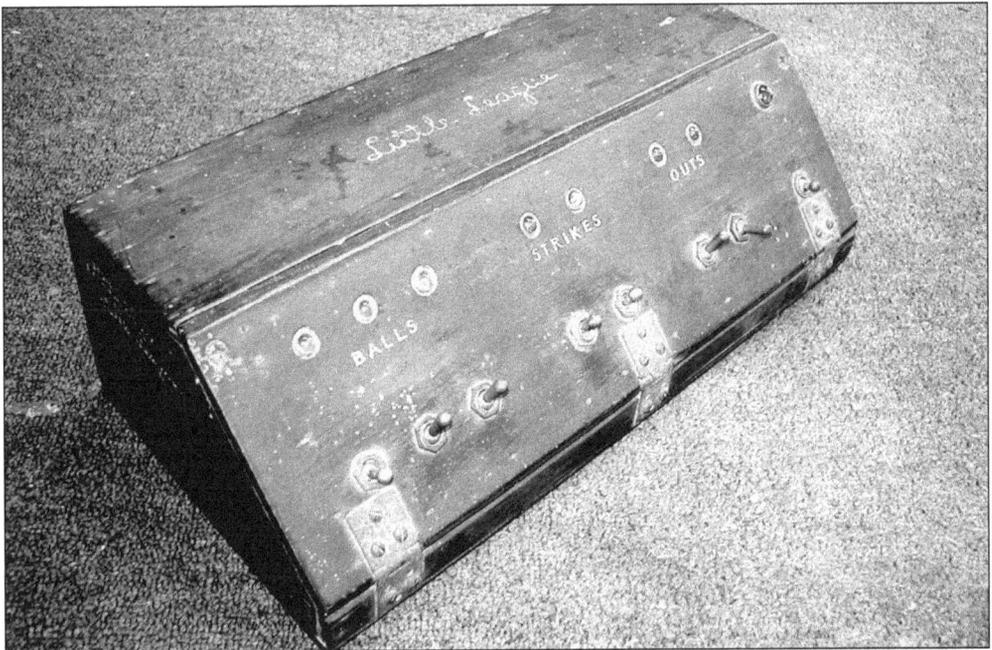

William "Mac" McCloskey, Little League's official scorekeeper, invented an electronic scoreboard using this control box, thought to be the first of its kind. The box is displayed at Original League.

17

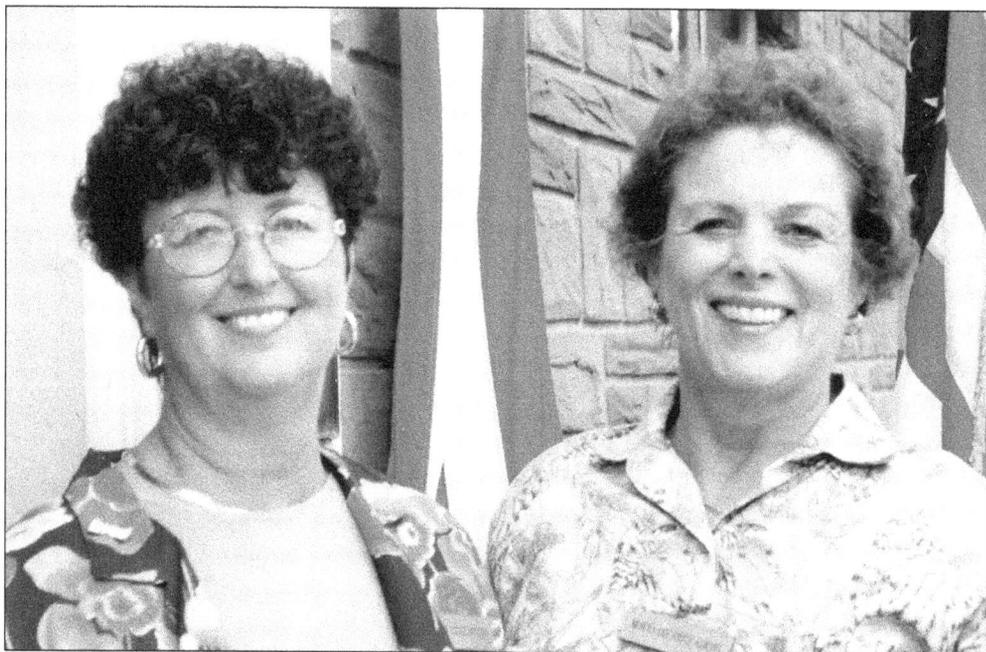

Karen Stotz Myers (left) and her sister Monya Lee Stotz Adkins host an open house in 1997 at Original League, the birthplace of Little League Baseball. The Williamsport-Lycoming Foundation and Lundy Lumber partially funded major reconstruction of the facility.

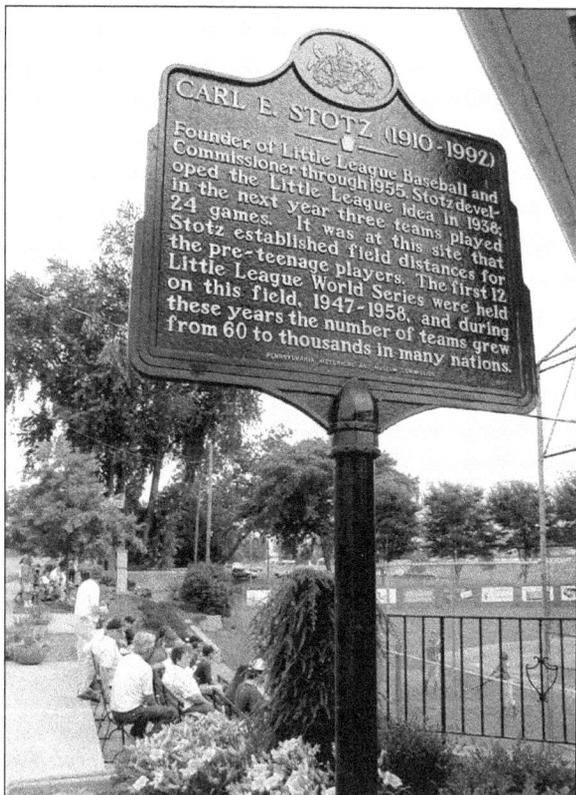

In 1995, the Pennsylvania Historical and Museum Commission recognized the significance of Original League and erected a historic marker. The site of the annual World Series from 1947 to 1958, the field was renamed in Stotz's honor in 1974 and serves the community as a living-history museum.

Two

A NATIONAL TOURNAMENT

In 1941, Little League expanded to 12 leagues, all in Pennsylvania. The future looked bright for Little League Baseball, as the board halved the budget deficit by the end of the 1941 season.

The 1942 season turned out to be Carl Stotz's last as a manager because of a change in his work schedule. Bill Bair, a teenager who volunteered as Stotz's assistant, took over as manager. Stotz continued to provide personal funds to carry the program until 1943, when he could finally be reimbursed. Income for the inaugural season totaled $174.63.

As World War II raged on two fronts, Little League felt the effects. Besides the shortages of equipment and cloth for uniforms, some of Little League's volunteers were called to service.

After the war, a 1946 *Williamsport Sun* report read, "Throughout the United States, leagues patterned after Carl's brainchild are springing up like weeds in a flower bed." Nearby communities copied Little League's model, prompting its board of directors to consider forming an umbrella organization to oversee all the leagues patterned after Stotz's. In the months leading up to the 1947 season, Stotz visited or mailed information to dozens of communities on how to start and operate a league. The 1947 Little League National Tournament is considered the first Little League World Series, although not so named until 1949.

Media reports helped to spread the word even more. Stories in the *Saturday Evening Post* and *Life* magazine in 1949 provided national exposure for the first time and were read by millions. Newsreels about Little League reached millions more in movie theaters and, for the first time, interest in Little League came from outside the United States.

The first non-U.S. league was in Panama, where Canal Zone personnel applied for a charter in 1950. Teams from Panama and Canada entered postseason play in 1951. In the 50 years in which foreign teams were eligible to reach the Little League Baseball World Series through 2001, the United States won 22 times.

In 1963, ABC began televising the final game of the Little League Baseball World Series on its fledgling *Wide World of Sports* program. High ratings convinced ABC to keep the series on its annual schedule. In the 1980s, ESPN also began televising series games. Today, more than 10 million people tune in annually to the August event.

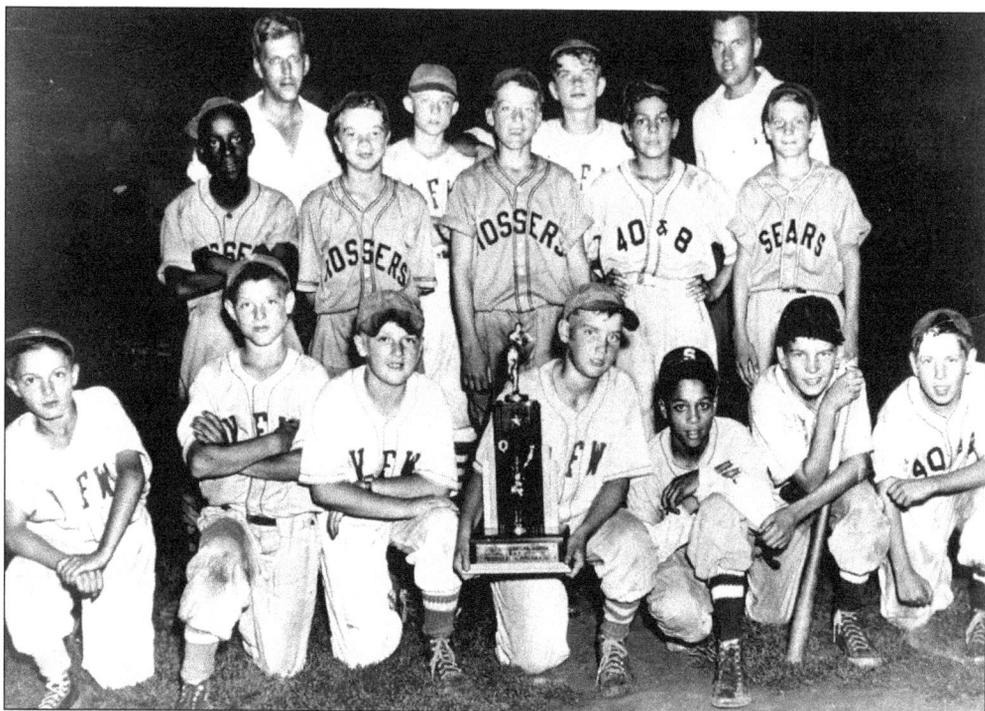

The Maynard Midgets of Williamsport won the first series, defeating Lock Haven, Pennsylvania, 16-7. The board named the 1947 event the Little League National Tournament. Center fielder for the team was Jack Losch (middle row, third from left), who later played football for the Miami Hurricanes and Green Bay Packers.

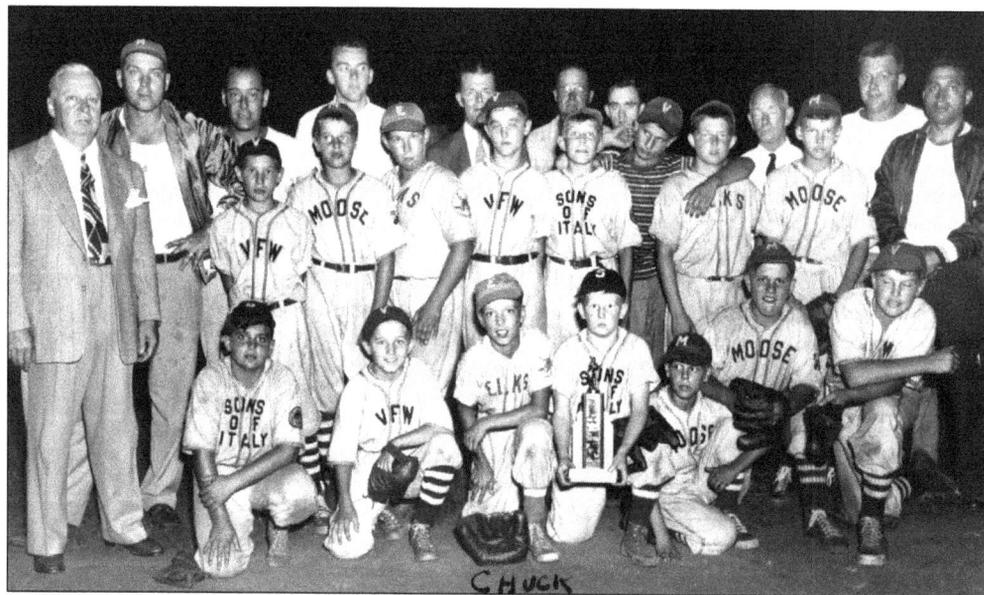

Lock Haven Little League's all-star team, organized in 1947, consisted of players from teams sponsored by the Elks, Moose, Sons of Italy, and Veterans of Foreign Wars. Launched on a scale that captivated its townspeople, the youth baseball program generated an interest that rivaled the community's successful gridiron history.

Little League's first tournament boasted a program complete with team photographs and a schedule of events. Represented at the tournament were teams from Williamsport Little League, the Sunday School League, the Lincoln Boys League, Montour, Brandon Boys, Montgomery, Jersey Shore All Stars, Maynard Midgets, Milton Midgets, Perry Lions, Lock Haven All-Stars, and Hammonton (New Jersey) All-Stars.

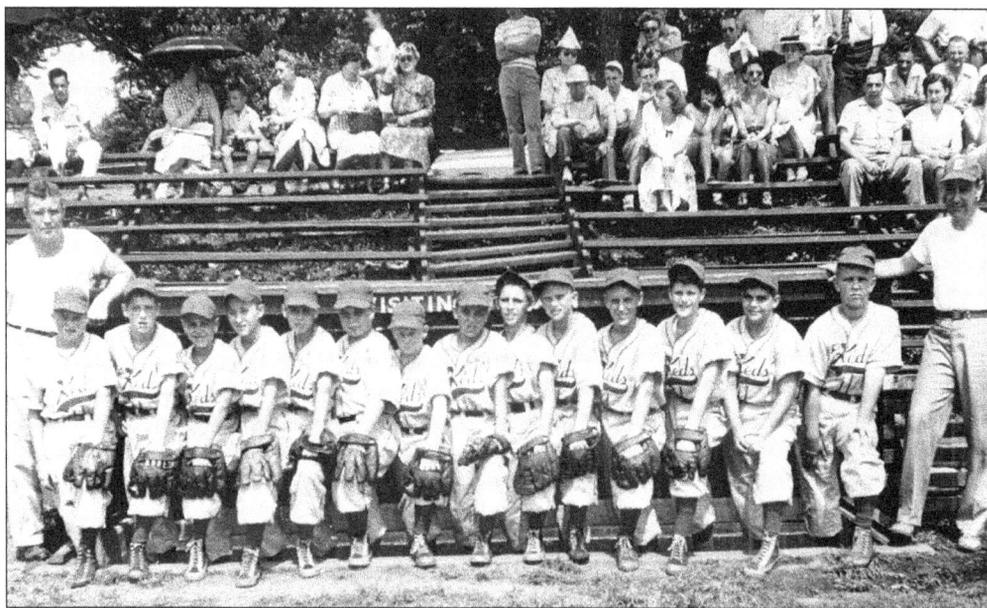

In 1948, Little League grew to 94 leagues. Carl Stotz wrote to all of the leagues to explain the new lines of shoes, bats, and balls and how they could be ordered. At the time, Little League did not receive royalties on the sale of merchandise bearing the Little League name. The relationship between sporting-goods manufacturers and Little League increased public awareness and increased revenue.

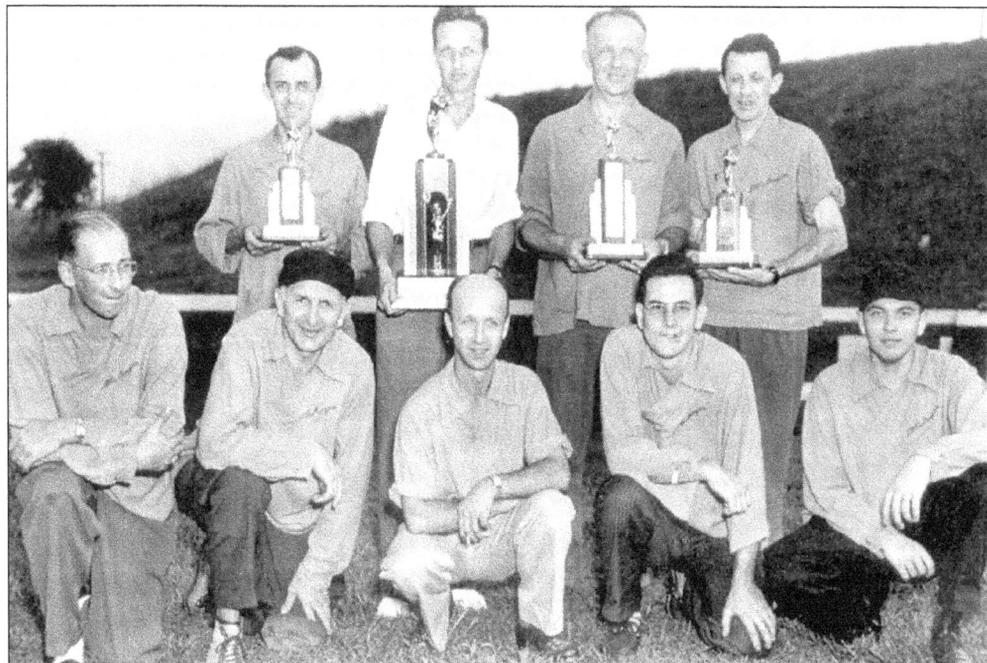

Little League Tournament Association personnel display trophies for the 1947 tournament. From left to right are the following: (front row) Oliver Fawcett, Howard Gair, Clyde Clark, Bert Haag, and Vance Gair; (back row) Martin Miller, Carl Stotz, John Lindemuth, and Mac McCloskey.

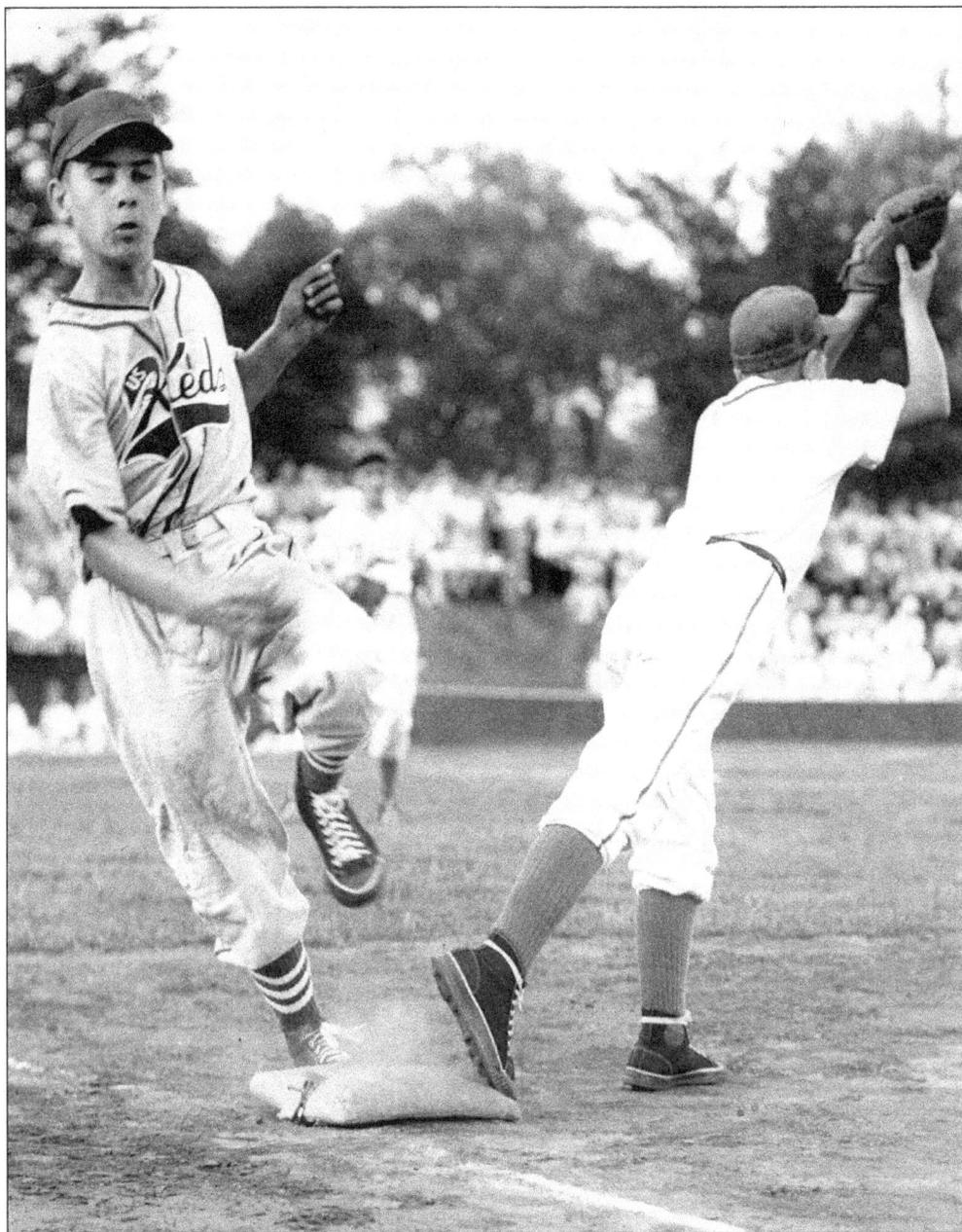

U.S. Rubber (now Uniroyal) became the first corporate sponsor of Little League, and tournament uniforms sported the sponsor name Keds. To its credit, U.S. Rubber asked Carl Stotz not to put sponsors on uniforms, a tradition that continues in the World Series. Lock Haven, Pennsylvania, defeated a team from St. Petersburg, Florida, 6-5 in the championship. The tournament received television exposure. On radio, New York's Ted Husing broadcast a play-by-play account of the final game over 106 NBC stations.

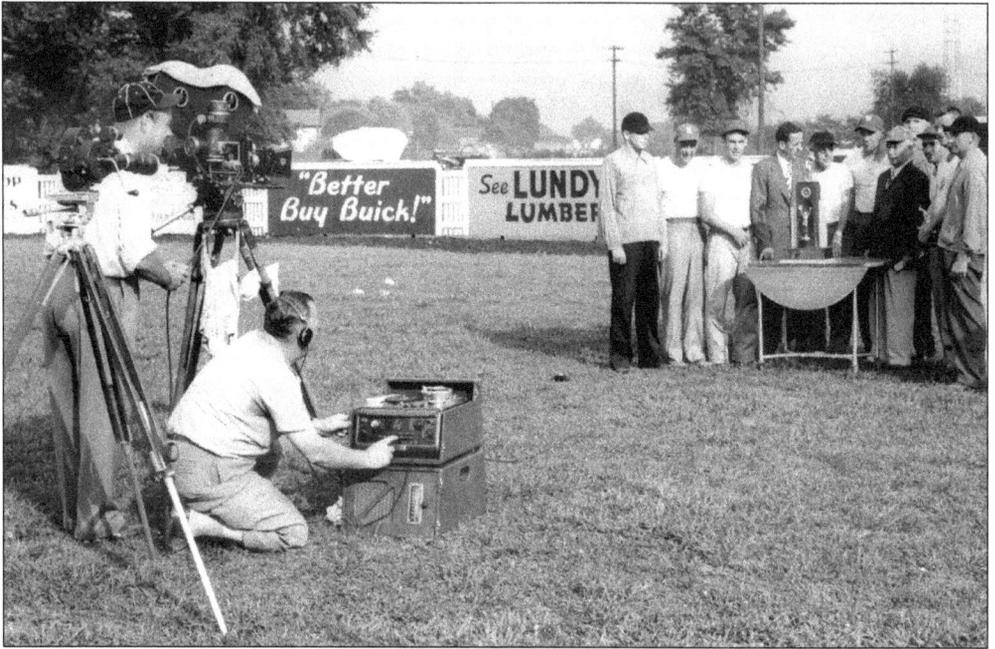

A film crew for Emerson Yorke filmed Carl Stotz and Little League officials at Memorial Field for a variety of newsreels. Each season brought more media exposure, and Little League occupied 3 minutes of the 15-minute Camel program on CBS.

LITTLE LEAGUE

ORGANIZED, 1939

WILLIAMSPORT, PENNA.

SCHEDULE AND TEAM ROSTERS
— 1949 —

MANAGING PERSONNEL

Carl E. Stotz President
John Lindemuth, Vice Pres., Mgr., Hemperly's
Vance Gair, Secretary Umpire
Howard Gair, Treasurer Umpire-In-Chief
Wm. F. McCloskey Scorer and Statistician
Marty Miller Mgr., Buick
Ollie Fawcett Mgr., Lycoming
Clyde Clark Mgr., Lundy's

SPONSORS

LYCOMING DAIRY FARMS
LUNDY LUMBER COMPANY
RICHARDSON BUICK COMPANY
HEMPERLY'S SERVICE

This collectable schedule and team roster from the regular season for the first Little League is maintained at Original League, birthplace of Little League. As Little League's first paid Pied Piper, Carl Stotz visited seven states in 1949, and the program expanded to 307 leagues nationwide.

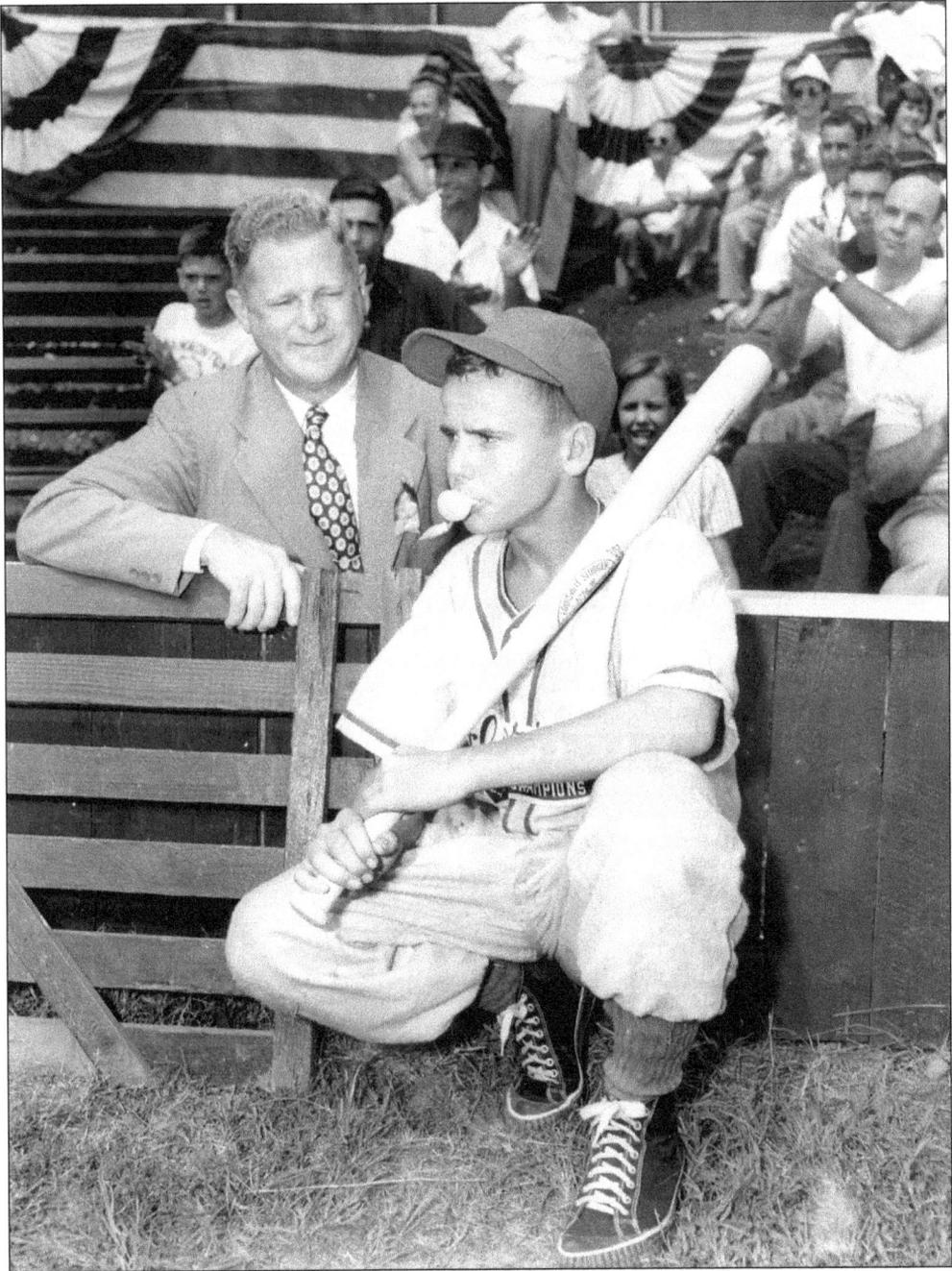

Paul Kerr—vice president of the National Baseball Hall of Fame and Museum and chairman of Little League Baseball from 1953 to 1955—chats with Little Leaguer Jerry Hudson of Florida in a 1949 series game at Memorial Field. "Just as Major League Baseball has become a permanent fixture in American life, so will Little League Baseball," the 1949 program boasted.

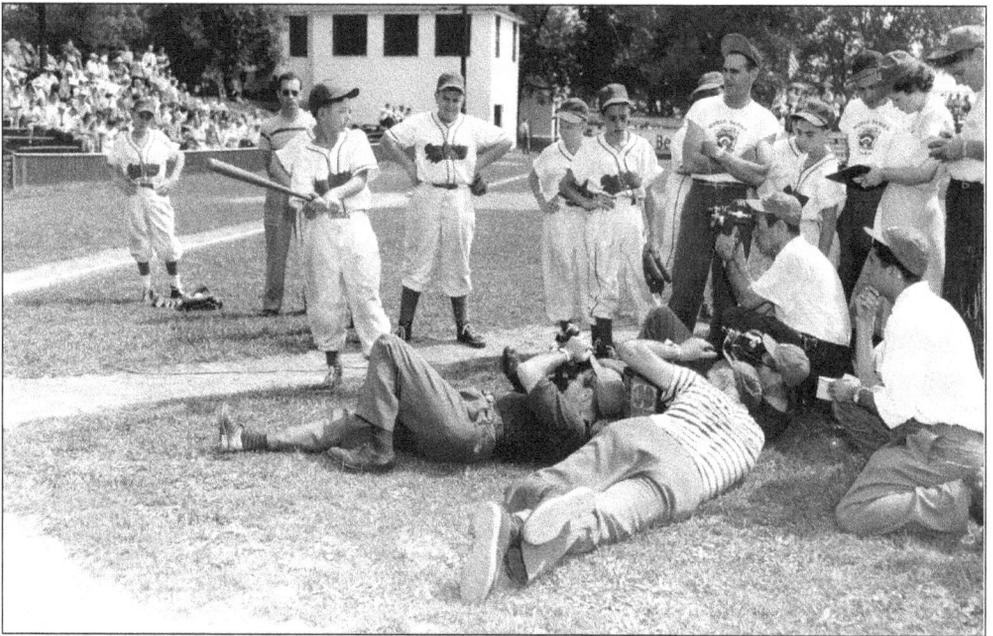

A feature about Little League in the *Saturday Evening Post* reached 4 million people, and 80 million Americans viewed newsreels from the Little League National Tournament. The players were already media darlings, but a story in *Life* magazine later in the year boosted the international growth of Little League even further.

NATIONAL LITTLE LEAGUE BASEBALL TOURNAMENT

CARL E. STOTZ, FOUNDER

THIRD ANNUAL

NATIONAL **LITTLE LEAGUE** BASEBALL
TOURNAMENT
AUGUST 24-27, 1949

WILLIAMSPORT, PENNSYLVANIA
BIRTHPLACE
OF
LITTLE LEAGUE BASEBALL

WILLIAMSPORT, PENNA. AUG. 24-27, 1949

OFFICIAL PROGRAM 15c

Hammonton, New Jersey, defeated Pensacola, Florida, 5-0 at the 1949 National Little League Baseball Tournament. Carl Stotz, president and national director of Little League, announced that the program would organize to "allow for representation of leagues throughout the country." Reluctantly, Stotz finally agreed to centralize the governing of Little League to help protect the trademark.

26

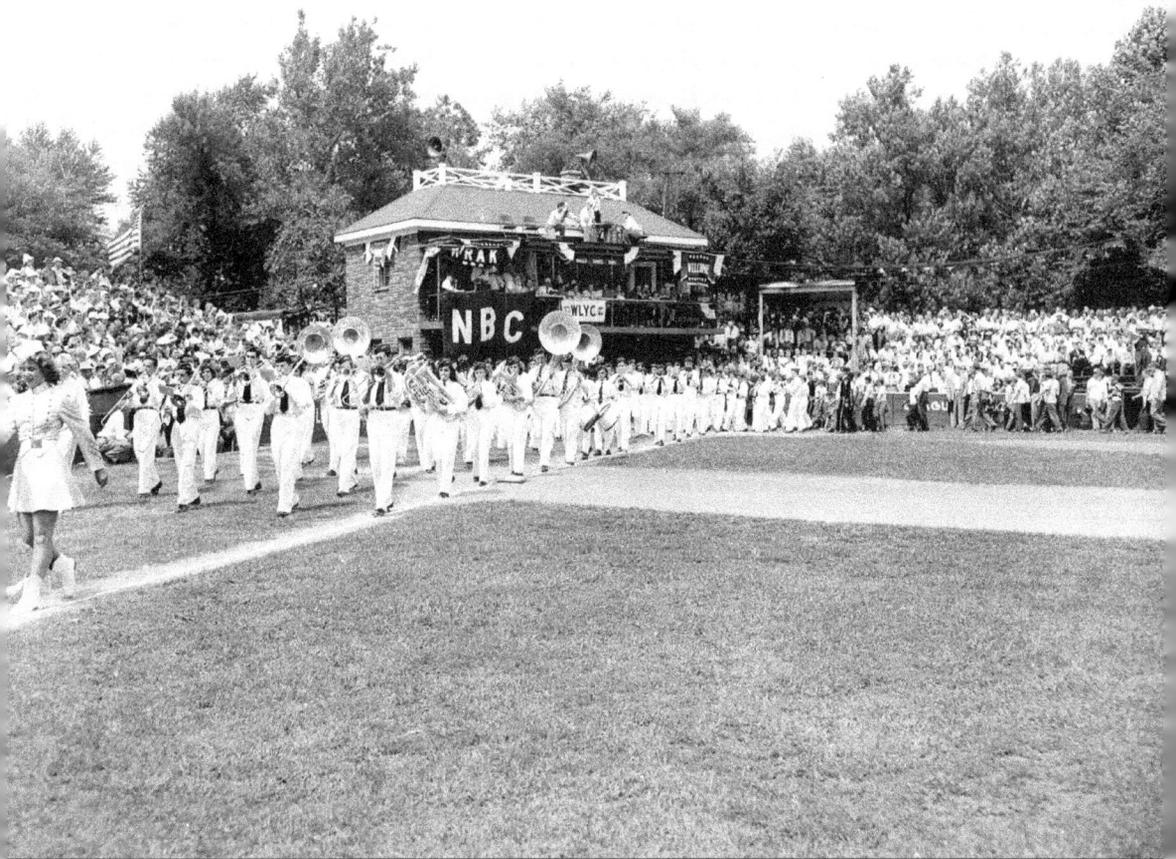

Pregame ceremonies at the 1949 Little League National Tournament featured a marching band and majorettes. It marked the first year the Williamsport Community Trade Association joined with Carl Stotz to promote and publicize the tournaments and assist in local arrangements. Committees formed to round up baseball dignitaries, to decorate and entertain, to feed and transport players, to provide medical aid, to publicize the event, and to organize the parade. An additional 2,000 people were seated in bleachers purchased at a cost of $8,500.

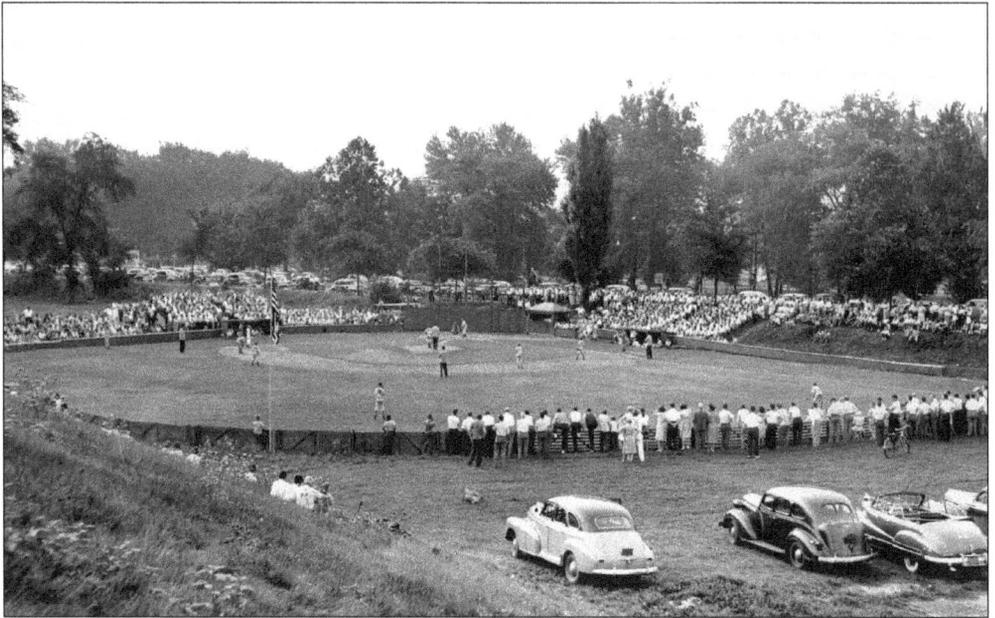

Watching the tournament ball games at Memorial Field was a pleasant interlude, and a tradition began that continues today at Little League's current stadium—fans sitting on the hill. In 1950, the shortest World Series game ever (lasting exactly one hour) was played between Hagerstown, Maryland, and Kankakee, Illinois.

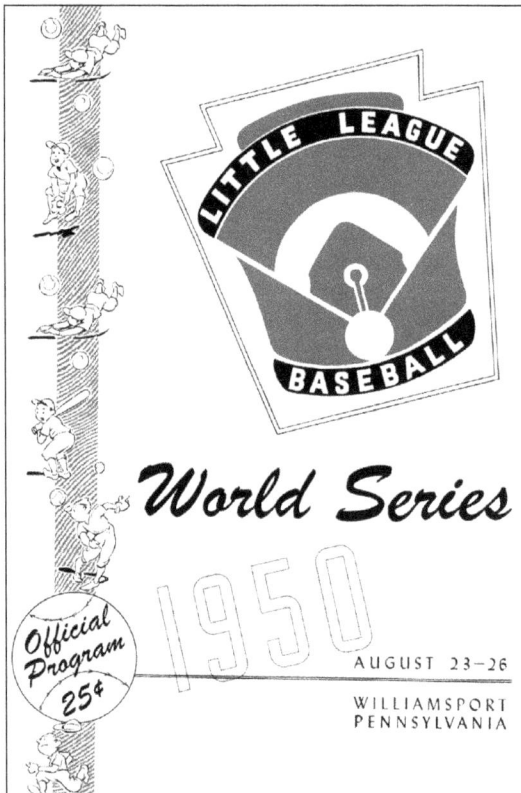

The 1950 World Series was won by National Little League of Houston, Texas, 2-1 against Bridgeport, Connecticut. The first chartered Little Leagues outside the United States were in 1950 on each end of the Panama Canal. The same year, Canada, Cuba, Puerto Rico, Hawaii, and Alaska established leagues outside the borders of the 48 states.

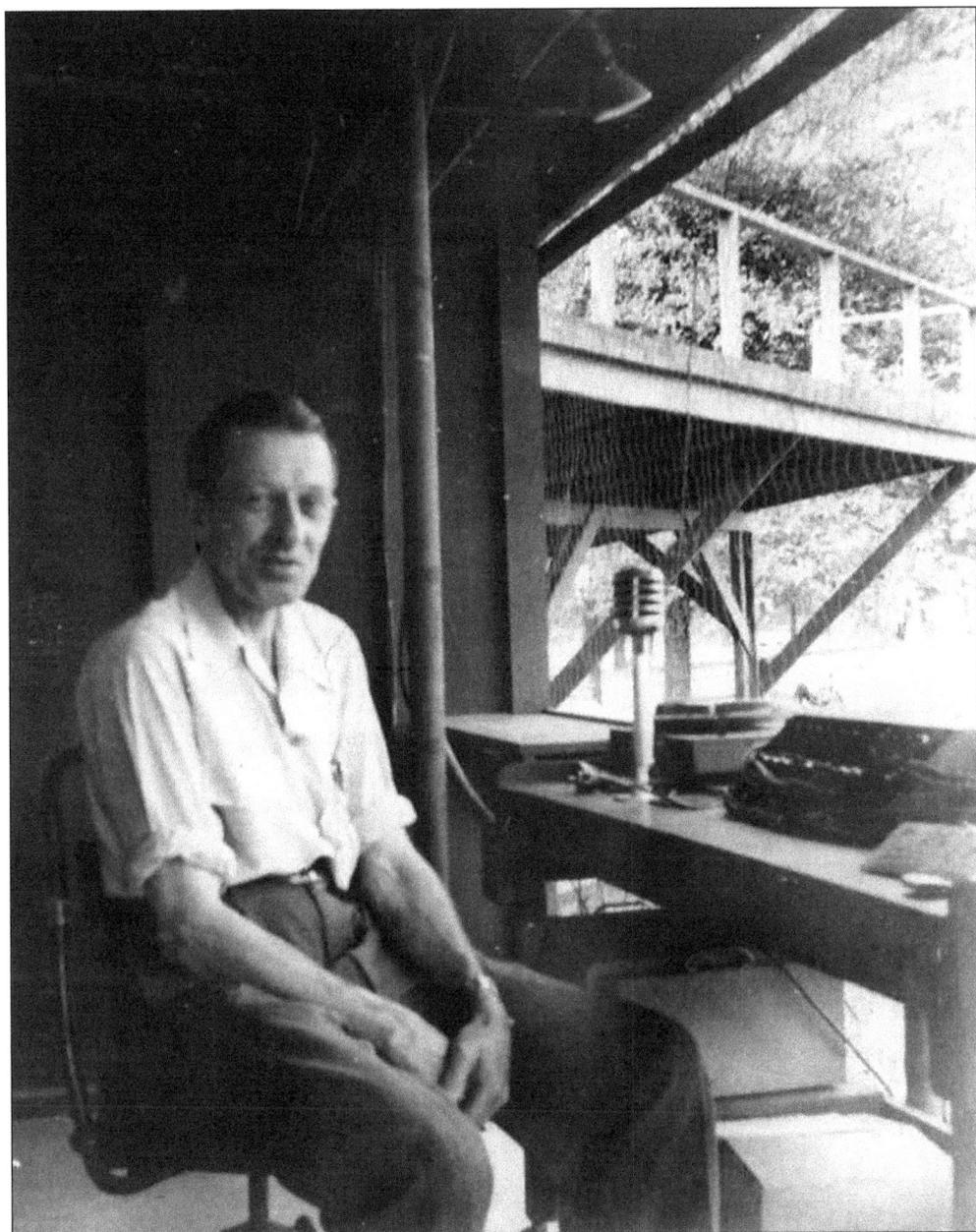

William "Mac" McCloskey's career as a scorekeeper spanned 27 years and 1,327 consecutive games beginning August 20, 1940, when the regular scorekeeper was absent. The father of a Little Leaguer, McCloskey kept the score book at every game played. On August 14, 1945, he noted the attendance at 350 and the weather as fair and hot. He also noted the reason the game had been stopped—at 7:15 p.m., Pres. Harry S Truman announced that the Japanese had surrendered, thus ending the war.

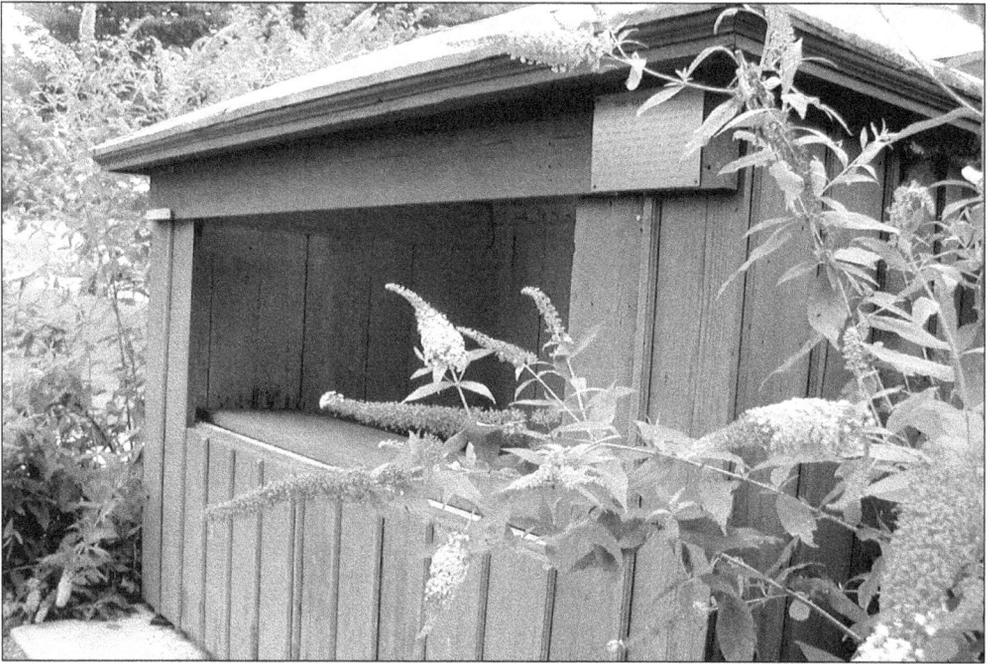

Little League's first clubhouse is maintained as part of the living-history museum at Original League. By 1951, Quebec, Manitoba, British Columbia, and Vancouver boasted Little League programs. A year later, Prince Edward Island and Nova Scotia joined.

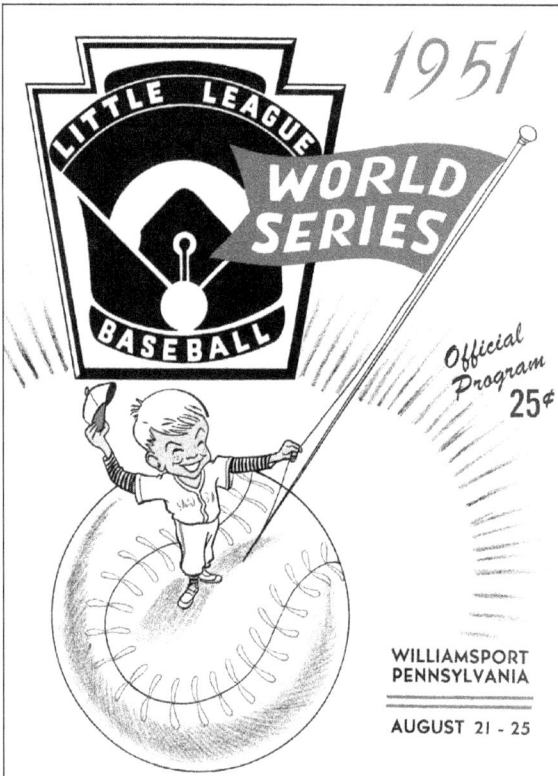

Little League fever caught on, and in less than 12 years, there were 3,333 teams. Stamford, Connecticut, defeated the North Austin Lions of Austin, Texas, 3-0 at the 1951 World Series. That year, Howard J. Lamade, vice president and secretary of the Grit Publishing Company, began his tenure on the Little League board of directors.

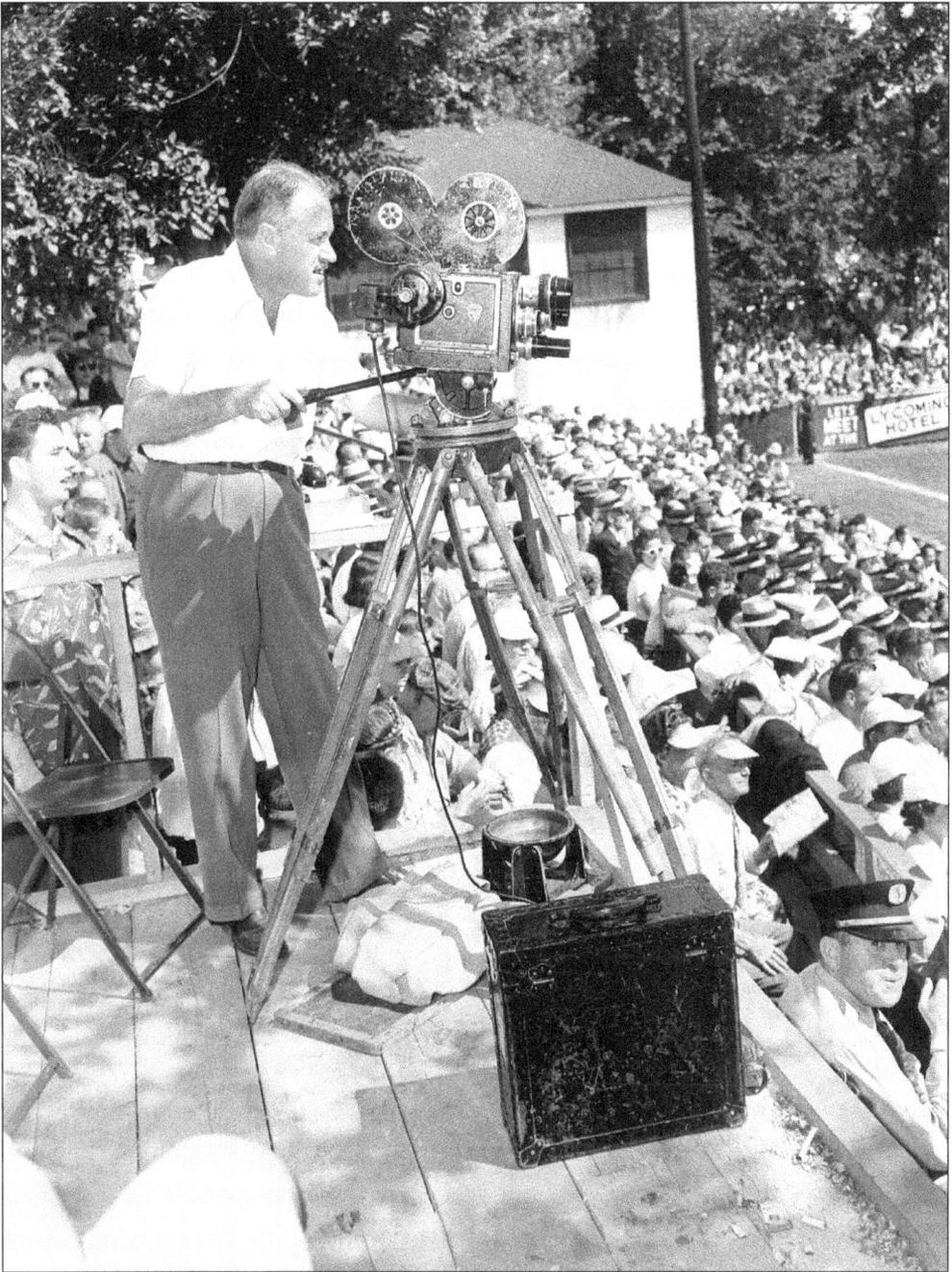

In 1951, NBC decided that the championship game might make for good listening on a Friday afternoon. Reporters, photographers, and cameramen became common sights at the Little League Baseball World Series.

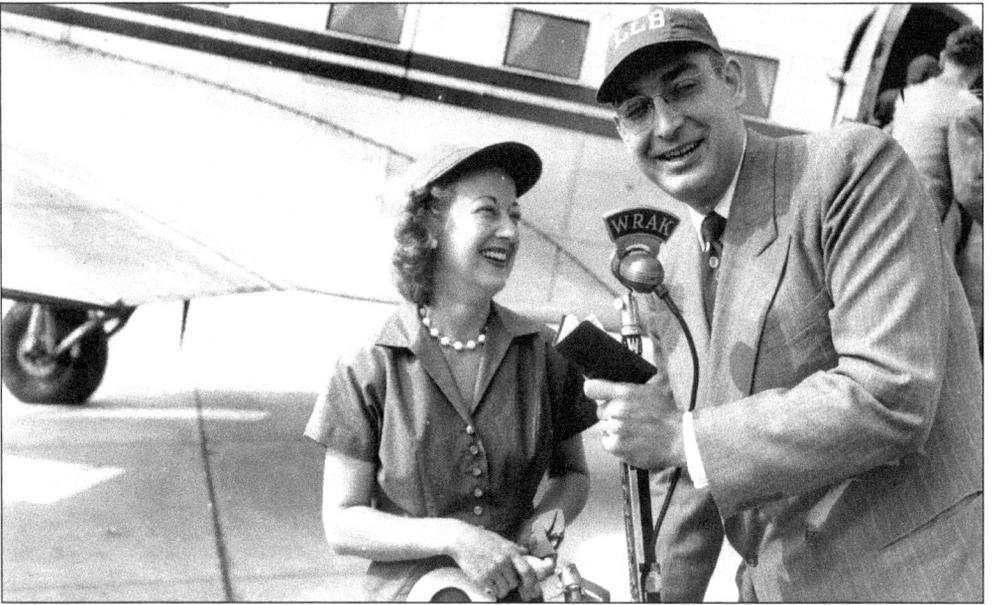

WRAK radio announcer Irving "Bud" Berndt interviews Solita Palmer, author of the song "Little Leaguer" and a visitor to the 1951 series. Peg Baldwin authored an article about Little League for the 1951 *Reader's Digest*. She also wrote a book with Carl Stotz, *At Bat with the Little League*, a guide for starting and operating a program.

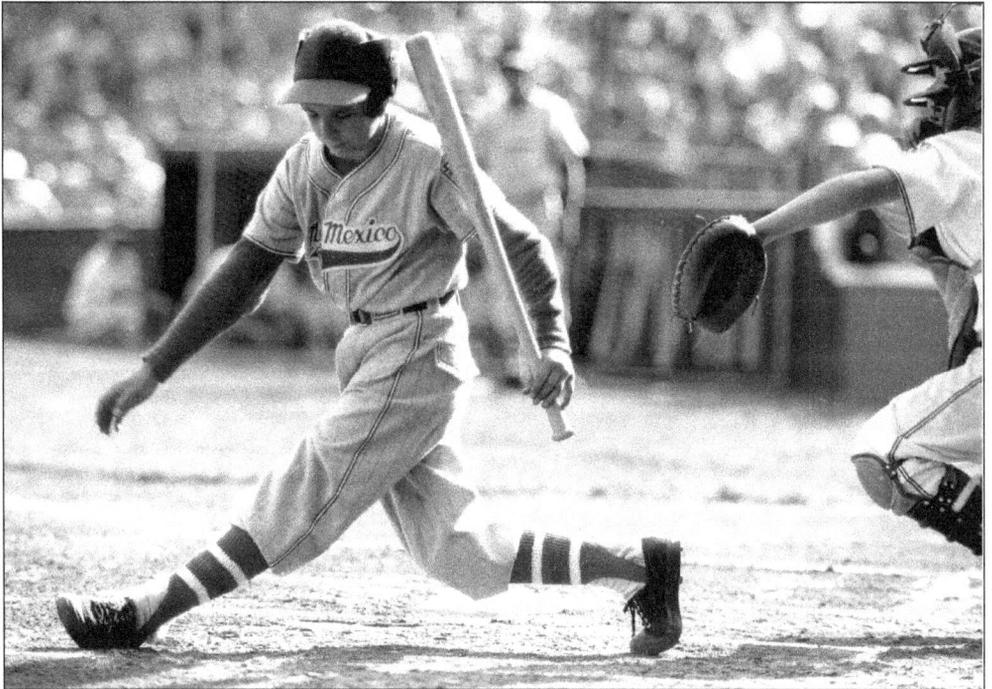

Early World Series action finds a Roswell, New Mexico batter swinging. The Babe Ruth League and Pony Baseball were founded in Hamilton Township, New Jersey, and Washington, Pennsylvania, respectively. Both programs aimed to provide a baseball league to which Little Leaguers could graduate once boys entered their teens.

At the 1951 World Series are Notre Dame football coach Frank Leahy (left) and Baseball Hall of Famer Cy Young (center). Young traveled to Williamsport at Carl Stotz's invitation, attending every Little League World Series until his death at the age of 89. The two became close friends, and a tearful Stotz was a pallbearer at Young's funeral in late 1955.

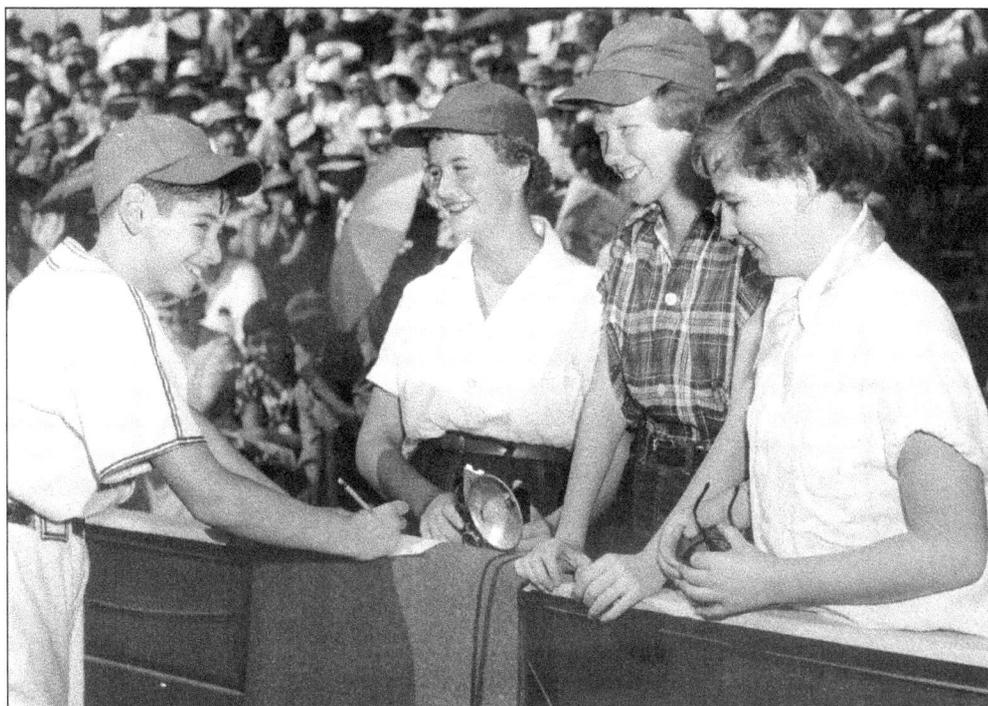

Teenage girls at the 1952 Little League World Series admire Howard Silverman, pitcher for the Hackensack, New Jersey team. Having been asked for his autograph, the smiling Little Leaguer obliges. Seeking autographs has been a series staple, although it continues to embarrass some of the 12-year-olds.

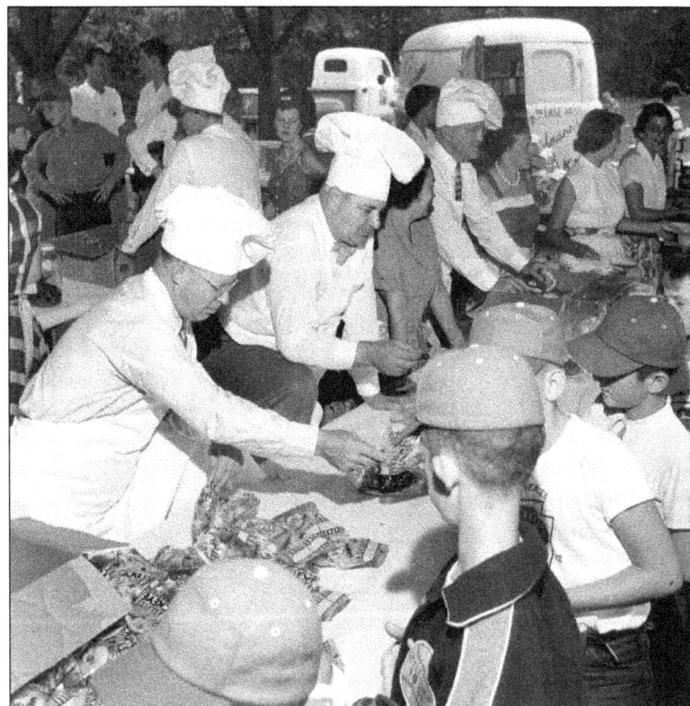

Handing out Buckeye's pretzels to 1952 World Series players are volunteers organized by the Williamsport Community Trade Association. Proud of its growth, the organization credited commissioner and president Carl Stotz with guarding "against exploitation of the boys" and retaining "the original purposes and ideals of the program he fostered."

A single line made its first appearance in the Little League regulations: "Girls are not eligible under any conditions." Kathryn "Tubby" Johnston (Massar) may have been the first girl to play Little League, tucking her hair under her hat. Little League officials read newspaper reports of her 1950 King's Dairy team in Corning, New York, and added the rule in 1951. She attended the 2001 Little League World Series, throwing out one of the game's ceremonial first pitches.

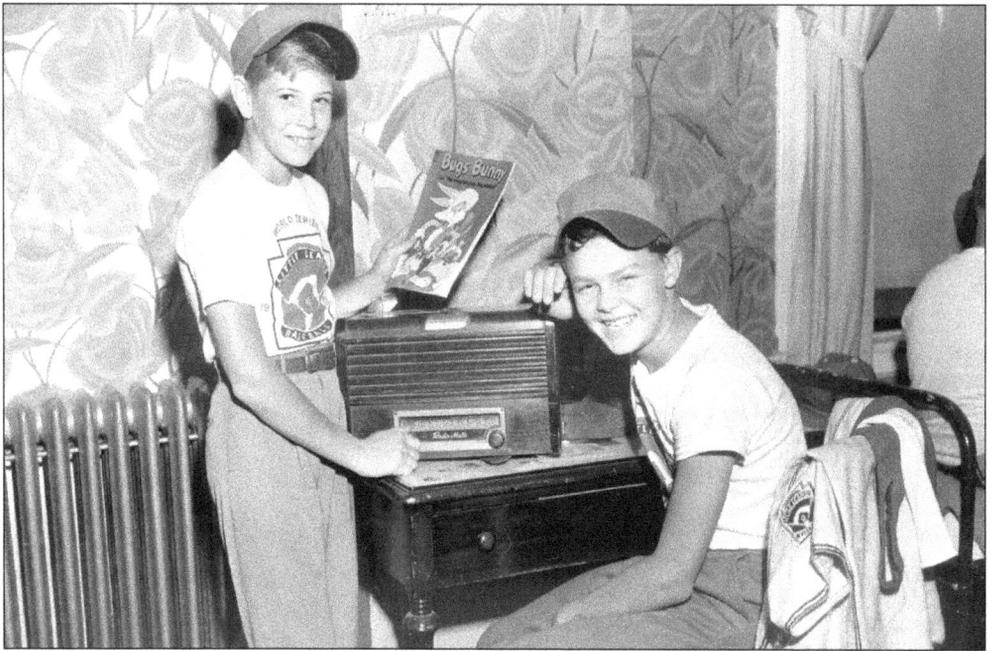

Len Oorbeck (left) and Frank Storicks, members of the 1952 Hackensack, New Jersey team, relax in their room with comic books and music. Thanks to generous community support, visiting Little League World Series participants were housed at the luxurious Lycoming Hotel (now the Genetti and still the tallest building in Williamsport).

Little League's official sponsor, U.S. Rubber, appointed Peter J. McGovern, an executive from Detroit and 1926 graduate of the University of Pennsylvania, as Little League's full-time president, and McGovern moved to Williamsport. At the 1952 series, National of Norwalk, Connecticut, won 4-3 against Optimist of Monongahela, Pennsylvania.

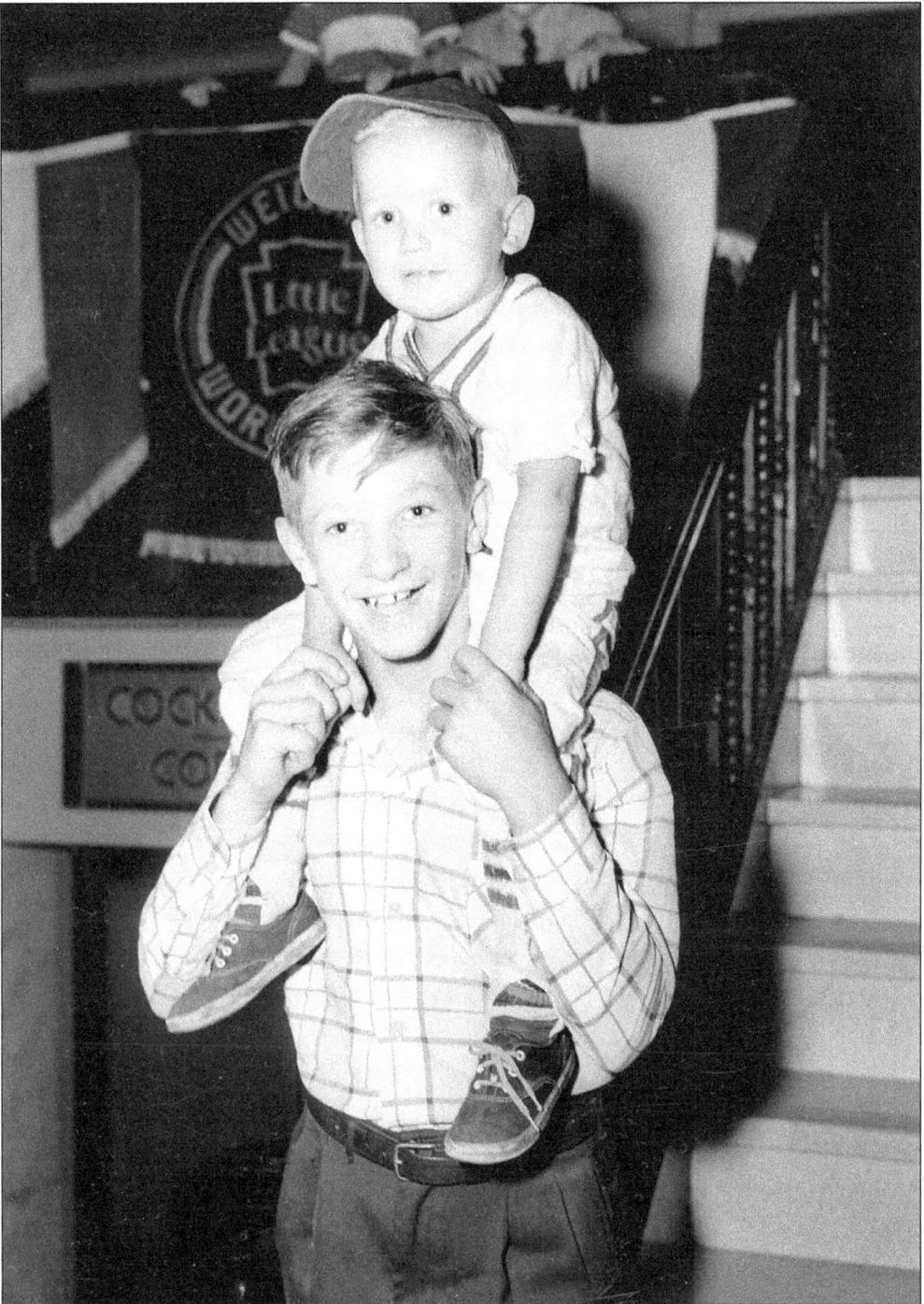

Many teams attending the Little League Baseball World Series brought mascots. George Fabin, pitcher for the 1952 team from Monongehela, Pennsylvania, carries his team's mascot, two-year-old Chuckie Flasher, on his shoulders. By then, Little League boasted 7,562 teams in 44 states playing 7,000 games a week during a 10-week season. With an average of 300 fans per game, Little League officials estimated that attendance surpassed 20 million in 1952.

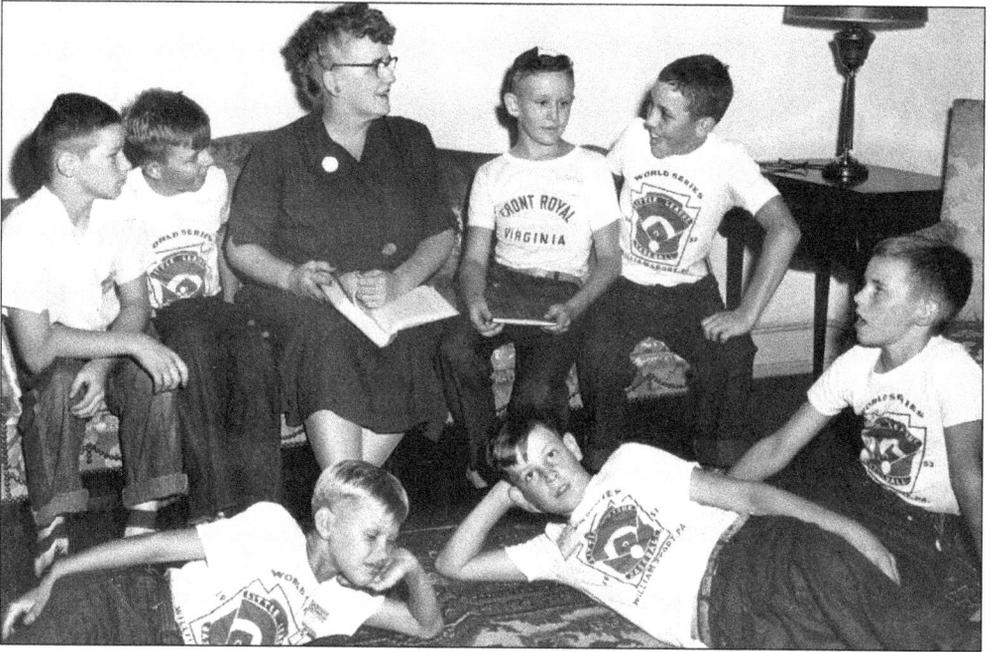

The Williamsport community opened its arms to the Little Leaguers, and volunteers enjoyed the interaction. In this photograph, Ida May Dittmar, housemother, reads books to Front Royal, Virginia, Little Leaguers at Lycoming College during the 1953 World Series.

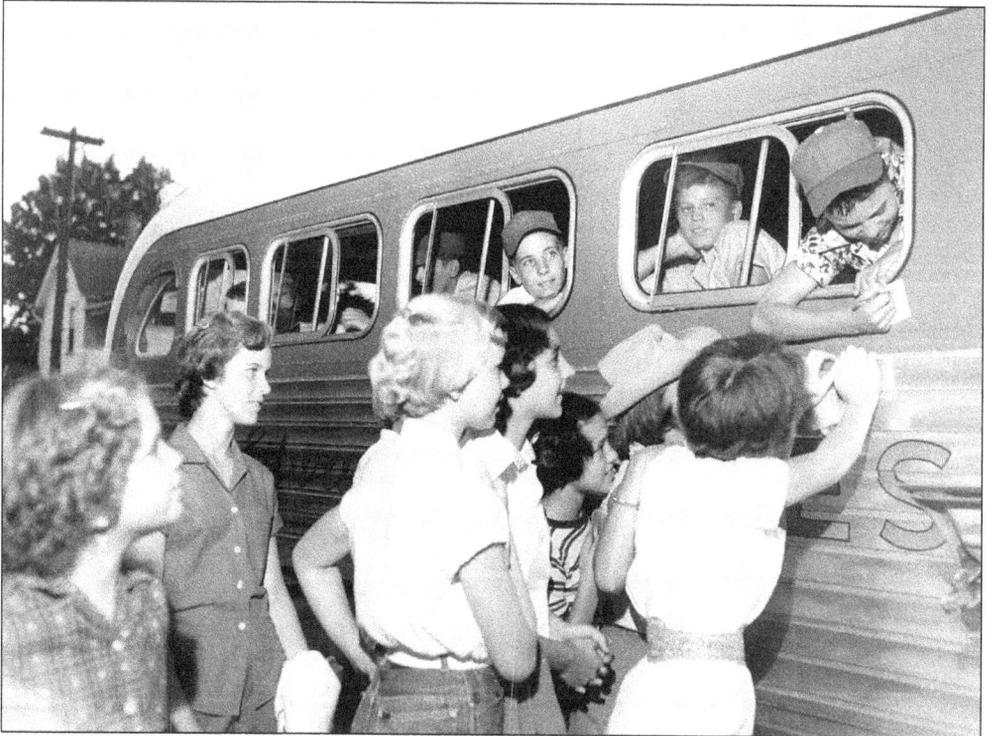

Young girls target one player in transport to the 1953 Little League World Series. The boy signs autographs through his bus window while his teammates look on.

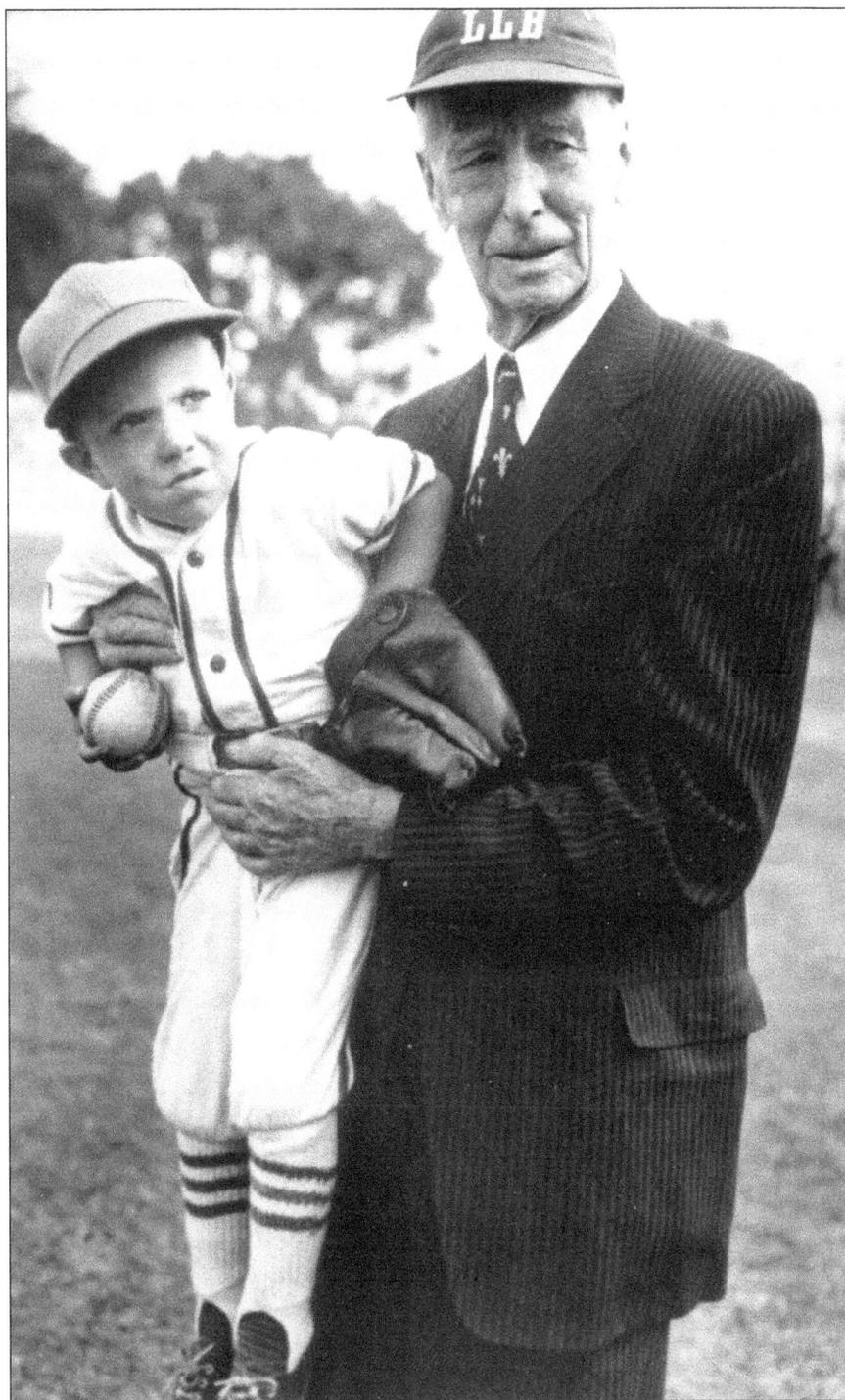

Major League legend Connie Mack was a visitor to the 1953 World Series. One of four distinguished men who lent support through Little League's early days, Mack was presented a scroll signifying honorary membership for life in the organization. Others awarded life memberships were Ford Frick, Cy Young, and Charles Durban.

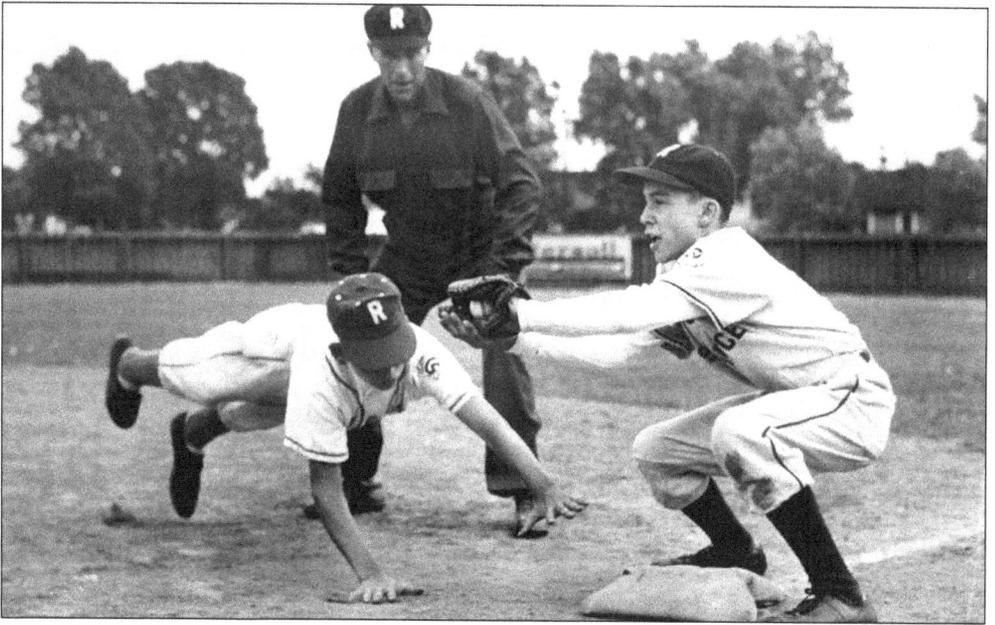

This early action shot at the Little League World Series is a testament to athleticism and endurance. Rutherford (New Jersey) National played a 17-inning game with the Lundhurst Eastern team. The game took two days, with 10 innings on July 27 and 7 innings on July 28. Rutherford won by a score of 3-2.

Little League officials estimate that more than 320,000 boys were playing in 5,000 leagues in 46 states and several foreign countries. Joey Jay, who played Little League in Middletown, Connecticut, became the first former Little Leaguer to reach the Major League, pitching for the Milwaukee Braves in 1953.

CBS newsmen filmed and interviewed players at the 1953 World Series. The series was televised for the first time by CBS, with rookie announcer Jim McKay behind the microphone. Howard Cosell handled the play-by-play for ABC radio as Birmingham, Alabama, defeated Schenectady, New York, 1-0 in one of only two 1-0 finals in World Series history.

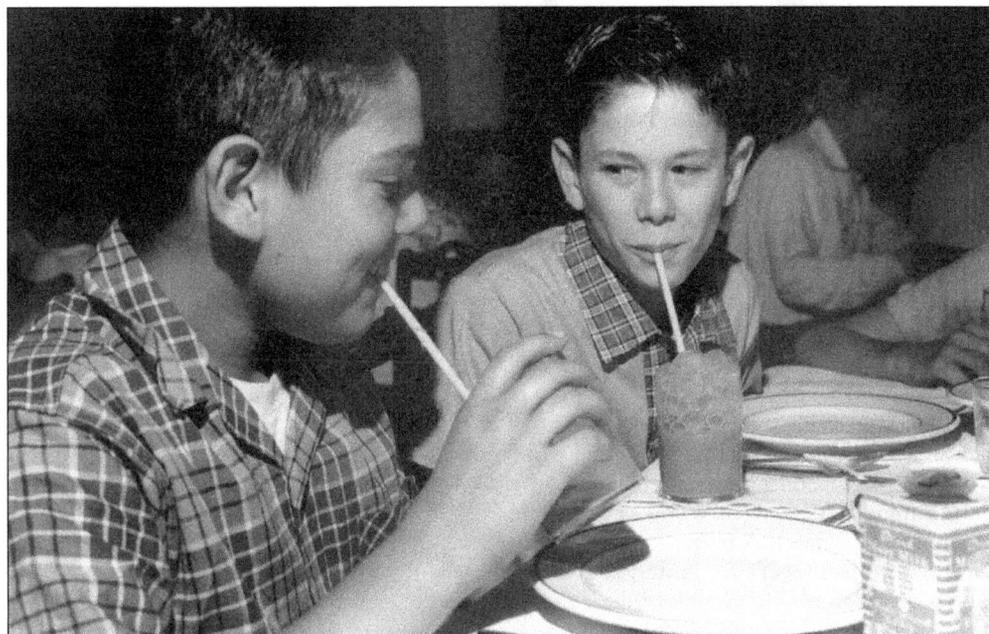

Bill Connors (left) and Jim Barbieri blow bubbles in their milk at the 1954 World Series. Both ended up in the Major Leagues. Ken Hubbs, who went on to win the 1962 National League Rookie of the Year Award with the Chicago Cubs, played in the series for Colton, California, and John "Boog" Powell, future first baseman for the Baltimore Orioles, played for Lakeland, Florida.

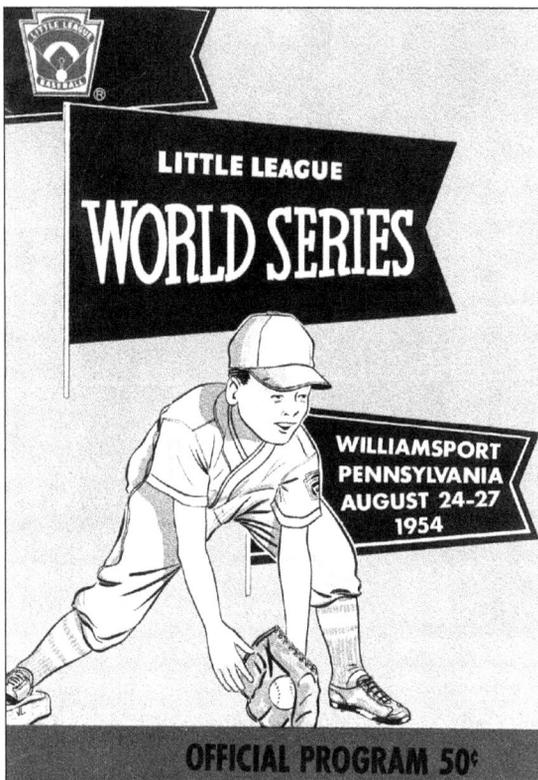

LITTLE LEAGUE
WORLD SERIES

WILLIAMSPORT
PENNSYLVANIA
AUGUST 24-27
1954

OFFICIAL PROGRAM 50¢

National Little League of Schenectady, New York, won the 1954 series, defeating the Lions of Colton, California, 7-5. The program expanded to more than 3,300 leagues, and participants were housed in the women's dormitories of Lycoming College.

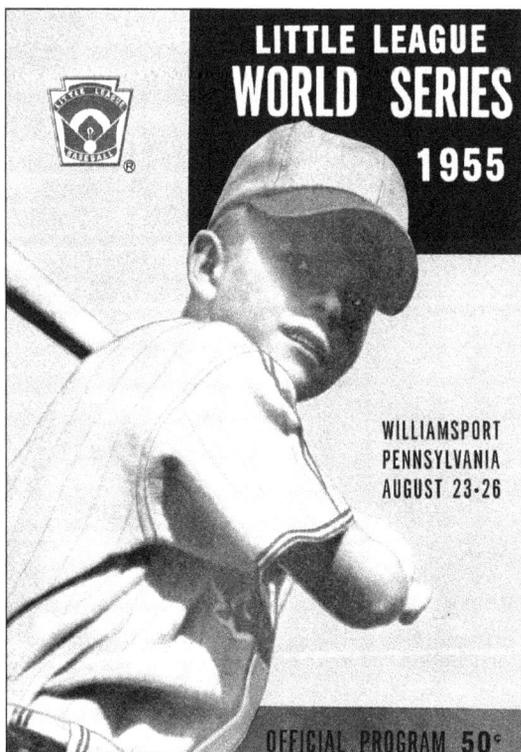

LITTLE LEAGUE
WORLD SERIES
1955

WILLIAMSPORT
PENNSYLVANIA
AUGUST 23-26

OFFICIAL PROGRAM 50¢

In 1955, Morrisville, Pennsylvania, defeated Delaware Township, New Jersey, 4-3 in seven innings (the first extra-inning Little League World Series championship game). A player for the New Jersey team was Billy Hunter, who went on to play football for the Washington Redskins and Miami Dolphins. He also served as executive director of the National Basketball Association Players Association. By 1955, Little League was played in all 48 states.

Three

LITTLE LEAGUE
GROWS UP

By 1955, Carl Stotz had grown resentful that Little League had become what he called "a commercial enterprise" and that New York businessmen—not volunteers from Williamsport Little Leagues—dominated the board of directors.

Stotz was president and commissioner; Charles Durban of U.S. Rubber was chairman of the board; John Lindemuth was treasurer. The balance of the board consisted of Ford Frick, president of the National League of Professional Baseball Clubs in New York City; Paul Kerr, vice president of the National Baseball Hall of Fame and Museum in Cooperstown, New York; Emerson Yorke, owner of Emerson Yorke Studios in New York City; Bernie O'Rourke, treasurer for the city of Middletown, Connecticut; Howard J. Lamade, secretary of the Grit Publishing Company, Williamsport; and Ted Husing of radio station WMGM in New York City. J. Walter Kennedy of Stamford, Connecticut, was elected secretary, a nonvoting position. He previously worked in public relations for Notre Dame University and the National Basketball Association.

After Durban's death, Peter J. McGovern, a U.S. Rubber executive, moved to Williamsport to become full-time president. Stotz's responsibilities declined. On November 21, 1955, Stotz fired the first shot of Little League's civil war, locking the nonprofit's office doors in an attempt to reclaim the program.

While the doors were being locked, the board voted to remove Stotz from his position as commissioner. The board named Lindemuth, Stotz's assistant and friend, as acting commissioner. The next morning, a deputy removed the padlock and Little League continued operating as usual.

On November 26, 1955, Stotz filed a lawsuit against Little League, which claimed that the original bylaws of the corporation guaranteed Stotz a job as head of Little League Baseball for the rest of his life and that the bylaws were subsequently changed to give other people his duties. He opened a new office for his "Original Little League." Four Little League employees—Howard Gair, Allen Yearick, Richard Snauffer, and Ralph Hoyt—resigned and joined Stotz's team, along with Irma Gehrig, who had been Stotz's secretary at Little League.

Little League sought an injunction against Stotz to prevent him from establishing a rival league, and what ensued was a heartbreaking court battle that resulted in Little League's founder parting ways with the program.

On February 3, 1956, Little League Baseball and Stotz issued this statement: "The controversy between Carl E. Stotz has been settled. Mr. Stotz is not associated with any competitive program, nor is he any longer an officer, director or employee of Little League Baseball. The settlement did not involve any financial consideration."

Before he settled, however, Stotz had three stipulations: that Little League remain in Williamsport, that there be more voting representation on the board of directors by field volunteers, and that Little League Baseball not contest his status as founder of the program.

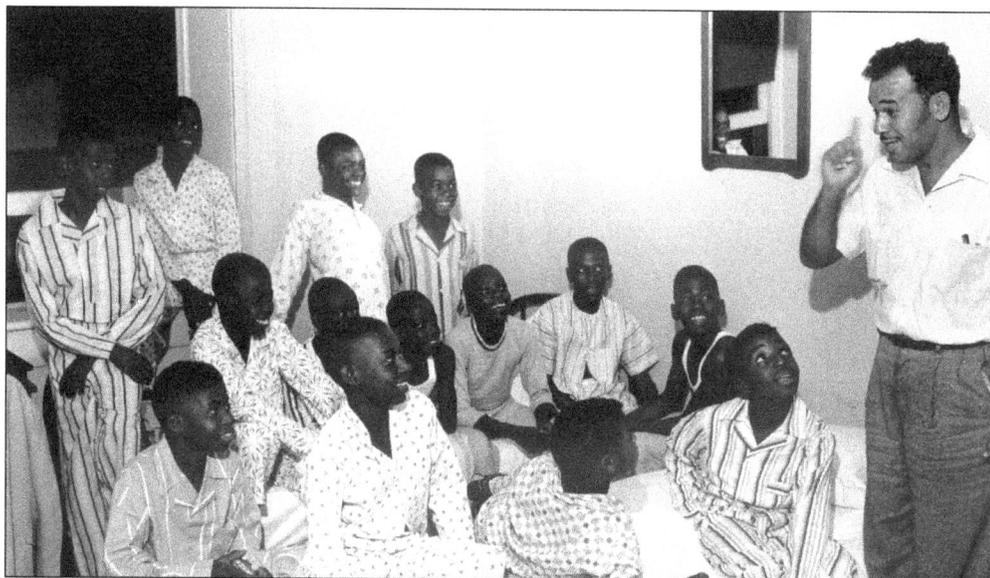

Little League programs first appeared in South Carolina in 1949. Two years later, an estimated 4,000 people witnessed several games of the South Carolina State Championship Series. Led by Danny Jones, state director for Little League, 62 leagues formed for the 1955 season. Every player in 61 of those leagues was white. In 1955, those leagues refused to play the all-black Cannon Street YMCA team, shown here.

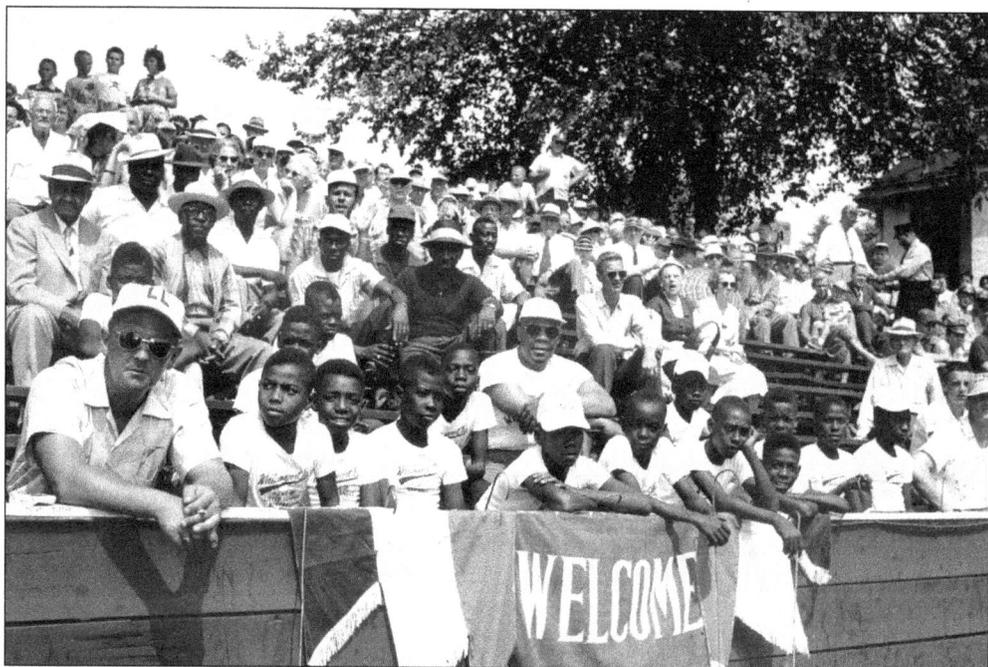

Danny Jones and the white leagues in South Carolina staged a mass exodus, leaving only one "legal" team in South Carolina—Cannon Street YMCA. Because Little League tournament rules said that all teams advancing to another level must have played and won the previous tournament's title, Cannon Street could not play. Little League invited the team as a guest to the 1955 series.

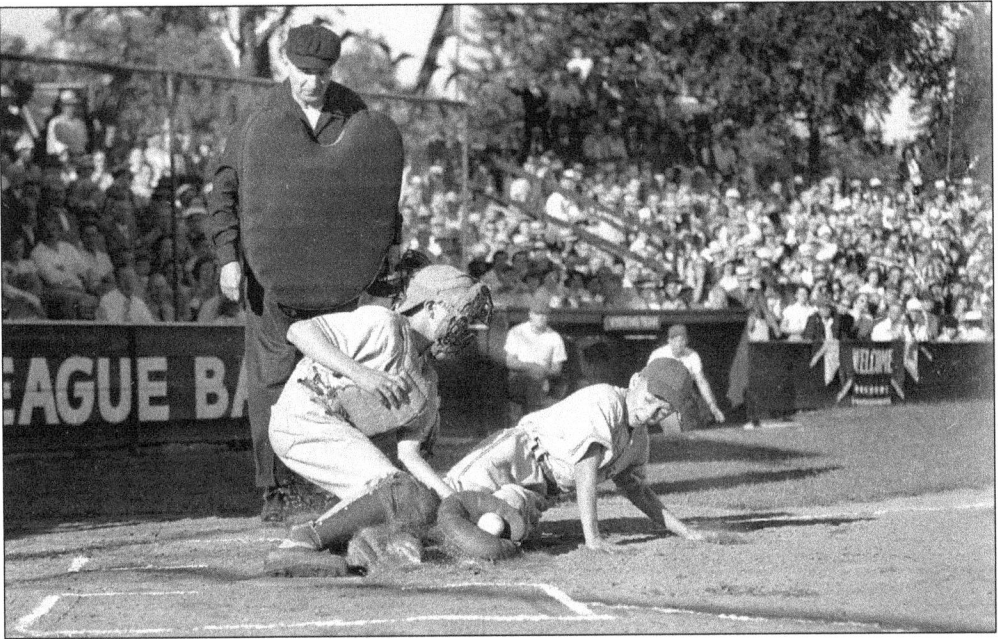

This early action shot features umpire Howard Gair (left). The first perfect game pitched in a Little League World Series was in 1956 by Fred Shapiro of Delaware Township, New Jersey. By 1956, Little League had grown to more than 4,000 leagues.

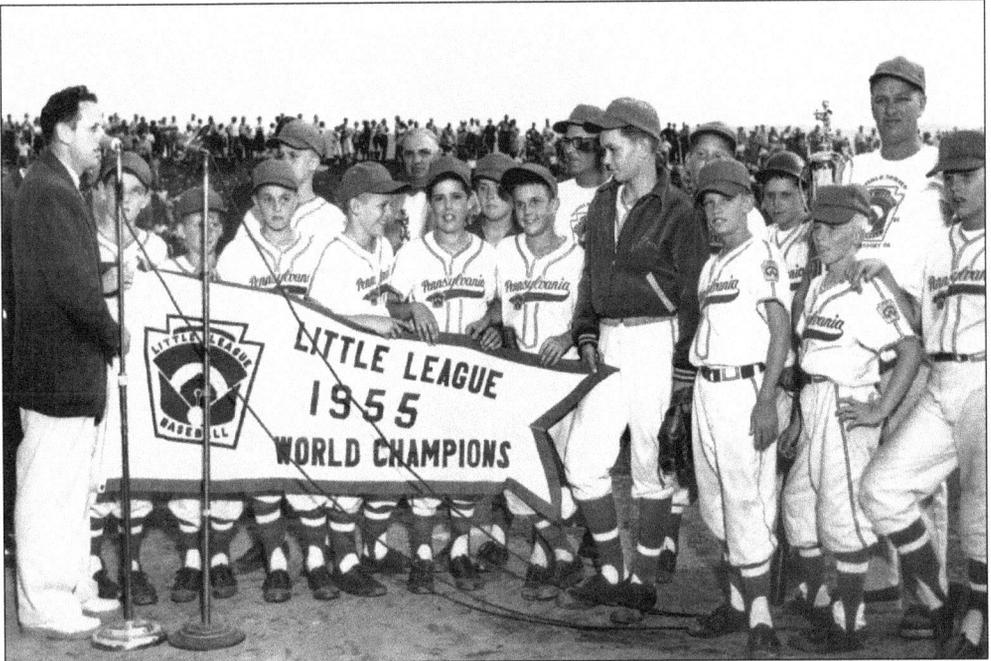

Carl Stotz (left) presents the banner at his final Little League World Series. Eventually, an out-of-court settlement ended with Stotz leaving the program. Original Little League (later forced to change its name to Original League) proceeded during the 1956 season without franchising with Little League, and it did so with Carl Stotz at the helm as its newly elected president. That led to another controversy: Where would the Little League Baseball World Series be played?

Peter J. McGovern's position as president of Little League Baseball was strengthened after Carl Stotz left the program. The withdrawal of U.S. Rubber as official sponsor resulted in the creation of the Little League Foundation. After negotiations ended the lawsuits, bylaws called for "field representative directors," elected from and by the leagues, to meet annually as delegates to the National Congress.

John Lindemuth, a track star in his youth, joined Little League's first board of directors and served as manager for the young organization's fourth team. After Carl Stotz's split with Little League, Lindemuth was named commissioner and the longtime friendship between the two men ended.

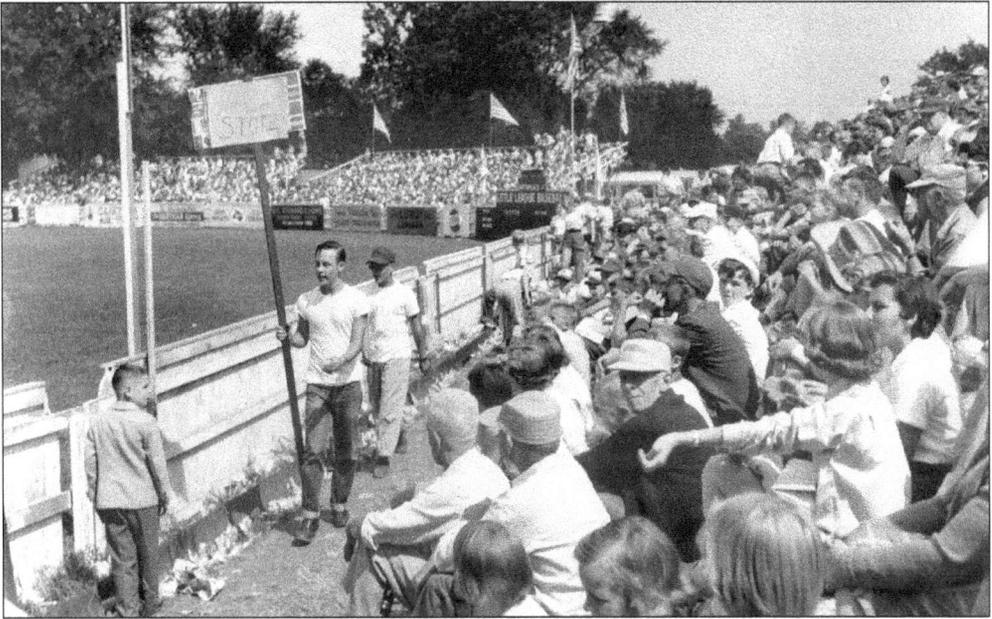

A young man protests at the 1956 Little League World Series, carrying a sign in support of Carl Stotz. No longer part of Little League, Stotz continued his Original League program independently. Despite the conflict, Little League thrived and leagues were chartered in record numbers.

The Little League Pledge, penned by Peter J. McGovern, was published in the 1956 series program. Lions Hondo of Roswell, New Mexico, won the 1956 Little League World Series 3-1 against National of Delaware Township, New Jersey. Fitness expert and scientist Dr. Creighton J. Hale joined Little League, taking an extended leave from his laboratory at Springfield College in Massachusetts.

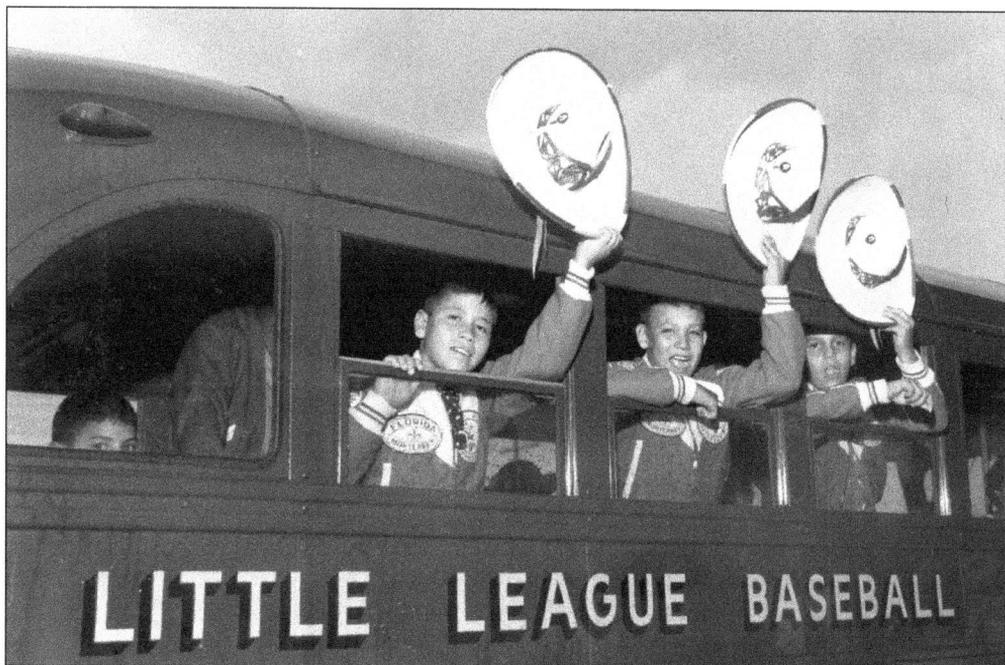

Little Leaguers from Monterry, Mexico, wave sombreros as they ride in a bus from Williamsport's airport to their lodging at Lycoming College. Carrying their clothes in paper bags, members of the 1957 Monterrey Industrial Little League arrived in Williamsport.

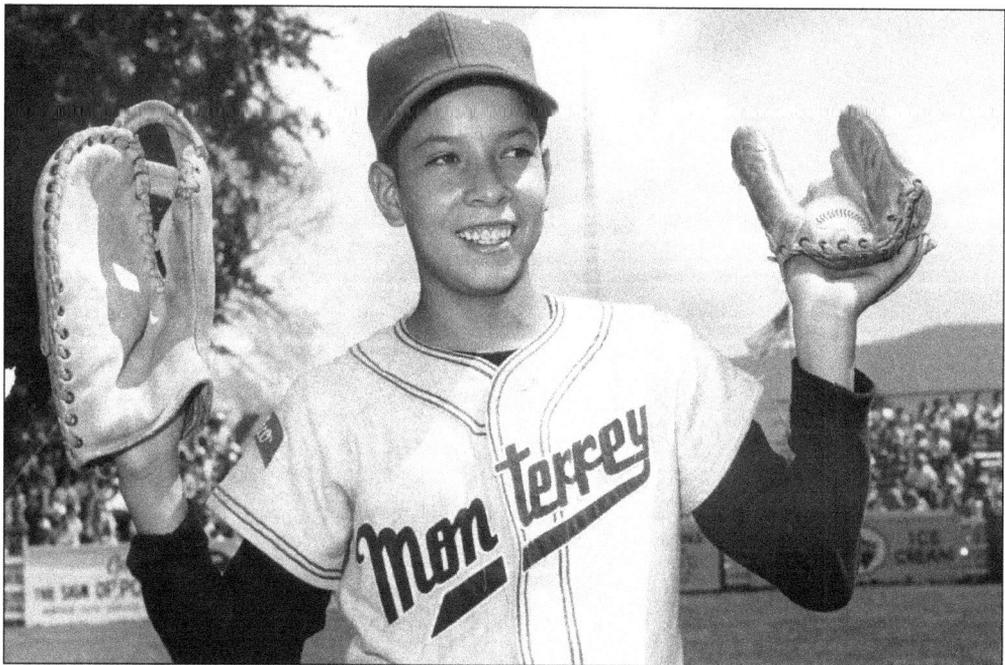

Monterrey, Mexico, became the first team from outside the United States to win the Little League World Series. In 1957, Angel Macias, who was ambidextrous, pitched the only perfect game to date in a championship final. Monterrey defeated Northern of La Mesa, California, 4-0.

48

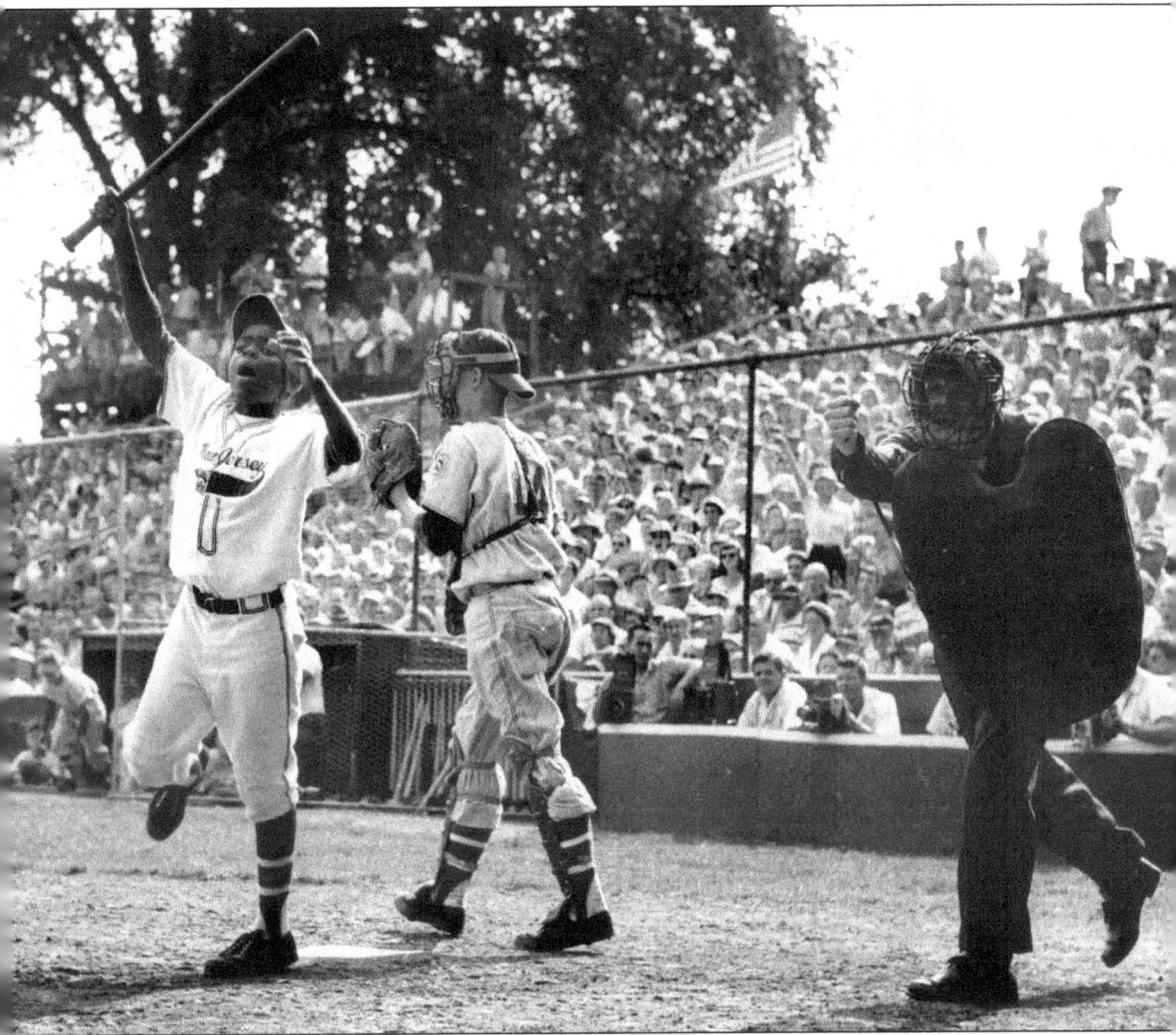

A Little Leaguer agonizes over a strike at the tournament. Because of finances, only four teams participated in the 1957 Little League World Series. The streamlined event realigned geographical boundaries, with teams representing the north, south, east, and west.

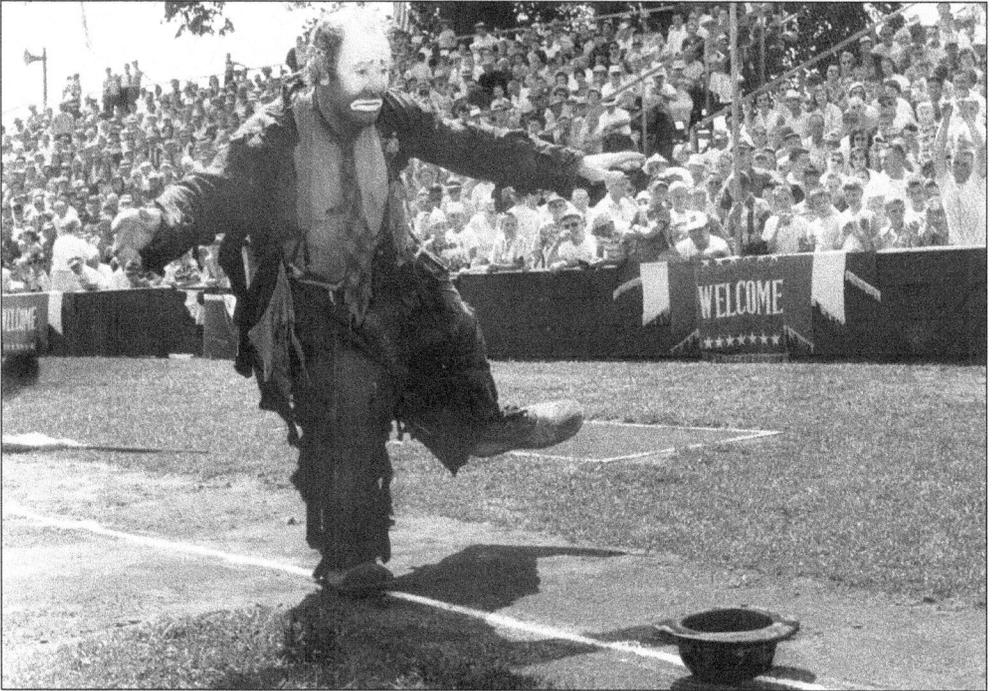

A famous clown performs at the Little League Baseball World Series in 1957. Emmett Kelly was under contract to the Brooklyn Dodgers, and the Dodgers released him to visit Williamsport for the series.

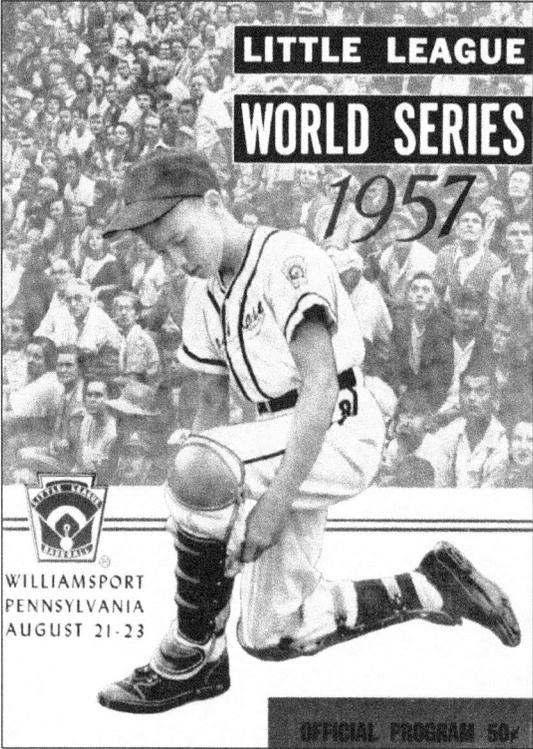

During his keynote speech before the third annual National Congress, Dr. Creighton Hale estimated that in 1957, three million boys, parents, managers, coaches, and other adults were exposed to Little League Baseball. He added that the final game of 1957, which featured a perfect game by Mexico pitcher Angel Macias, purportedly generated goodwill that was comparable to more than $1 million in foreign aid.

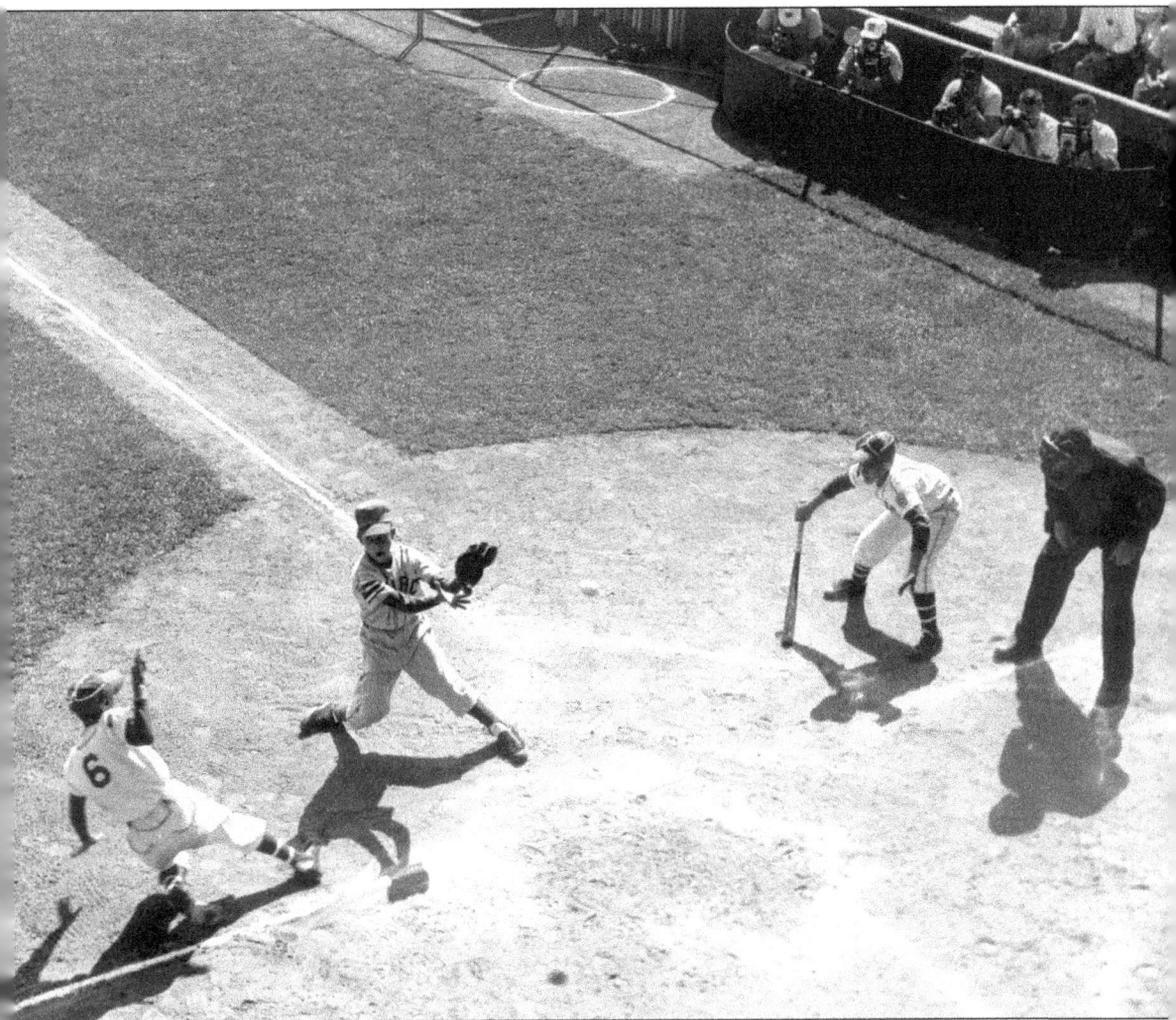

This aerial view of a rundown at home captures the excitement of a Little League Baseball championship game.

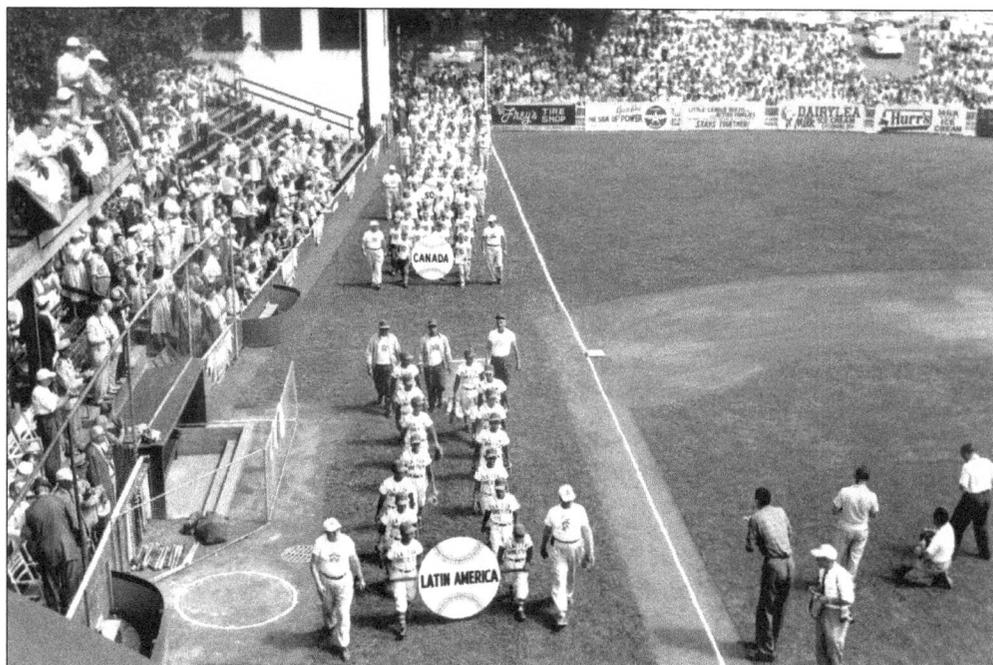

Latin America and Canada earned berths in the 1958 Little League World Series without having to play through tournaments in the United States. The number of teams increased from four to seven, with three of the regions (Latin America, Canada, and Pacific) producing teams from outside the United States.

LITTLE
LEAGUE

WORLD
SERIES

1958

WILLIAMSPORT
PENNSYLVANIA
AUGUST 19-22

OFFICIAL PROGRAM 50¢

Monterrey, Mexico, returned to the 1958 series and defeated Jaycee of Kankakee, Illinois, 10-1. The Little League Foundation, which collected $12,000 from local leagues in 1957, doubled that amount in 1958. The average contribution per league in 1958 was $5.11, compared to about $2.50 in 1957.

Monterrey, Mexico, became the first Little League to win consecutive World Series championships. Playing were Hector Torres, for Monterrey, and Rick Wise, for Portland, Oregon—both of whom later played in the Major Leagues.

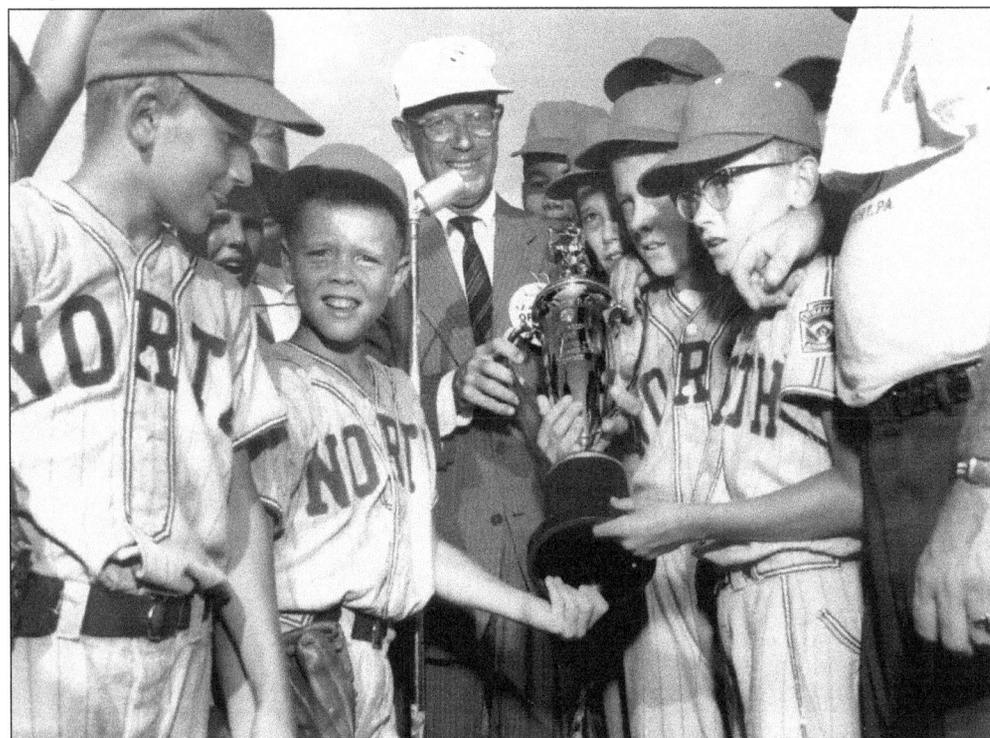

H.E. Humphries of U.S. Rubber congratulates the 1958 World Series runners-up, Kankakee, Illinois, which was defeated by Monterrey, Mexico. More than 12,000 fans (a record for the site) packed Memorial Field for the 1958 series, the last played there.

Besides the uncomfortable feeling of borrowing a baseball field for its biggest event, Little League officials acknowledged that the original home of the Little League Baseball World Series had become too small. Seating was limited at Memorial Field, sandwiched between West Fourth Street and the dike protecting Williamsport from Susquehanna River floods. At the new stadium, National of Hamtramck, Michigan, defeated West Auburn of Auburn, California, 12-0 in 1959.

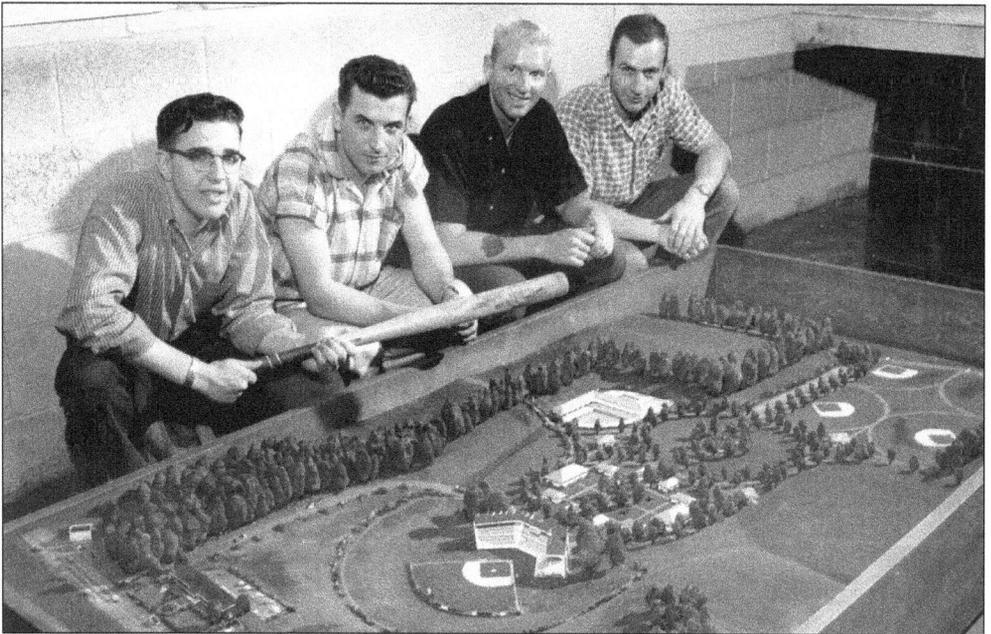

Plans for a new Little League stadium to seat 7,000 came not from an architectural firm but from a student project at Williamsport Technical Institute (now Pennsylvania College of Technology). Pictured from left to right are students Robert Mondock, Jack Kavelack Jr., Dean Palmer, and Don Miller.

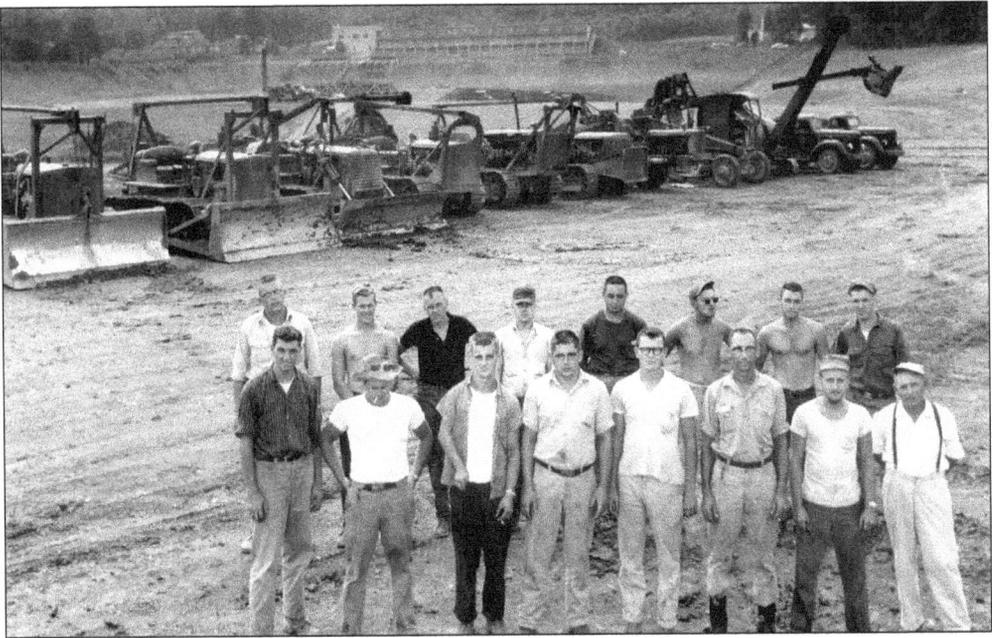

Tractors, steam shovels, and graders—supplied by the Williamsport Technical Institute (now Pennsylvania College of Technology) and operated by its students—cleared the land. Local businesses and individuals donated funds as well as much of the equipment, materials, and services. Local Little League volunteers also helped.

Little League headquarters celebrated in 1959, when the U.S. House of Representatives and Senate passed a resolution proclaiming the second week in June as National Little League Baseball Week. Five-term Pennsylvania Rep. Alvin R. Bush initiated the action to mark the 20th anniversary of Little League's founding. Pres. Dwight Eisenhower, whose support of Little League was well known by then, signed the proclamation.

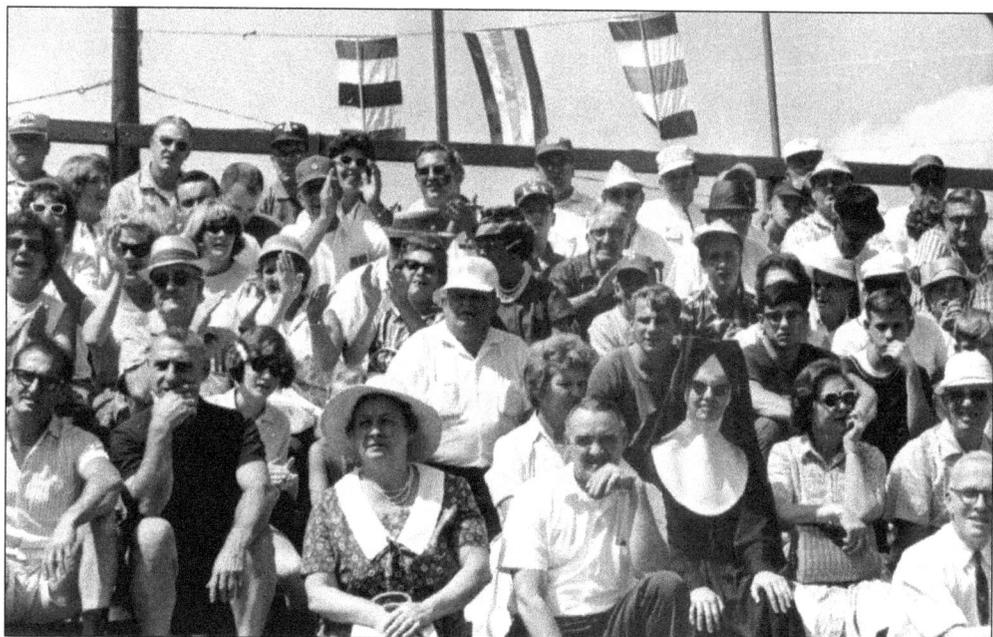

At this Little League World Series, a nun can be seen in the front row. In 1959, Little League boasted 25,000 teams in 25 countries. The pitching distance for the 1959 season increased from 44 to 46 feet, and the move to a new stadium also meant that the fences could be pushed back to 200 feet.

The first European entry in the Little League World Series was from a military base in Berlin, Germany, in 1960. ABC's first live national broadcast of the Little League Baseball World Series came the same year, and Levittown, Pennsylvania, defeated Fort Worth, Texas, 5-0. The signal bounced along seven mountaintop relays on the way to New York City, with Buddy Blattner, former New York Giants star, announcing.

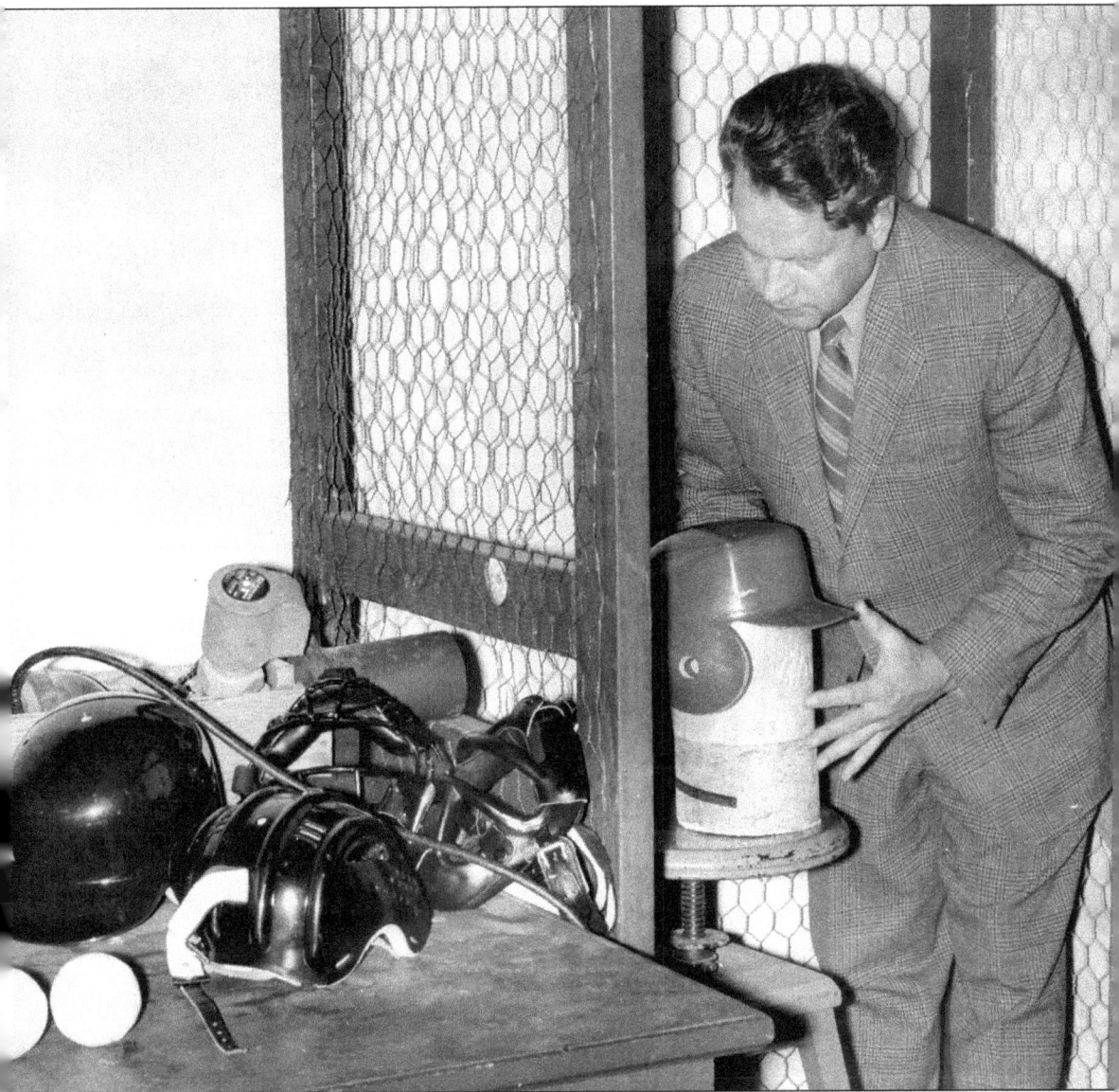

Dr. Creighton J. Hale, Little League vice president and director of research, developed the modern protective helmet after testing prototypes with a special cannon. The newly patented batting helmet, which covered the full head and ears, became a requirement in 1961. Hale's responsibility was to improve safety standards. While at Springfield College, he had conducted research on new helmets for baseball and for boxing.

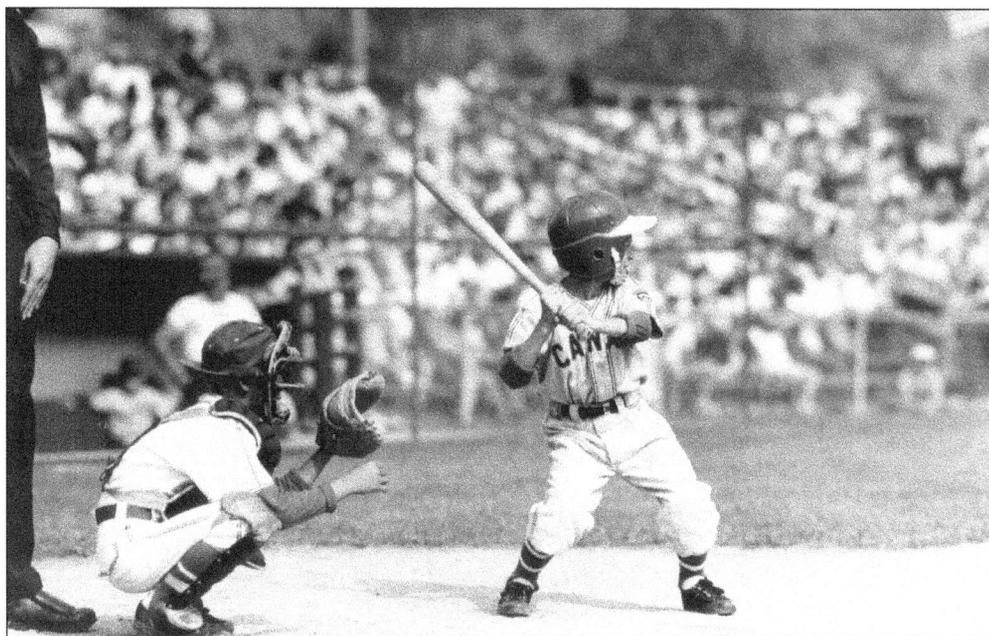

This Little Leaguer from Canada (right) offers a tight strike zone in the 1961 Little League World Series. The Pony and Babe Ruth programs numbered about 2,500 nationally, and 5,706 Little League local programs existed. In 1961, Little League encroached upon the Pony and Babe Ruth leagues, offering Senior League for 13- to 15-year-old players.

Brian Sipe, who later became quarterback for the Cleveland Browns, played for the 1961 Little League World Series champion team from El Cajon, California, which defeated El Campo, Texas, 4-2. Former Major Leaguer Ted Williams, announcing the series for ABC, gave each series player a new glove and ball.

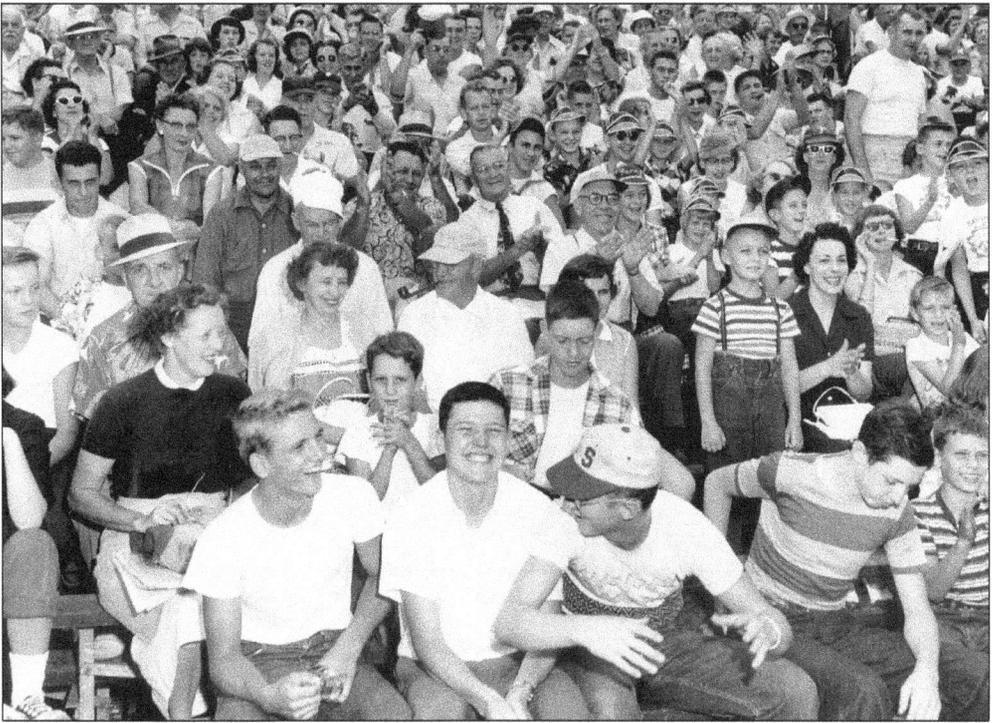

An enjoyable afternoon is spent at the new stadium during the 1961 Little League Baseball World Series. Noted *Sports Illustrated* photographer Robert Riger attended and shot the series for NBC's *Today Show*. Little League acquired more land through donations and erected bunkhouses for eight teams and its first headquarters building, at a cost of $104,000.

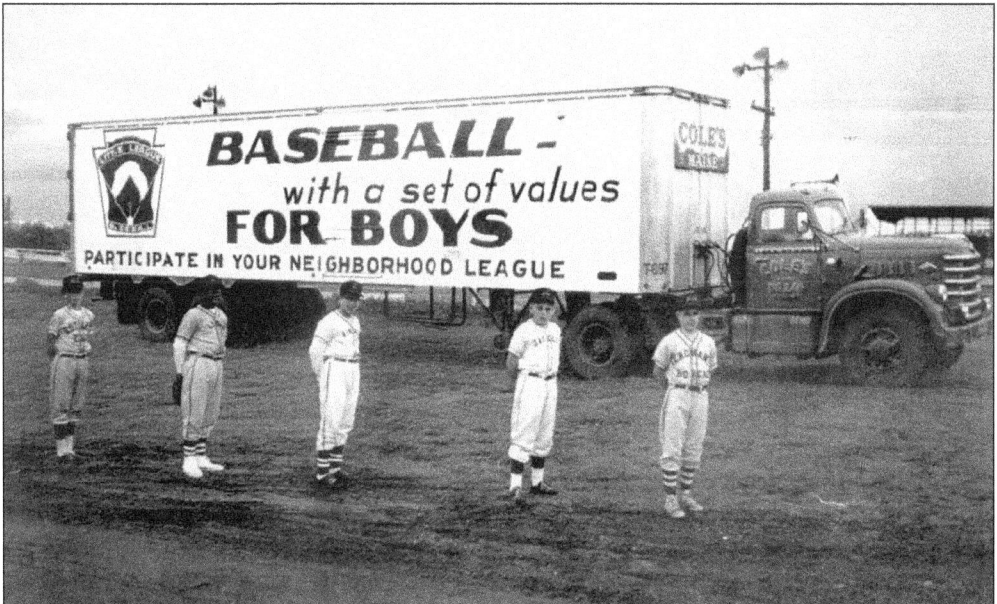

Expansion remained paramount, and officials promoted Little League and "baseball for boys" through a series of moving billboards. Painted on the sides of 18-wheelers, the signs bespoke the program's values and encouraged families to "participate in your neighborhood league."

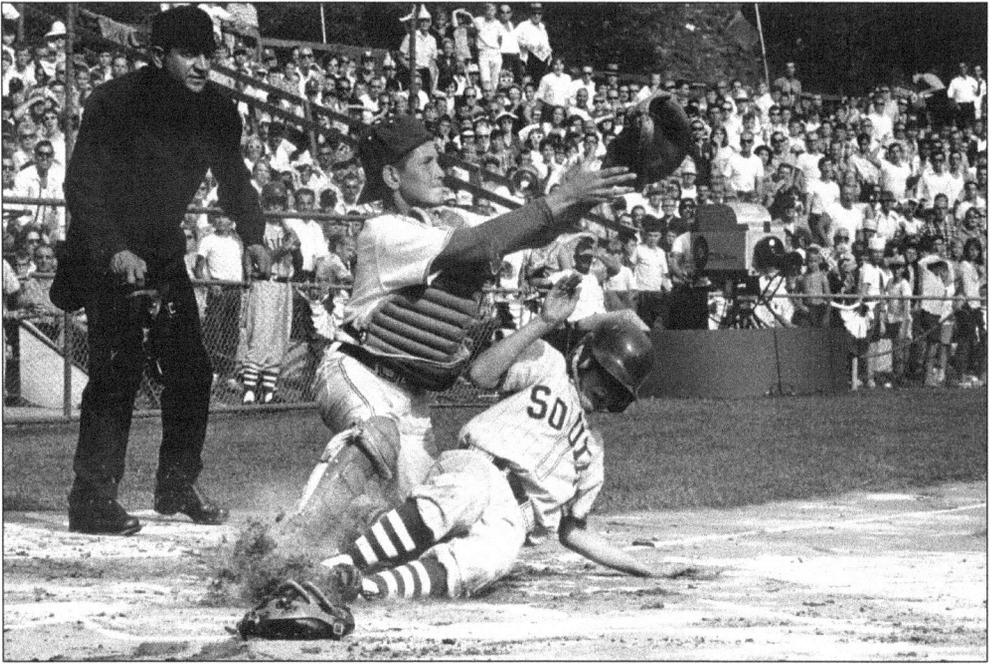

Umpire Frank Rizzo (left) was held in high esteem by Little League. With the program since 1948, he became Little League's chief umpire and was plate umpire in the championship games throughout the 1970s. In addition to umpiring, he coached in his home league of Newberry.

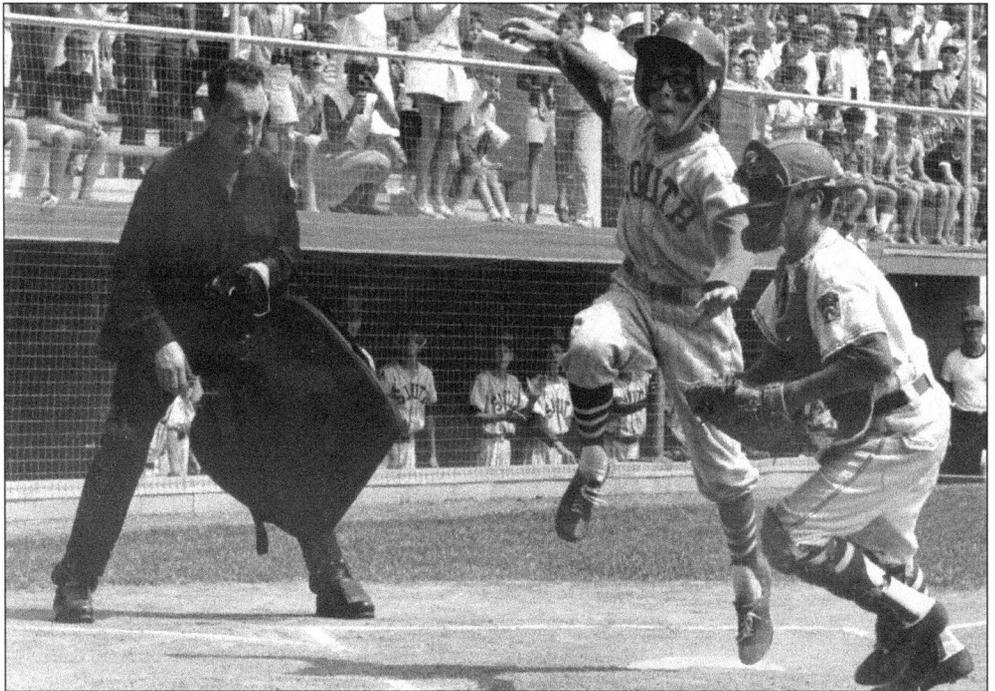

Terry Gramling (left), also an umpire with Little League during its beginnings, was a member of the Maynard League. In addition to his baseball chores, he was a trusted basketball official. He became a permanent member of Little League's World Series umpire team.

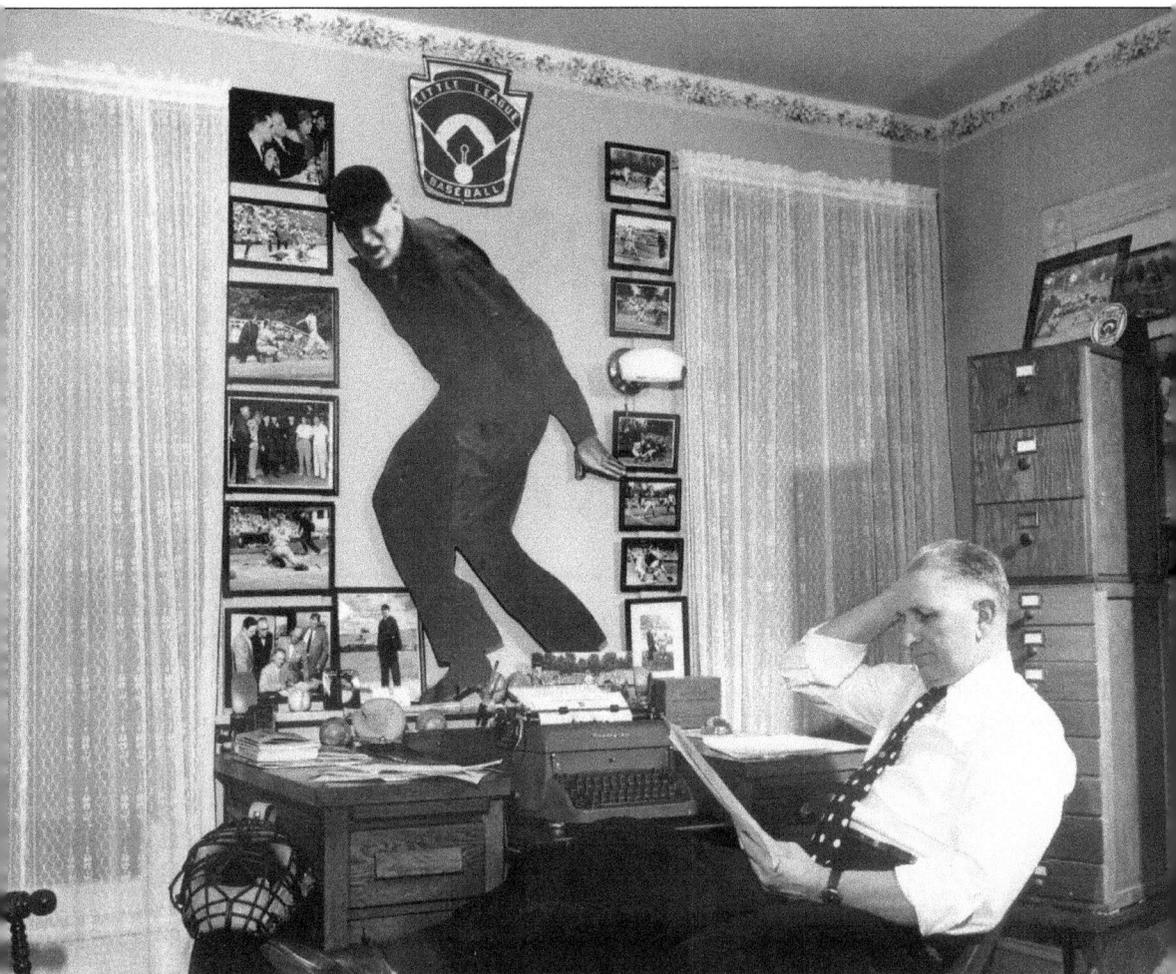

Howard Gair (shown here), umpire consultant for Little League Baseball, spent 42 years umpiring, first with the Sunday School League and then with Little League Baseball. He umpired sandlot, semiprofessional, and collegiate ball, as well as the Little League World Series. When Little League needed his assistance in 1940, Gair had already committed to umpiring at Penn State University. The first season he umpired only four games. During the next 15 years, he called 495 games at Original Little League and trained his son Vance to umpire. Vance Gair umpired for three years—a total of 52 games—before joining the U.S. Navy. Between 1946 and 1967, Vance Gair officiated in 637 games.

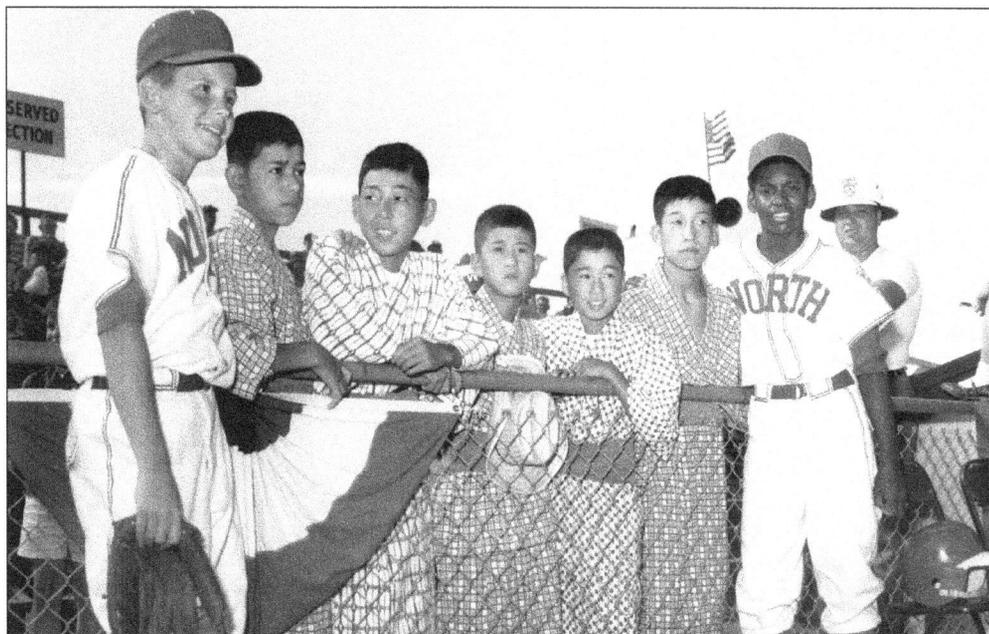

The first Japanese players in the World Series made a big hit in 1962, and visitors enjoyed their traditional kimono garb. Franchised in 1960, the team (from Kunitachi, Japan) had difficulty adjusting to American cuisine, often consisting of French fries and hot dogs. They fell 2-1 to a U.S. military team from Poiters, France, in the consolation bracket.

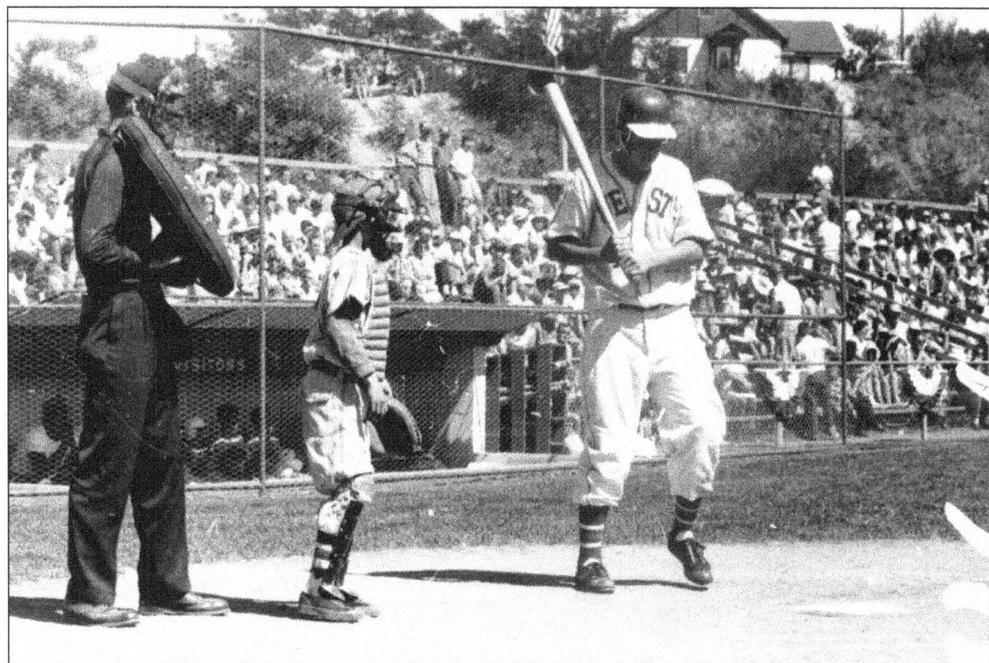

Six-foot-one-inch Ted Campbell (right), of the 1962 West team, was the tallest Little League series player yet. The 210-pound pitcher came within one call of pitching a perfect game during the series. Dr. Creighton Hale kept meticulous physical records of the series' participants and, using his data, adjusted the size of home plate, field dimensions, and safety equipment.

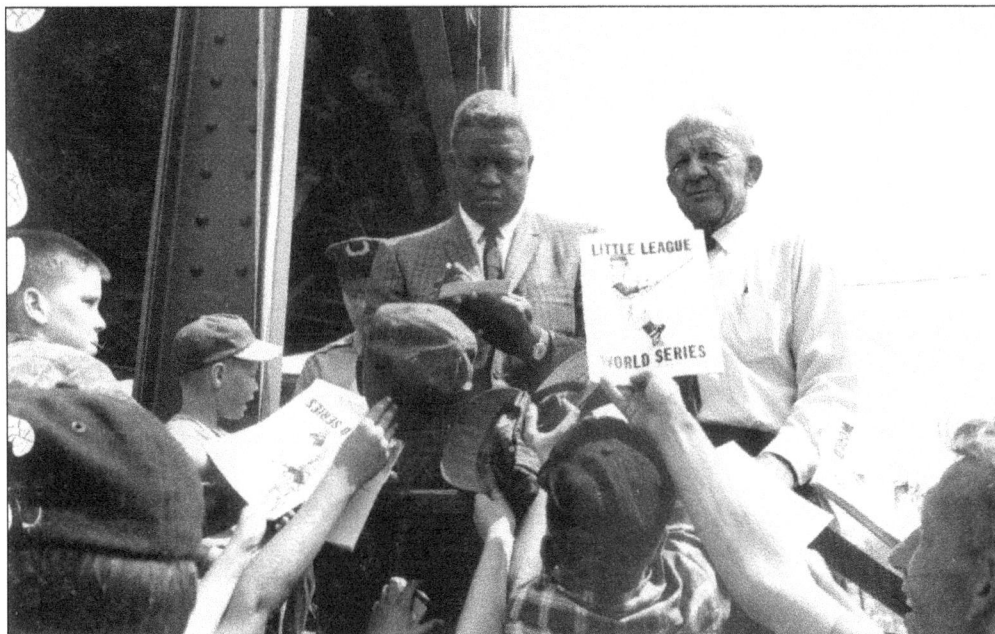

Jackie Robinson (left background) was inducted into the National Baseball Hall of Fame in 1962 and visited the Little League World Series, providing television commentary on WPIX of New York City. He signed hundreds of autographs and thrilled thousands of series spectators. Shown with him is John Lindemuth, baseball commissioner.

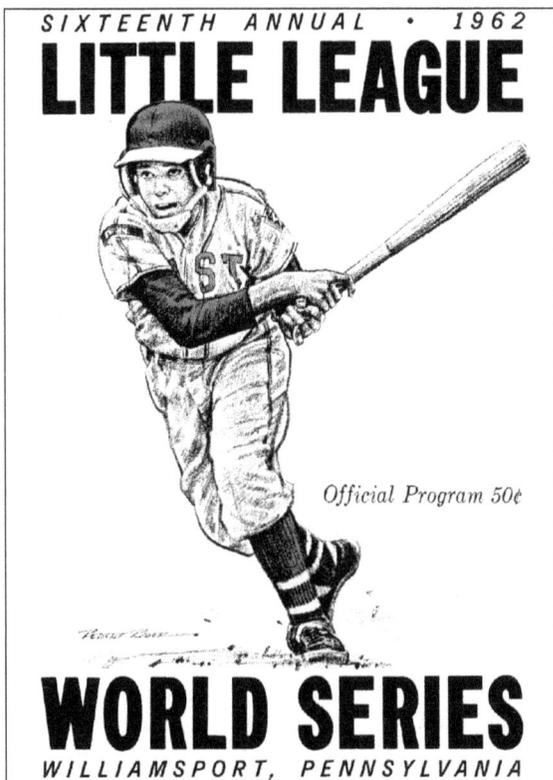

SIXTEENTH ANNUAL • 1962

LITTLE LEAGUE

Official Program 50¢

WORLD SERIES
WILLIAMSPORT, PENNSYLVANIA

Moreland of San Jose, California, defeated the Jaycees of Kankakee, Illinois, and won the 1962 World Series 3-0. Also in 1962, the Little League Summer Camp opened in Williamsport and Pres. John F. Kennedy proclaimed National Little League Week, in June of each year.

Ted Williams (back row, second from right) dispenses new shoes to Little Leaguers during the 1963 Little League World Series. An announcer for ABC's Wide World of Sports, Williams visited the series several times in the 1960s. ABC televised the championship game for the first time, with Chris Schenkel calling the play-by-play.

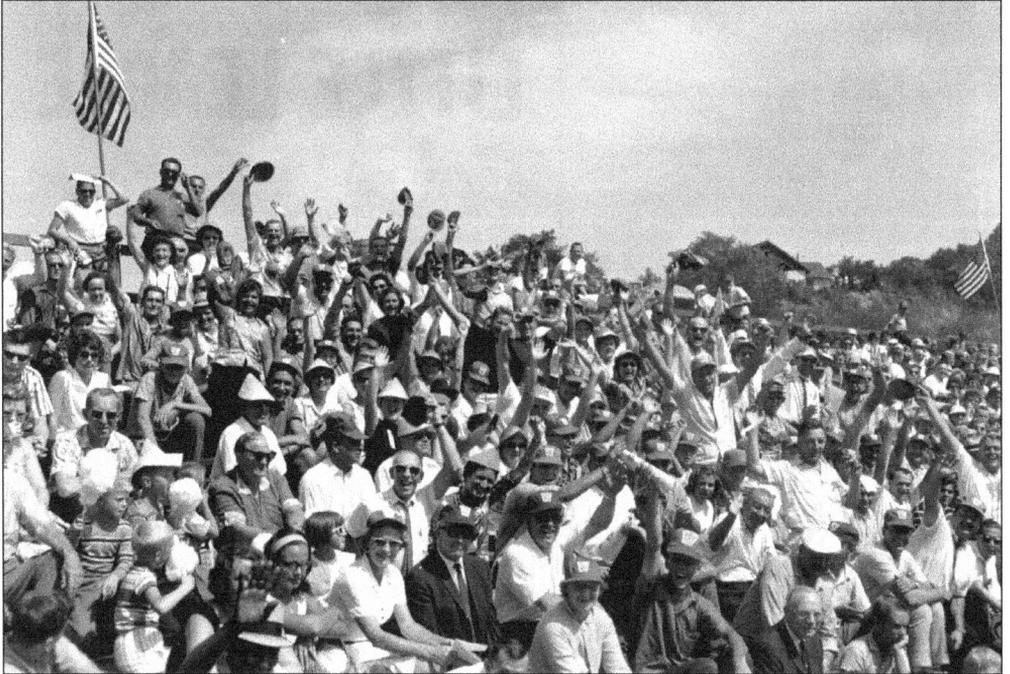

Baseball is America's favorite sport, and Little League games attract thousands of fans when the World Series is played each August. Baseball also became popular in the Far East as military men spread the game to Japan and to the island later known as the Republic of China, or Taiwan.

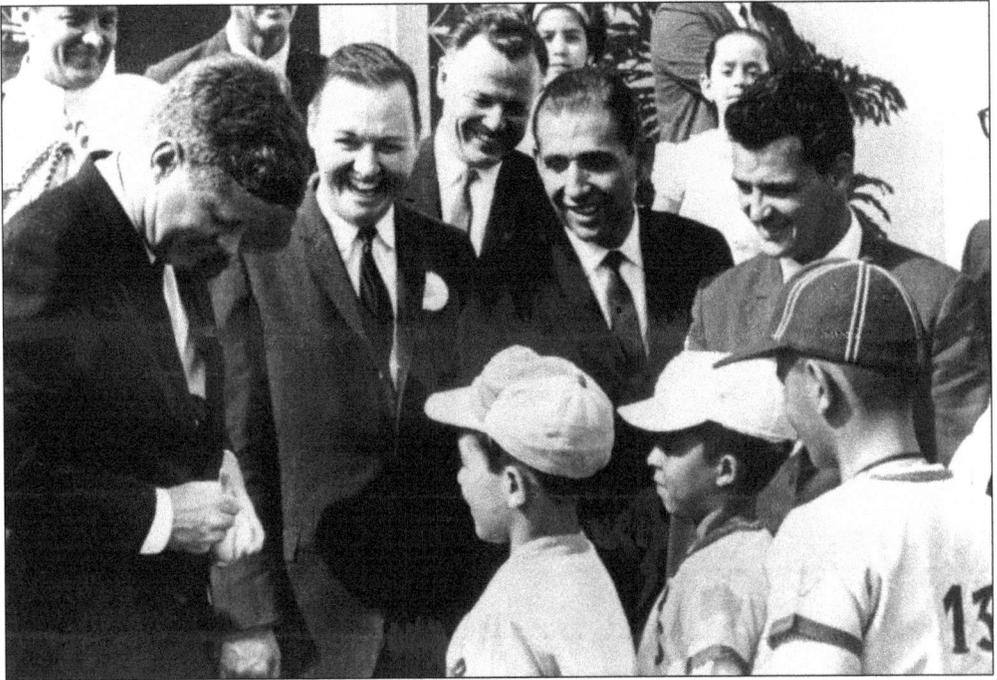

Pres. John F. Kennedy (left) signs baseballs for young American Little Leaguers, on hand to greet him at the residence of the American ambassador in San Jose, Costa Rica, during his visit to the Latin American nation in the spring of 1963.

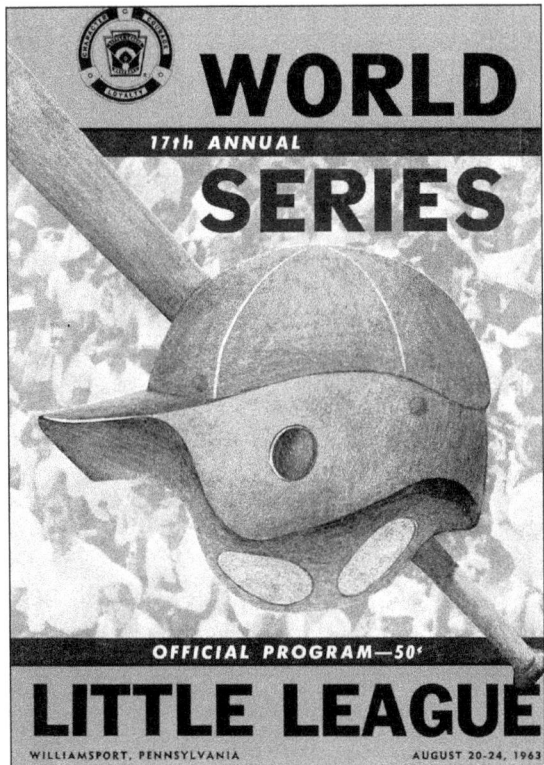

Northern of Granada Hills, California, won the 1962 series 2-1 over Original of Stratford, Connecticut.

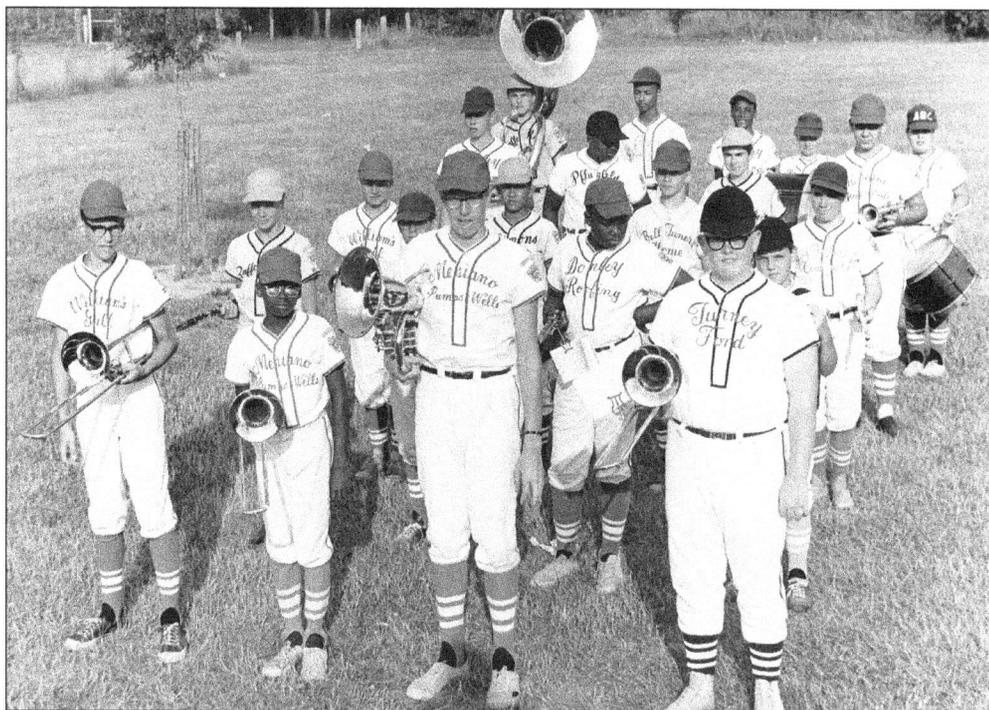

The Monroe Township Little League Band readies for a performance during the 1964 games, harking back to the days when founder Carl Stotz's nephews asked him, "Who would we play? Will people come to watch us? Do you think a band would ever come to play?"

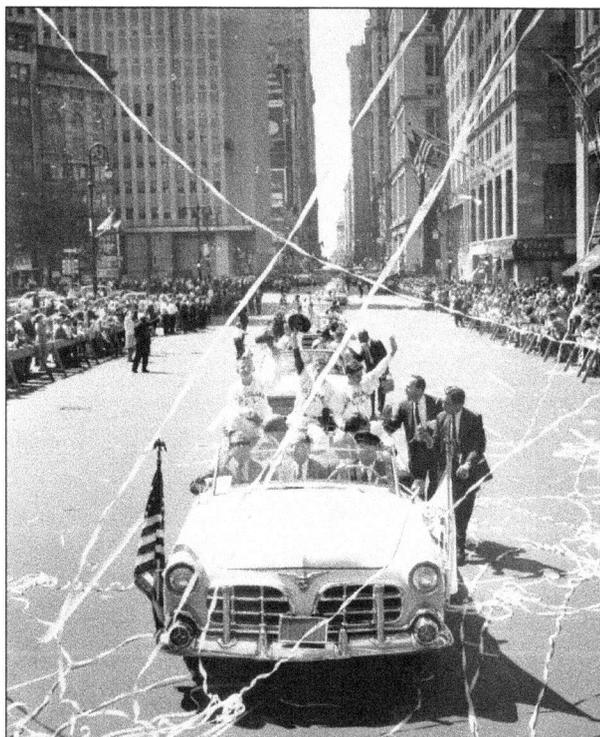

This ticker-tape parade down Broadway was held for the Mid-Island Little League of New York after its 1964 Little League World Series win. The team beat Liga Pequeña of Monterrey, Mexico, 4-0.

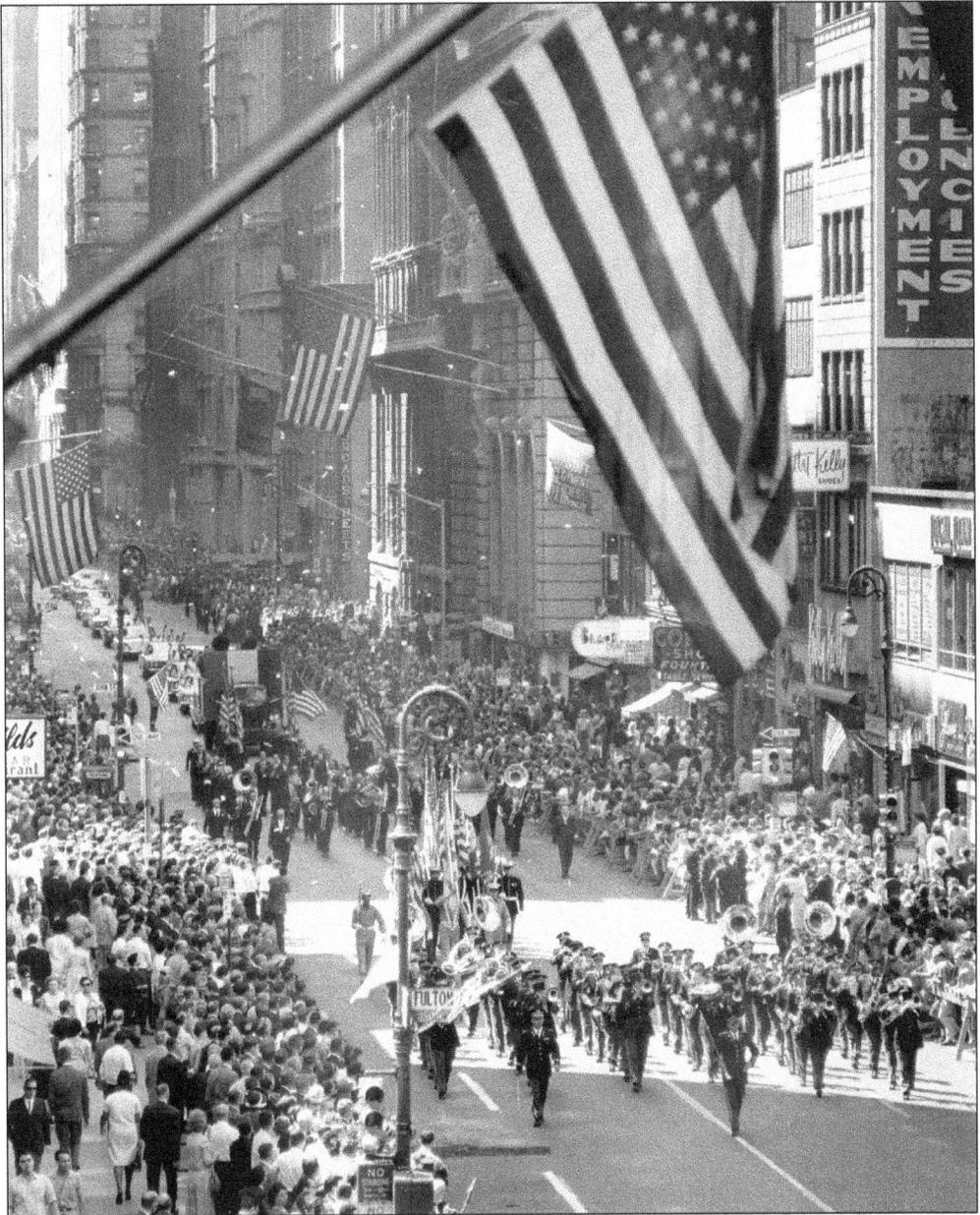

A marching band ushers the Mid-Island Little League parade through downtown Manhattan after Danny Yaccarino spun a no-hitter, issuing only one walk in the last inning of the 1964 Little League World Series. It was the third no-hitter by a winning American pitcher in the championship game during a five-year period. The first two were by Joe Mormello of Levittown, Pennsylvania, in 1960 and Ted Campbell of San Jose, California, in 1962.

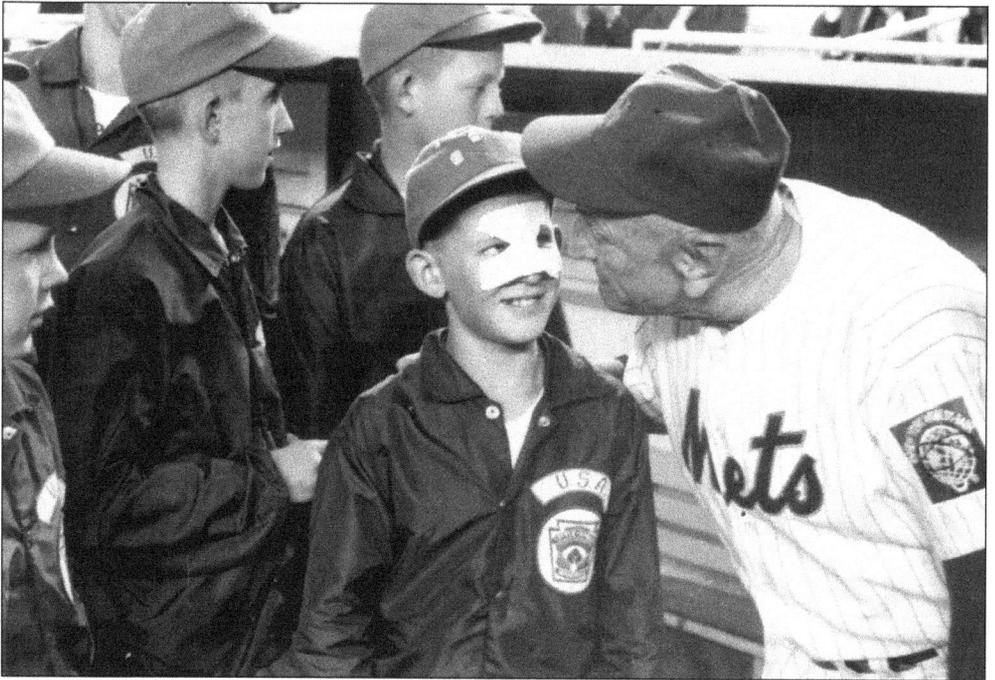

Smiling despite an injury received at the 1964 Little League World Series playoff, this small baseball player is happy to attend a New York Mets game and meet Mets manager Casey Stengel (right).

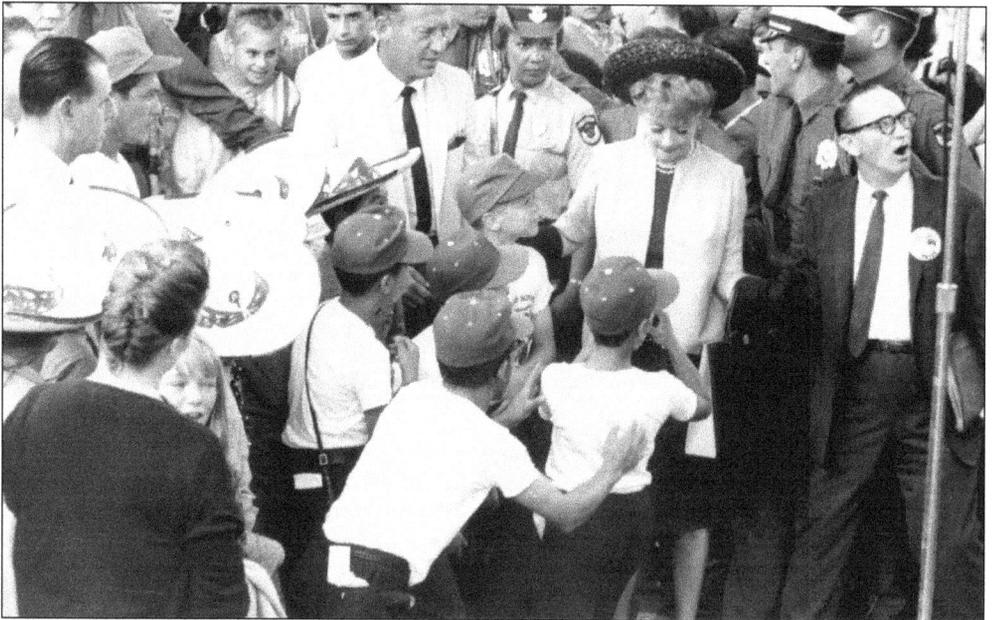

Little League players are thrilled to meet comedienne and movie star Lucille Ball at the 1964 World's Fair, held in New York. As a treat, the World Series Tour of Champions was often taken to New York or Washington, D.C.

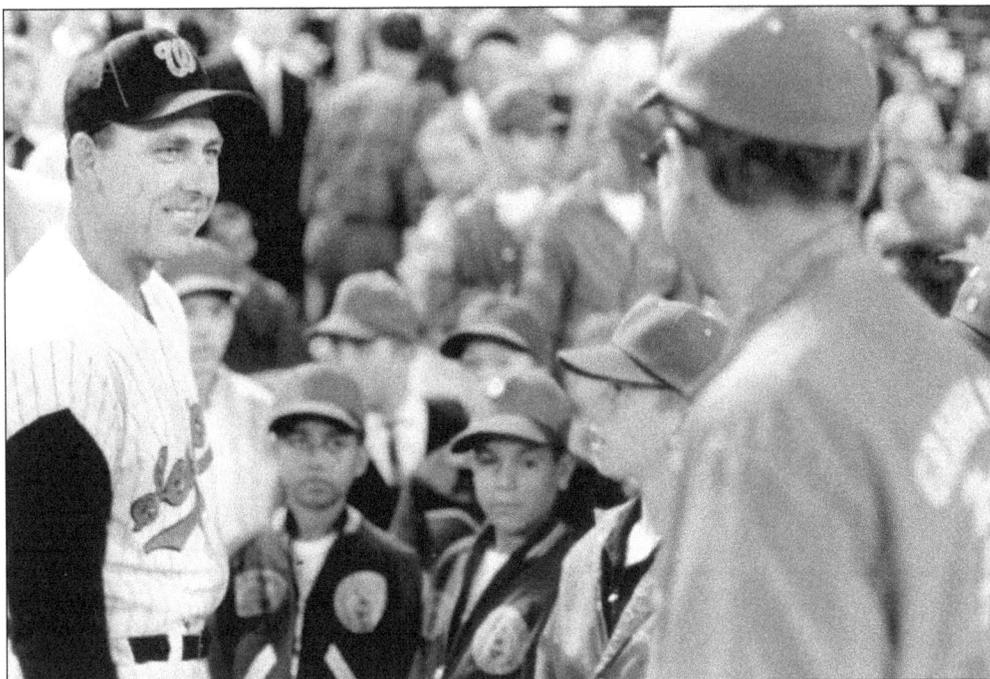

Gil Hodges (left) greets Little League World Series players at a Washington Senators game during the Tour of Champions, an annual trip made by series participants to Washington, D.C. Hodges managed the Senators from 1963 to 1967.

The final game of the 1964 World Series, telecast on ABC's Wide World of Sports, was viewed by more than 12 million people. Also in 1964, Little League was granted a charter of federal incorporation by the U.S. Congress.

LITTLE LEAGUE
Official Program 50¢

A Quarter Century of Service to Youth

1939 1964

Eighteenth Annual . . . 1964

WORLD SERIES

August 25-29 Williamsport, Pennsylvania

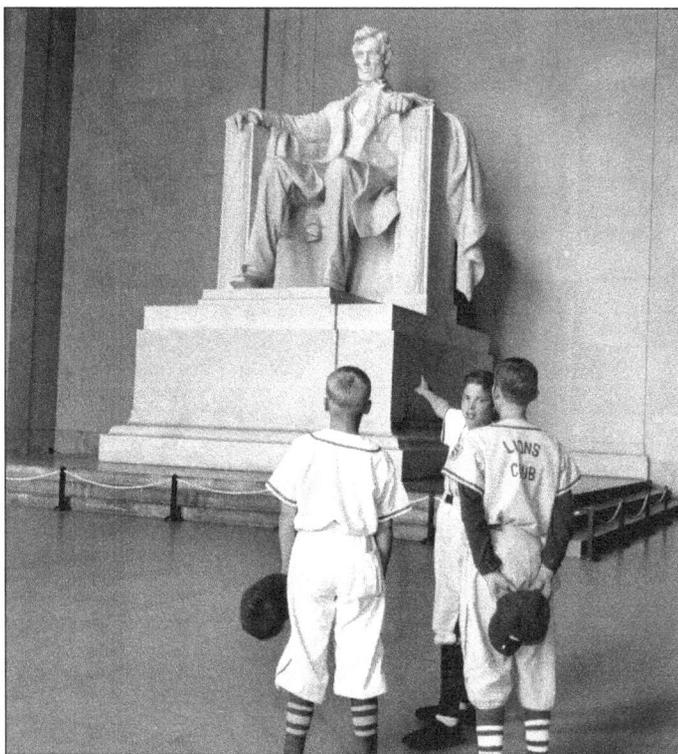

One of the bonuses of participating in the Little League World Series was trip that all of the players made to New York or Washington, D.C., on their way home. Here, a group of boys visits the Lincoln Memorial.

19th ANNUAL LITTLE LEAGUE

OFFICIAL PROGRAM 50¢

LITTLE LEAGUE'S CAVALCADE OF CHAMPIONS

WORLD SERIES

WILLIAMSPORT, PENNSYLVANIA

AUGUST 24-28, 1965

Venezuela and Spain were represented in the Little League World Series for the first time in 1965. Stoney Creek, Ontario, fell to Windsor Locks, Connecticut, 3-1 in the championship game, and Little League Baseball proudly announced that 600 Little League graduates were under contract to Major League clubs.

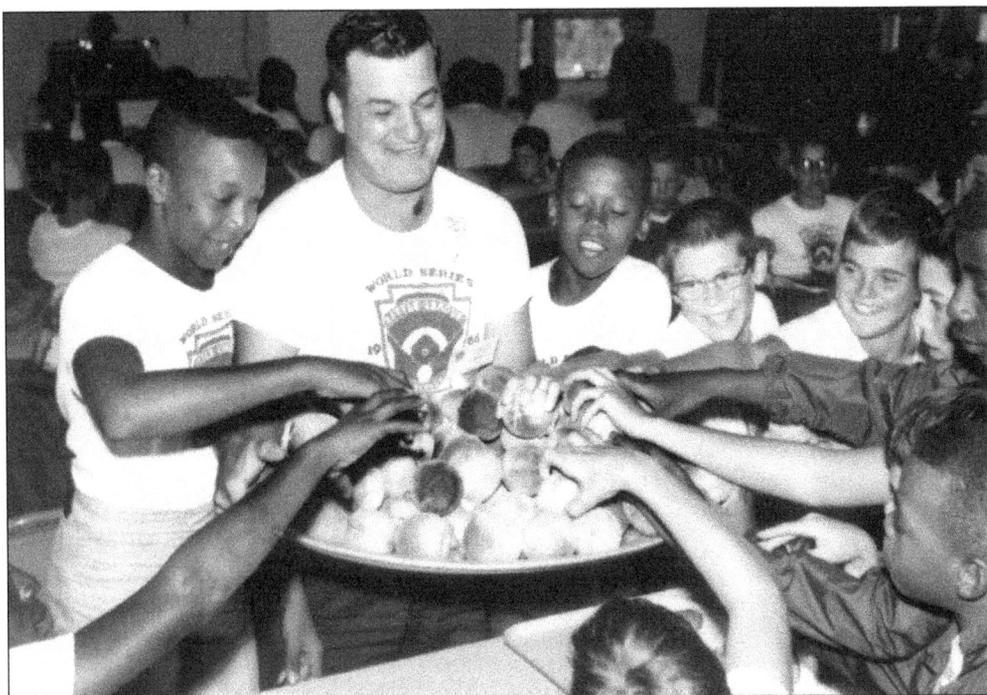

Peter Lupacchino, team "uncle," offers a plate of dinner rolls to players during the 1966 World Series. Carl Stotz borrowed the concept of team hosts (local volunteers assigned to specific teams to make them feel welcome) from the National Soapbox Derby in Akron, Ohio.

Carried by ABC's *Wide World of Sports*, the 1966 World Series was the first to be broadcast in color. Westbury American of Houston, Texas, bested American of West New York, New Jersey, 8-2. A Japanese team reached the series but failed to earn a berth in the championship. All but 5 of the next 25 World Series titles were won by teams from the Far East.

20th ANNUAL ✶ 1966

LITTLE LEAGUE WORLD SERIES

WILLIAMSPORT, PENNSYLVANIA

AUGUST 23, 24, 25, 26, 27

HOWARD J. LAMADE MEMORIAL FIELD

OFFICIAL PROGRAM 50¢

In 1967, West Tokyo, Japan, became the first Far East team to win the Little League World Series title, defeating North Roseland of Chicago, Illinois, 4-1. Rain postponed the start of the series. When it did get under way, a section of the stands at Lamade Field collapsed. The mishap slightly injured two spectators.

The catcher for the Japanese team autographs a baseball for fans after his team's 1967 World Series win.

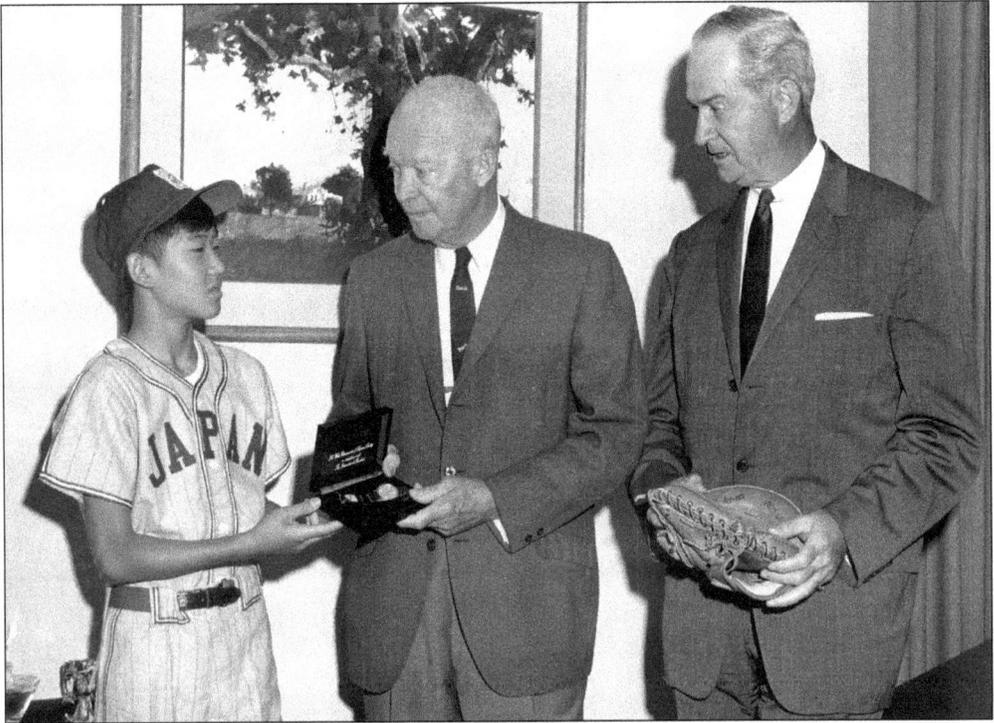

Dwight D. Eisenhower (center) greets the Japanese pitcher after the team's 1967 Little League World Series win. Peter J. McGovern, Little League president, stands by in the former U.S. president's Gettysburg home.

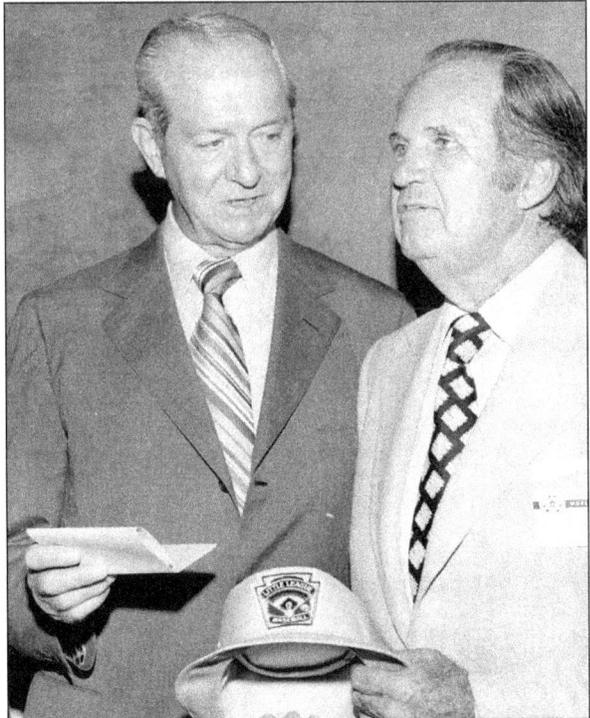

The head of the Madison Avenue–based law firm of Shea, Gould, Climenko and Casey, Bill Shea (right) meets with Peter J. McGovern, Little League president. Shea, an avid supporter of the organization, had served as a trustee of the Little League Foundation from his election in 1960 until his death in 1991. He was president of the foundation from 1976 to 1990.

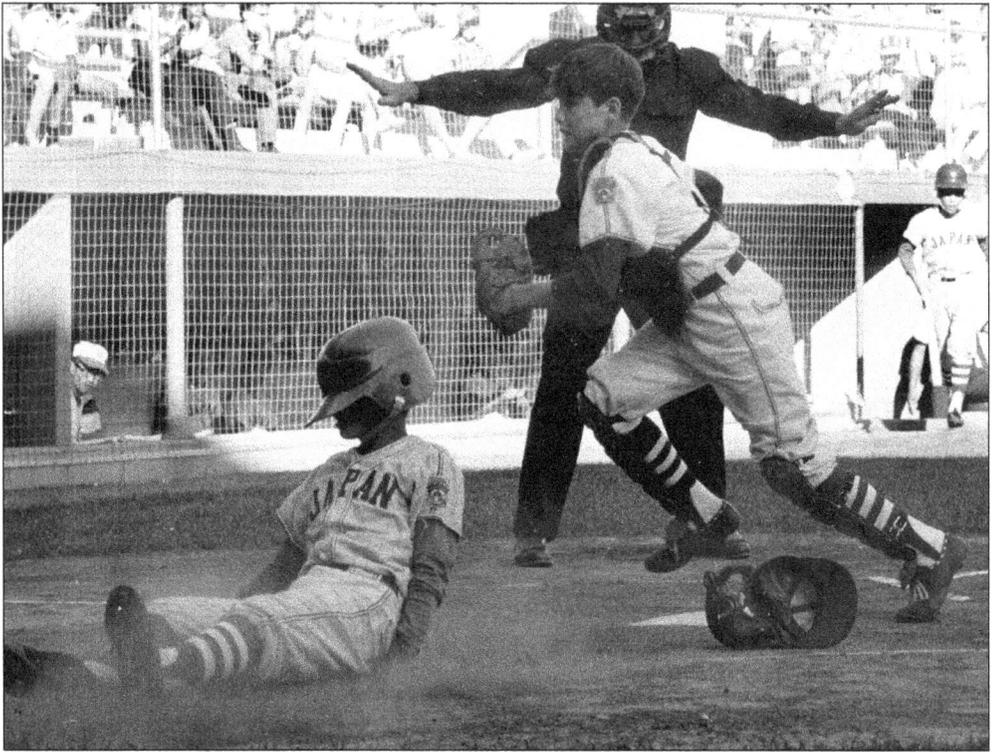

A player for the Japanese team is safe at home during the 1968 World Series. Wakayama of Osaka, Japan, won the series 1-0 against Tuckahoe of Richmond, Virginia, and Little League grew to more than 6,000 programs.

LITTLE
LEAGUE
WORLD
SERIES

AUGUST 20, 21, 22, 23, 24 / WILLIAMSPORT, PENNSYLVANIA

OFFICIAL PROGRAM 50¢

Howard J. Lamade Memorial Field became Howard J. Lamade Stadium when a new venue was dedicated before the 1968 final game. Another division of Little League began when Big League Baseball was formed for 16- through 18-year-olds, resulting in three baseball world series in the Little League, Senior League, and Big League divisions. Today, there are eight series in baseball and softball.

The Golden Dragons of Taipei, Taiwan, won the 1969 World Series 5-0 against Briarwood of Santa Clara, California. Vice Pres. Yen Chia-Kan of the Republic of China said that the win had given to Taiwan the best representation and exposure a country could hope for in deportment, skills, and determination to win.

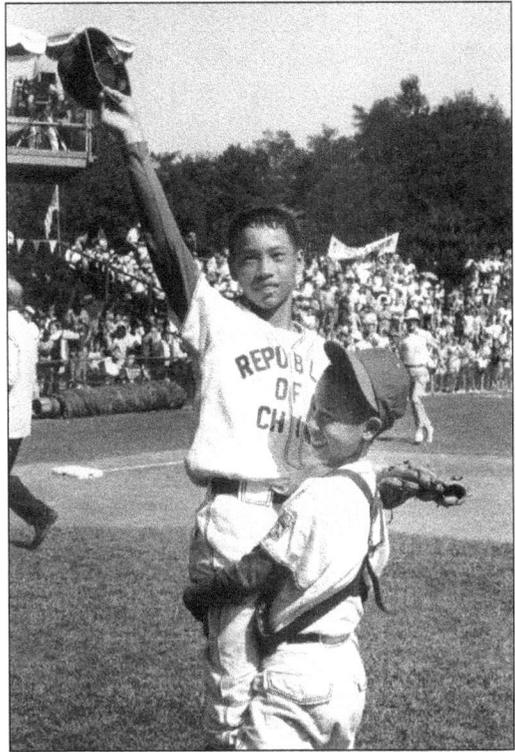

LITTLE LEAGUE WORLD SERIES

1969

Little League Candidates for "Player of the Year"

twenty-third annual august 19-23

WILLIAMSPORT, PENNSYLVANIA 50¢

Newberry Little League participated in the 1969 World Series, becoming the first Williamsport-area team to play in the World Series since 1948. Those who attended the 1969 series recalled it as one of the most memorable, too. Taiwan won the first of its 17 titles, and Mickey Mantle nearly stole the show as color commentator during ABC's *Wide World of Sports*.

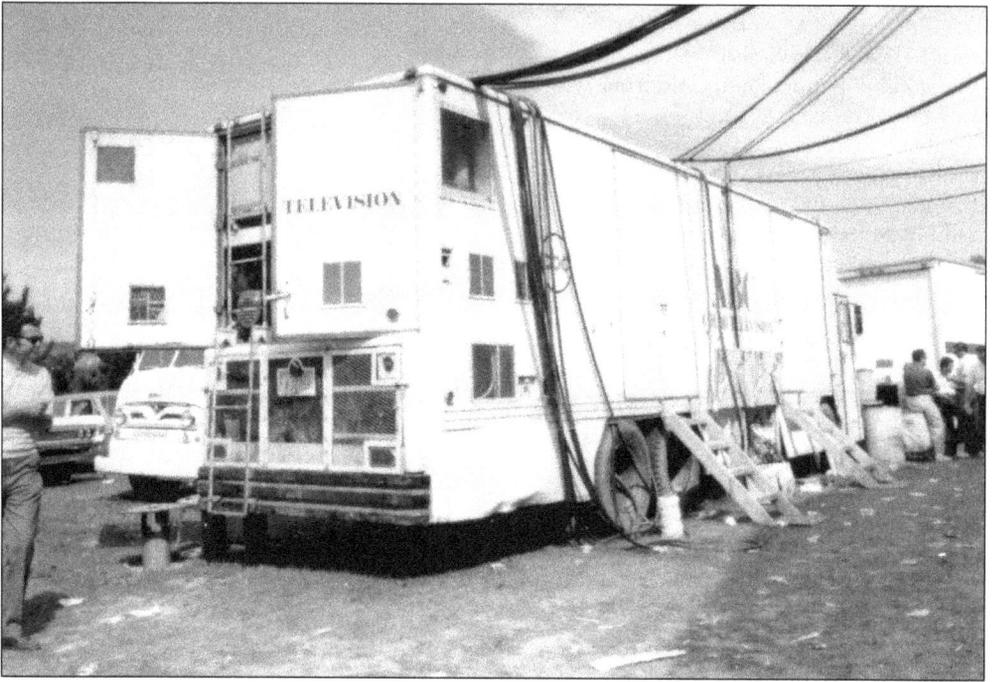

Every year, ABC provided coverage of the Little League World Series from large trucks filled with electronic equipment. Cables for electricity and television transmission stretched between the top of the stadium and the mobile station.

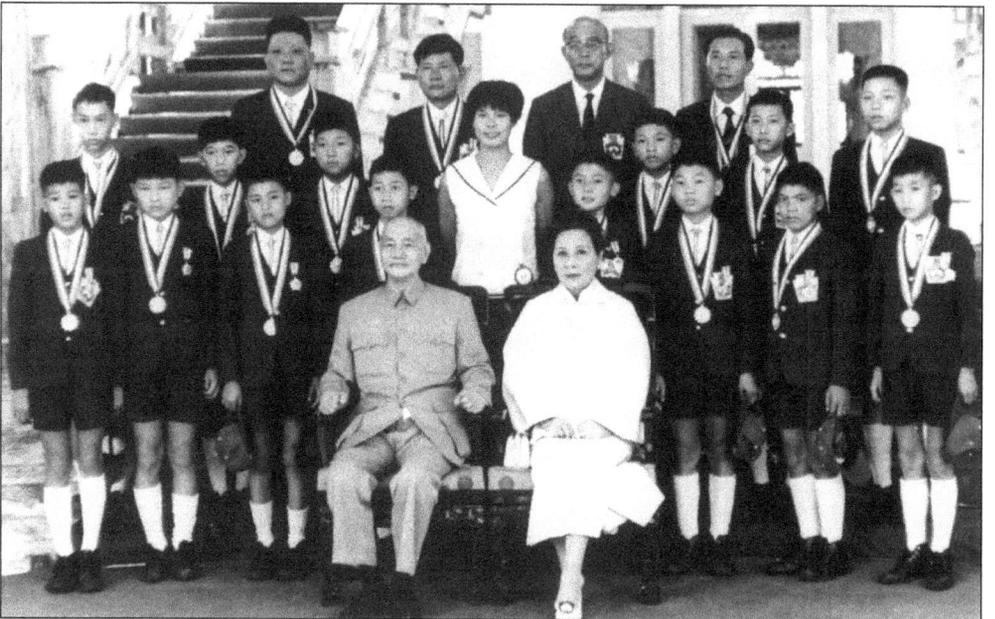

Pres. Chiang Kai-shek and his wife (seated) invited the 1969 Far East team to the capital in Taipei, Taiwan, where they were honored in a ceremony. Madame Chiang placed all 14 boys in a better school in southern Taiwan, in preparation for a college education provided by a provincial education fund and personal help from the president's wife. The government even issued a postage stamp commemorating the team's victory.

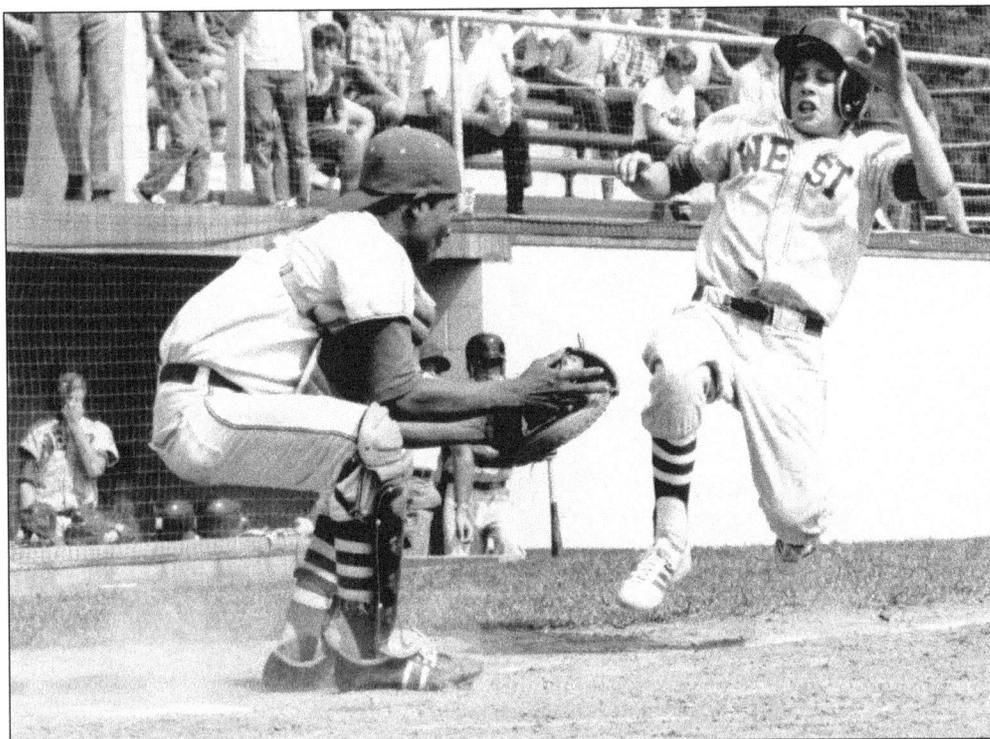

It is too late for this player from the West (right), who starts his slide under the glove of the catcher. The 1970 Little League World Series was won by American of Wayne, New Jersey, which defeated Campbell, California, 2-0.

The Wayne, New Jersey team earned the nickname "Mop Tops" because of the players' long hair. When Wayne players Mark Epstein and Craig Kornfield, as well as manager Gene Cancellieri and coach Tom DeAngelis, showed up with shaggy hair, Little League officials ordered them into the barber's chair before the first game.

LITTLE LEAGUE

24th ANNUAL 50¢
WORLD SERIES
1970 OFFICIAL PROGRAM
August 25-29, 1970
WILLIAMSPORT, PENNSYLVANIA

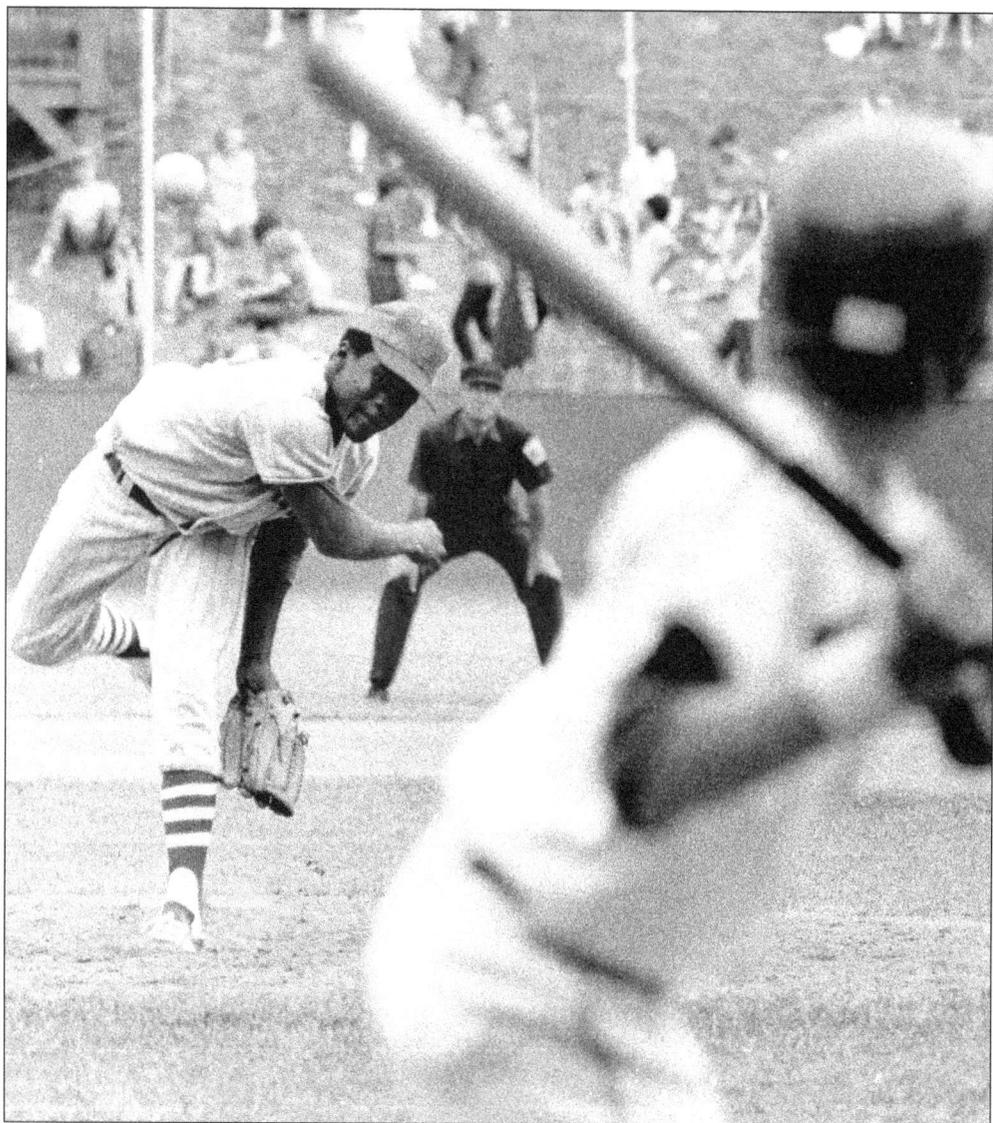

Lloyd McClendon (left), who later became manager of the Pittsburgh Pirates, pitches at the 1971 Little League World Series. McClendon also hit five home runs in five at-bats during the World Series for Gary, Indiana. One of the longest games in series history was played over 2 hours and 51 minutes as Gary and Tainan, Taiwan, battled for nine innings.

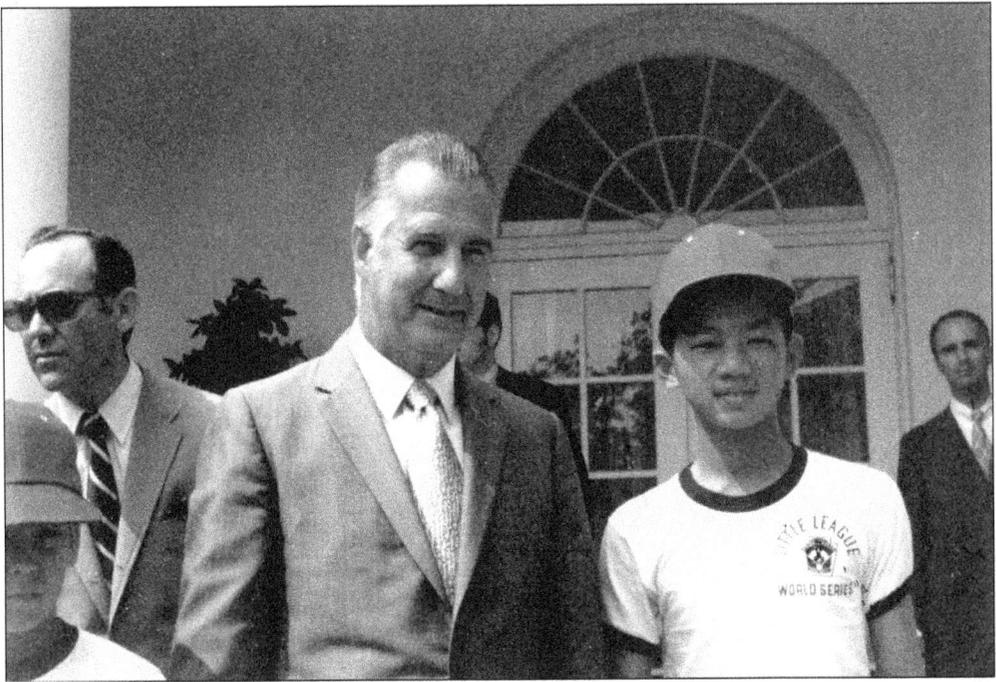

After winning the 1971 Little League World Series against Anderson of Gary, Indiana, by a score of 12-3, members of the Tainan, Taiwan, team traveled to Washington, D.C., and met Vice Pres. Spiro Agnew (center).

LITTLE LEAGUE 25th ANNIVERSARY WORLD SERIES OFFICIAL PROGRAM

"BOOG" POWELL:
HIS LITTLE LEAGUE
WORLD SERIES
RECORD IS STILL INTACT
(Page 1)

EIGHT PAGES OF PICTURES
WORLD CHAMPIONS
1947-1970

WILLIAMSPORT, PENNSYLVANIA
AUGUST 24-28/1971

50¢

Howard J. Lamade Stadium got a facelift in 1971 when "wings" were added down each of the foul lines. Seating capacity increased from 4,600 to 10,000, and the improvements cost $200,000. A Little League state center opened in Waco, Texas. The center was expanded into a full-service regional center in 2001.

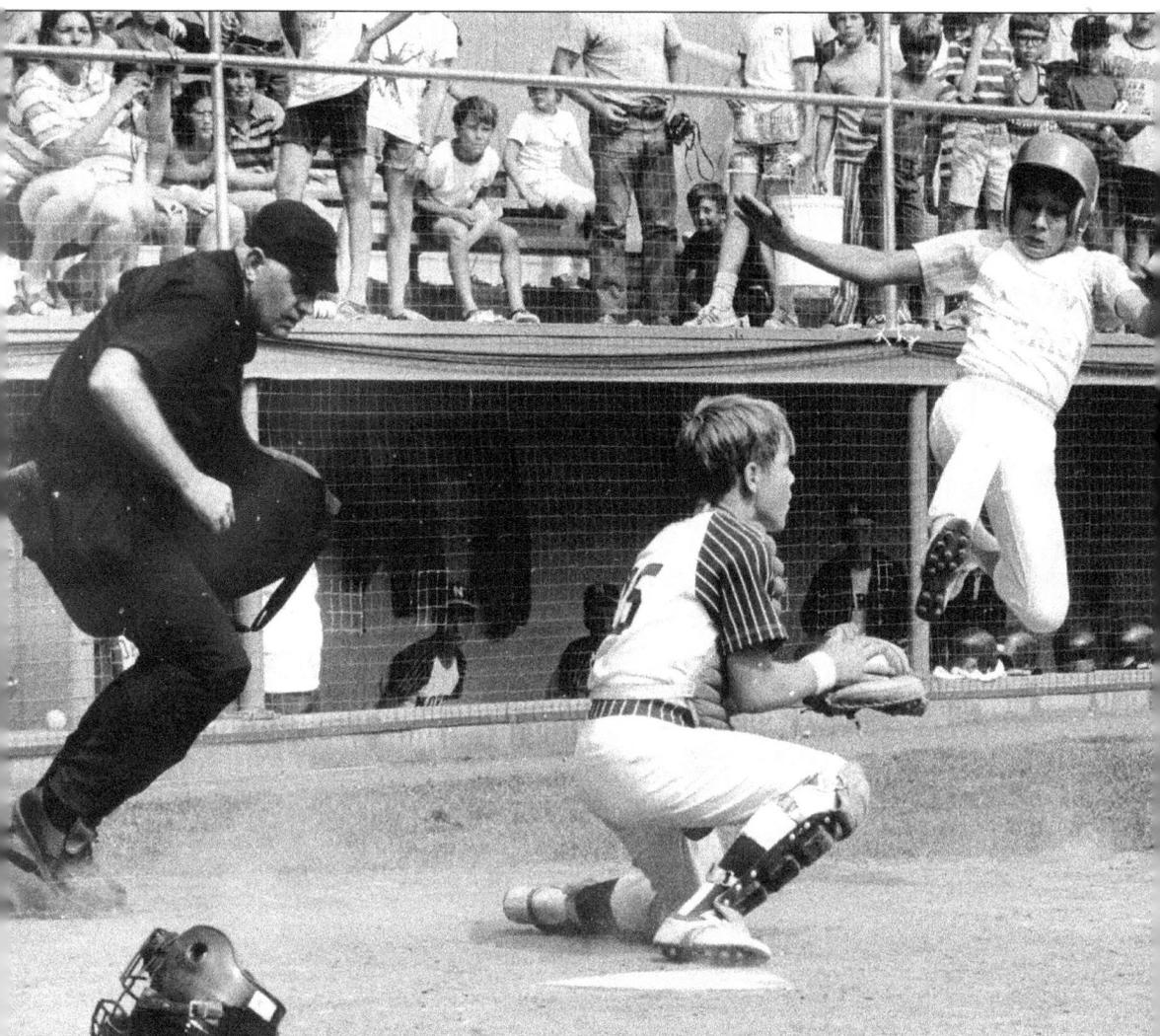

Trying to avoid an out, a player from the San Juan, Puerto Rico team hurdles the catcher's tag to score during the 1972 Little League World Series.

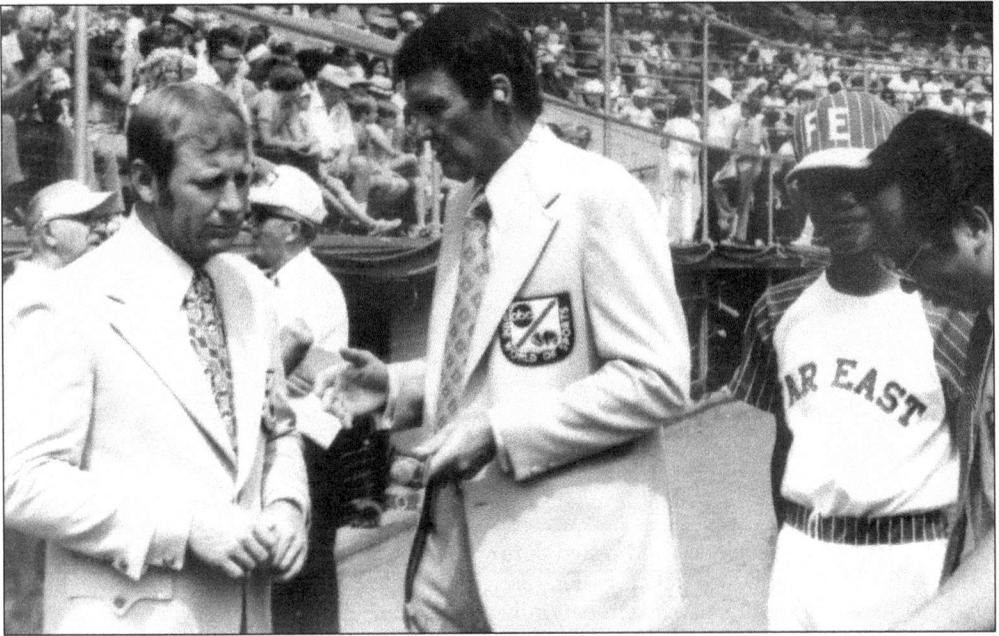

Mickey Mantle (left) and Bud Palmer, both commentators for ABC's *Wide World of Sports*, discuss coverage at the 1972 Little League World Series.

Taipei, Taiwan, won a second consecutive World Series championship for the Far East, defeating Edison of Hammond, Indiana, 6-0 in 1972. Title IX was enacted to the benefit of girls participating in sports, and Little League launched a new theme: "Build a Better Boy."

1972
LITTLE
LEAGUE

WORLD
SERIES

OFFICIAL PROGRAM

WILLIAMSPORT, PENNSYLVANIA AUGUST 22-26 / 1972 50¢

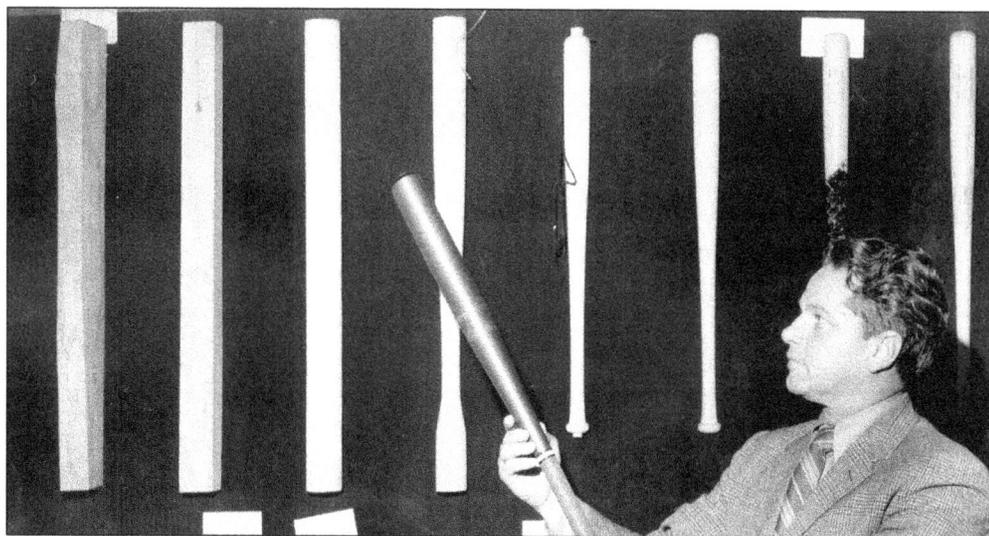

The aluminum bat, developed and tested during the 1971 season, was introduced during the 1972 series. Thoroughly researched by Dr. Creighton Hale (shown here), the lightweight bat replaced the easily splintered wooden bat on Little League ball fields nationwide.

Team "uncles" gather in International Grove to await the arrival of the 1972 Little League World Series players. International Grove consisted of a dining and recreation hall and bunkhouses for the teams, now housed at the Little League complex instead of Lycoming College.

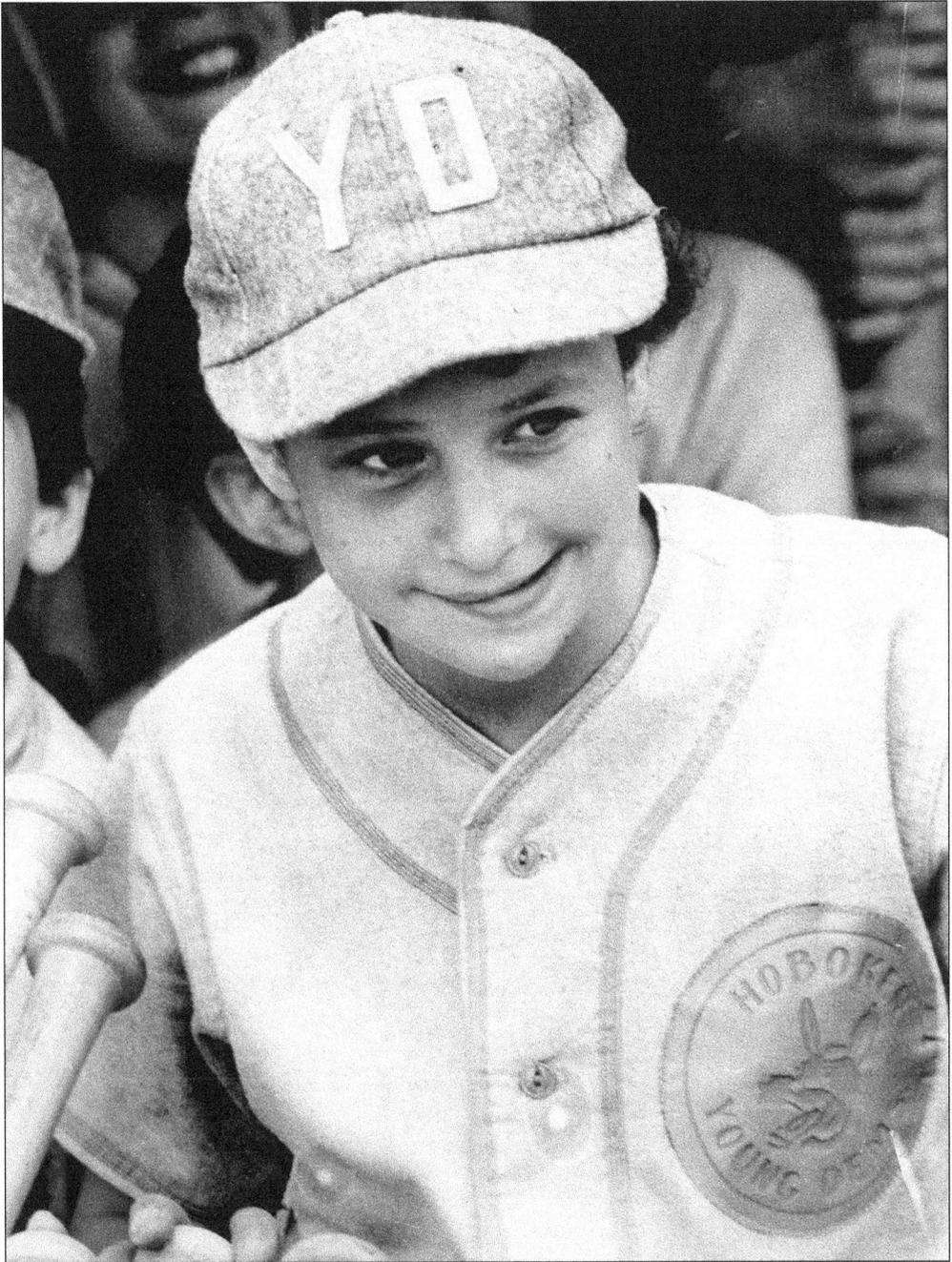

Maria Pepe was selected to play on the Young Democrats team in Hoboken in 1972. She played in the first three games of the season before Little League officials told the Hoboken league that "girls are not eligible" and that its charter would be revoked if Pepe were allowed to continue. The National Organization for Women took up Pepe's struggle and sued Little League in the New Jersey Division of Civil Rights. It was not the first lawsuit, but in 1974, Little League amended its rules, allowing girls to play baseball and creating the softball division.

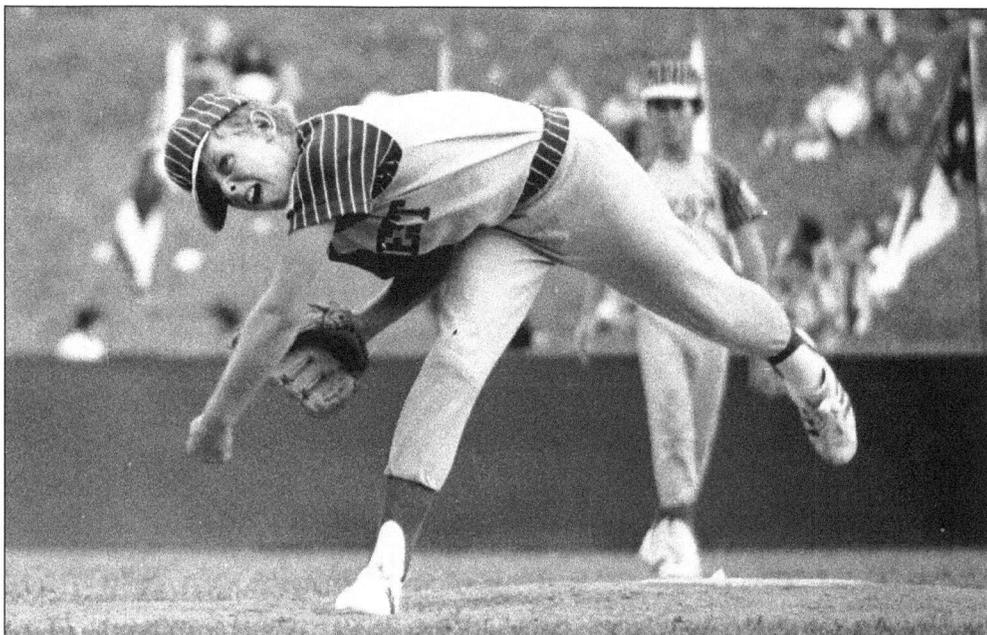

Ed Vosberg, who later pitched in the Major Leagues, plays in the 1973 Little League World Series for the runner-up team from Tucson, Arizona. Vosberg is the only person to participate in the Little League World Series, College World Series (University of Arizona, champions, 1980) and Major League World Series (Florida Marlins, champions, 1997).

Tainan City, Taiwan, shuts out Cactus Little League of Tucson, Arizona, 12-0, in the 1973 Little League World Series. In a nine-year period beginning in 1973, Belmont Heights made it to the Little League Baseball World Series four times—a record matched only by Kankakee, Illinois. Belmont Heights finished as the runner-up three times but never won the world championship.

Pres. Gerald Ford (left) speaks with Dr. Creighton J. Hale, newly elected president of Little League Baseball, during a White House tour by the 1974 Little League World Series champions.

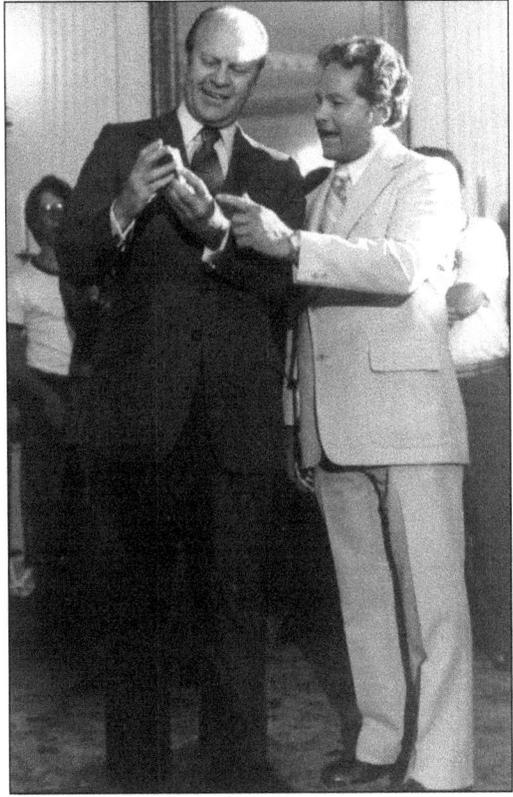

Carlton Fisk (left) visits with Dr. Creighton Hale outside of Little League Baseball headquarters in South Williamsport. Fisk, on the Major League disabled list, worked for ABC during the 1974 Little League World Series. Taiwan won all three divisions of Little League play. At the title game in Williamsport, pitcher Lin Wen-hsuing struck out 15 and was four-for-four at the plate.

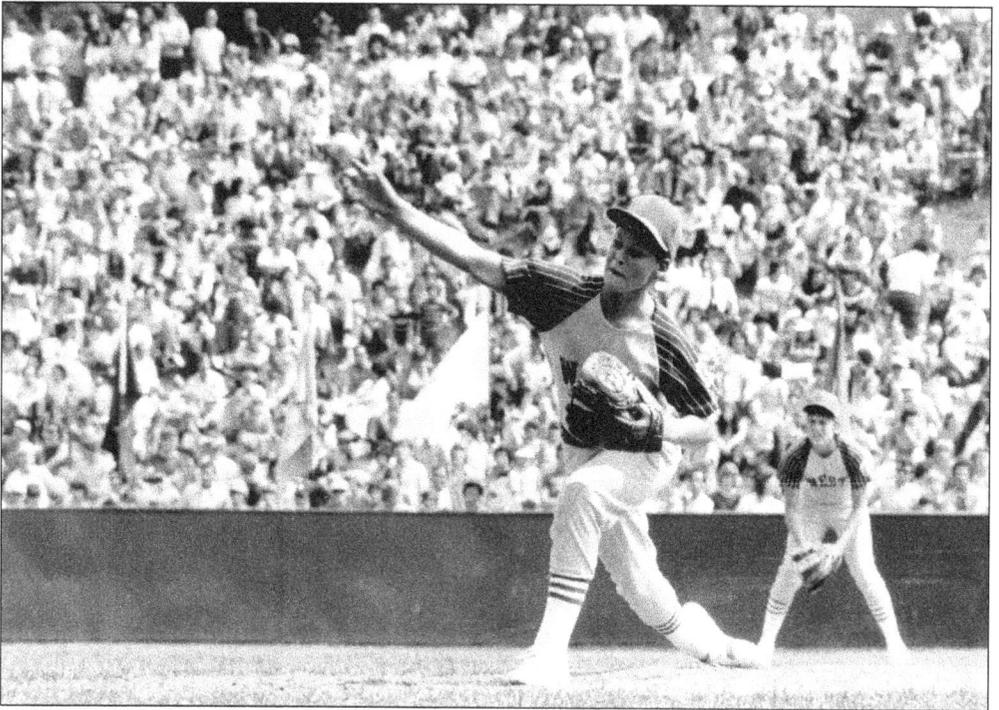

Is it a strike? The stadium is filled and the players take the field in 1974, but one thing is missing. Umpire consultant Howard Gair had died in October 1973 at the age of 78.

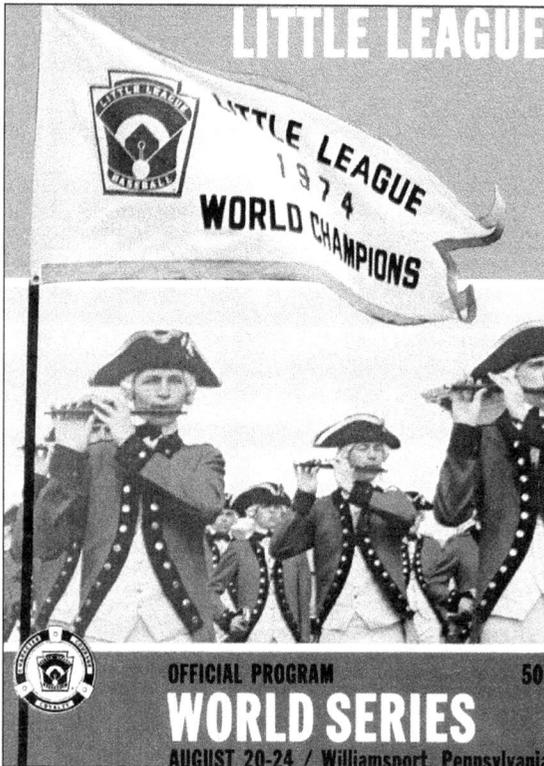

A new dimension was added to Little League when parallel programs were initiated for girls in Little League and Senior League Softball in 1974. More than 30,000 girls around the nation signed up to play. A world series was held in Freeport, New York, with Tampa, Florida, winning the title.

Taiwan swept all three divisions of 1974 Little League Baseball play: the Little League Baseball World Series, the Senior League Baseball World Series (in Gary, Indiana), and the Big League Baseball World Series (in Fort Lauderdale, Florida). In the Little League series, Taiwan blasted Red Bluff, California, 12-1.

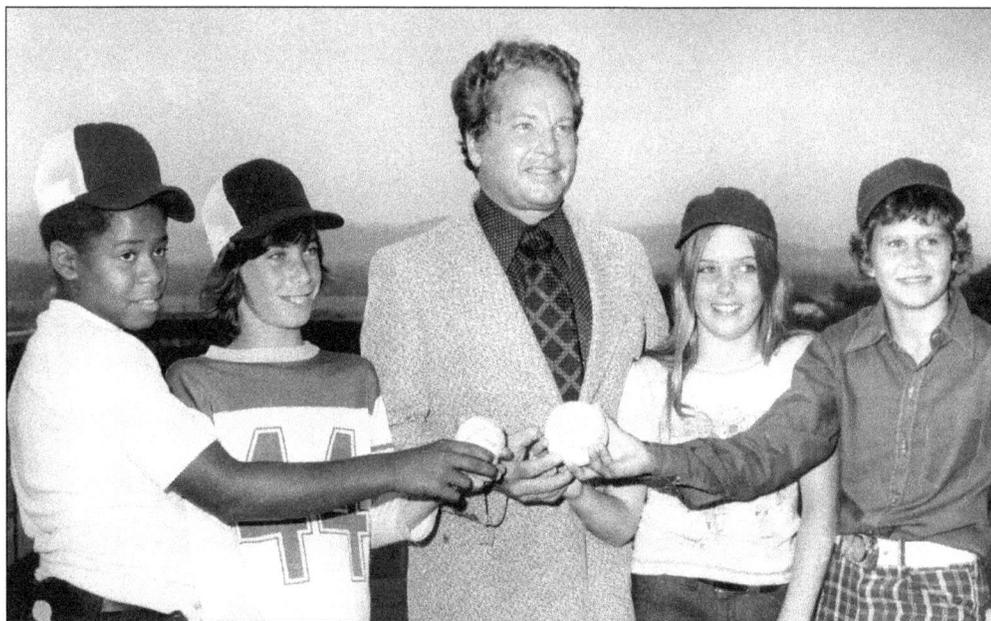

The 1975 World Series was played only by U.S. teams. The others were barred from advancing beyond regional play because of an "over-emphasis on tournament play." In this photograph, Dr. Creighton Hale meets with players competing in the various 1975 tournaments. With him are, from left to right, Gary Edwards, Jay Teitelbaum, Wendy Wills, and Robin Heidt.

The four U.S. regions (West, South, East, and Central) met in Williamsport for the 1975 championship series. In the World Series final, Lakewood, New Jersey, defeated Belmont Heights of Tampa, Florida, 4-3.

The Little League Softball World Series, also a four-team affair, was played simultaneously at Lamade Stadium. In the second year of the program, 1,000 leagues chartered to play softball. For the first time, women (team "aunts") were named to the host committee.

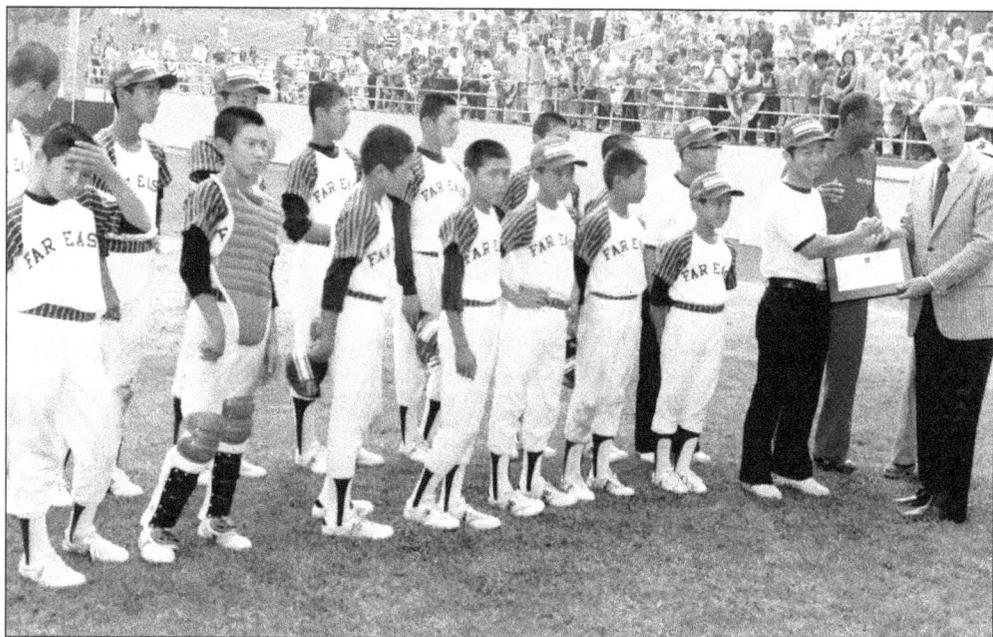

International teams were once again allowed to participate in the series, but Taiwan failed to capture the Far East title in 1976. Chofu, Japan, won the Little League World Series championship 10-3 against Campbell, California. In this view, Joe DiMaggio (right) presents the team with its award.

LITTLE LEAGUE
AUGUST 24-28, 1976

AMERICAN REVOLUTION BICENTENNIAL
1776-1976

30th ANNUAL

WORLD SERIES

WILLIAMSPORT, PENNSYLVANIA OFFICIAL PROGRAM 50¢

Hall of Famers Joe DiMaggio, Ernie Banks, and Bob Gibson were 1976 World Series guests. DiMaggio, the kind of player for whom the National Baseball Hall of Fame was built, gave batting tips to 11- and 12-year-old players at the series. William Shea became president of the Little League Foundation in 1976.

The Taiwan Dynasty returned to the 1977 Little League World Series, in which Li-Teh of Taiwan defeated Western of El Cajon, California, 7-2. Future Major Leaguer Charlie Hayes played in the 1977 Little League World Series for the Hattiesburg, Mississippi team.

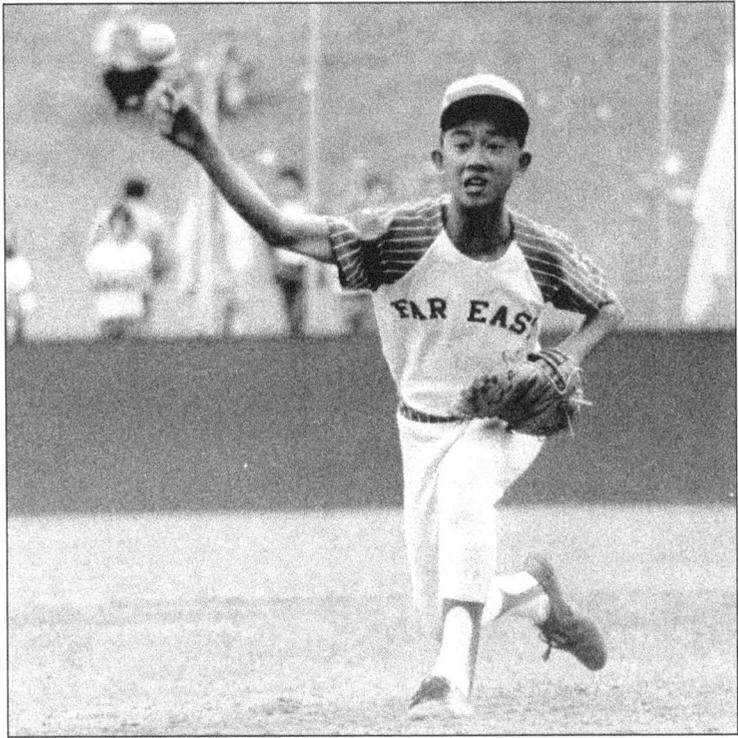

LITTLE LEAGUE

1977

31st Annual

WORLD SERIES

August 23-27

WILLIAMSPORT PENNSYLVANIA

Official Program 50

The outfield fence at Howard J. Lamade Stadium was extended to 209 feet in center field (and later moved back to 205 feet at all points). The extra nine feet was not expected to deter sluggers. A summer camp scholarship for Little Leaguers was established in memory of Robert H. Stirrat, former Little League official and early pioneer. The first softball umpire clinic was held in Williamsport. Attending the week-long session were eight women in blue.

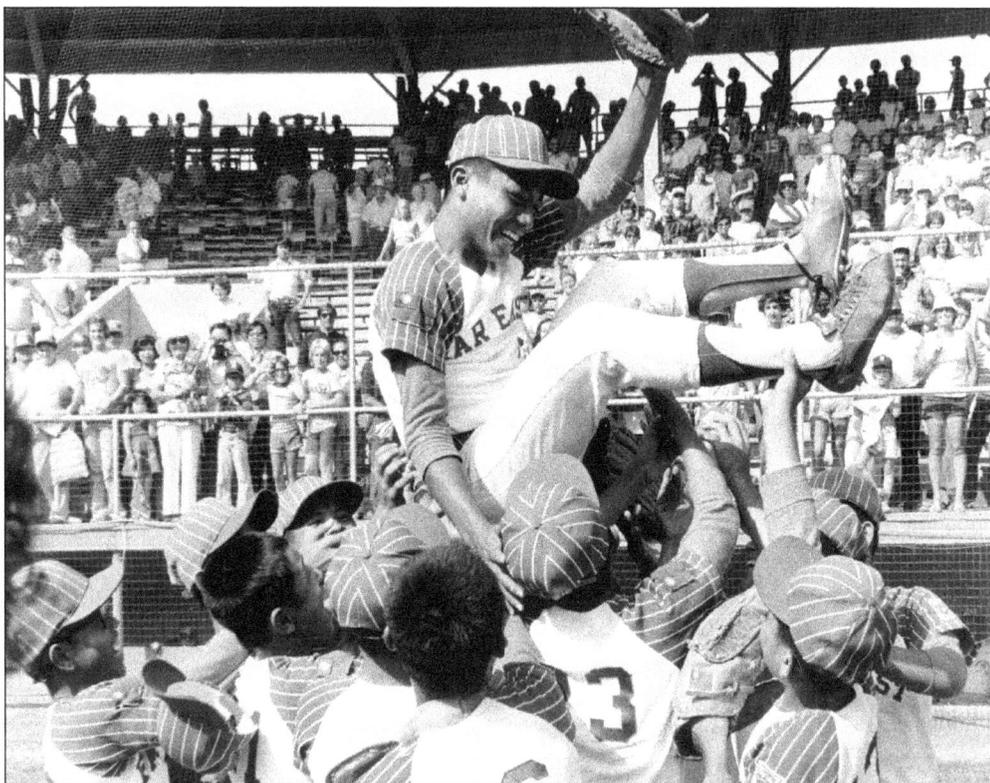

Teammates toss Pan Chau Min into the air after winning the 1978 Little League World Series championship game. Pin-Kuang, Taiwan, defeated San Ramon Valley of Danville, California, 11-1.

LITTLE LEAGUE
32nd WORLD SERIES

August 22-26, 1978
Williamsport, Pennsylvania

John Feichtel
Milton Little League

SPARKY LYLE
Pitcher—New York Yankees
Reynoldsville Little League
Reynoldsville, Pennsylvania

GEORGE FOSTER
Outfielder—Cincinnati Reds
Tri-Park Little League
Lawndale, California

OFFICIAL
PROGRAM
50¢

STEVE GARVEY
Infielder—Los Angeles Dodgers
Drew Park Little League
Tampa, Florida

In 1978, Little League grew to include more than 6,500 Little Leagues for 9- to 12-year-olds, 2,850 Senior Leagues for 13- to 15-year-olds, and 1,300 Big League programs for 16- to 18-year-olds. Little League and Senior League Softball teams totaled more than 7,400. A division for 16- to 18-year-olds, the Big League Softball Division, was added.

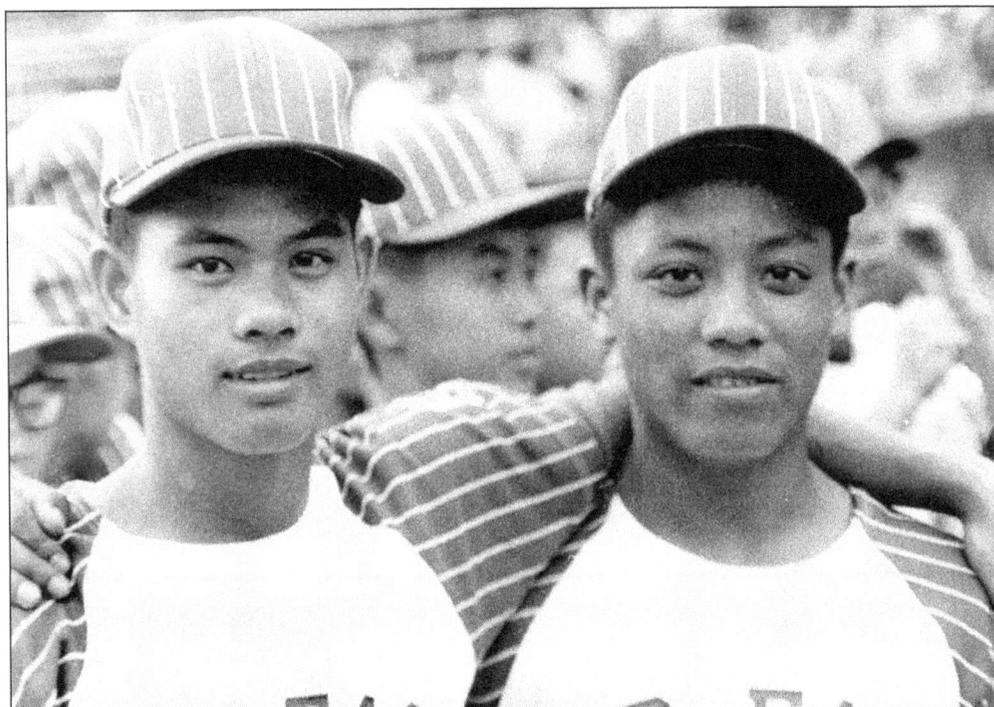

Pan Wen Chu (left) and Pan Chau Min of the Pin-Kuang, Taiwan, team congratulate each other and pose for a photograph following their win at the 1978 series.

Taiwan won again at the 1979 Little League World Series. Pu-Tzu Town, Taiwan, defeated Campbell, California, 2-1. At the conclusion of the series, the Tour of Champions began with teams boarding "Big Mac coaches (buses supplied by McDonalds) for a whirlwind trip to Hershey Park and Washington, D.C.

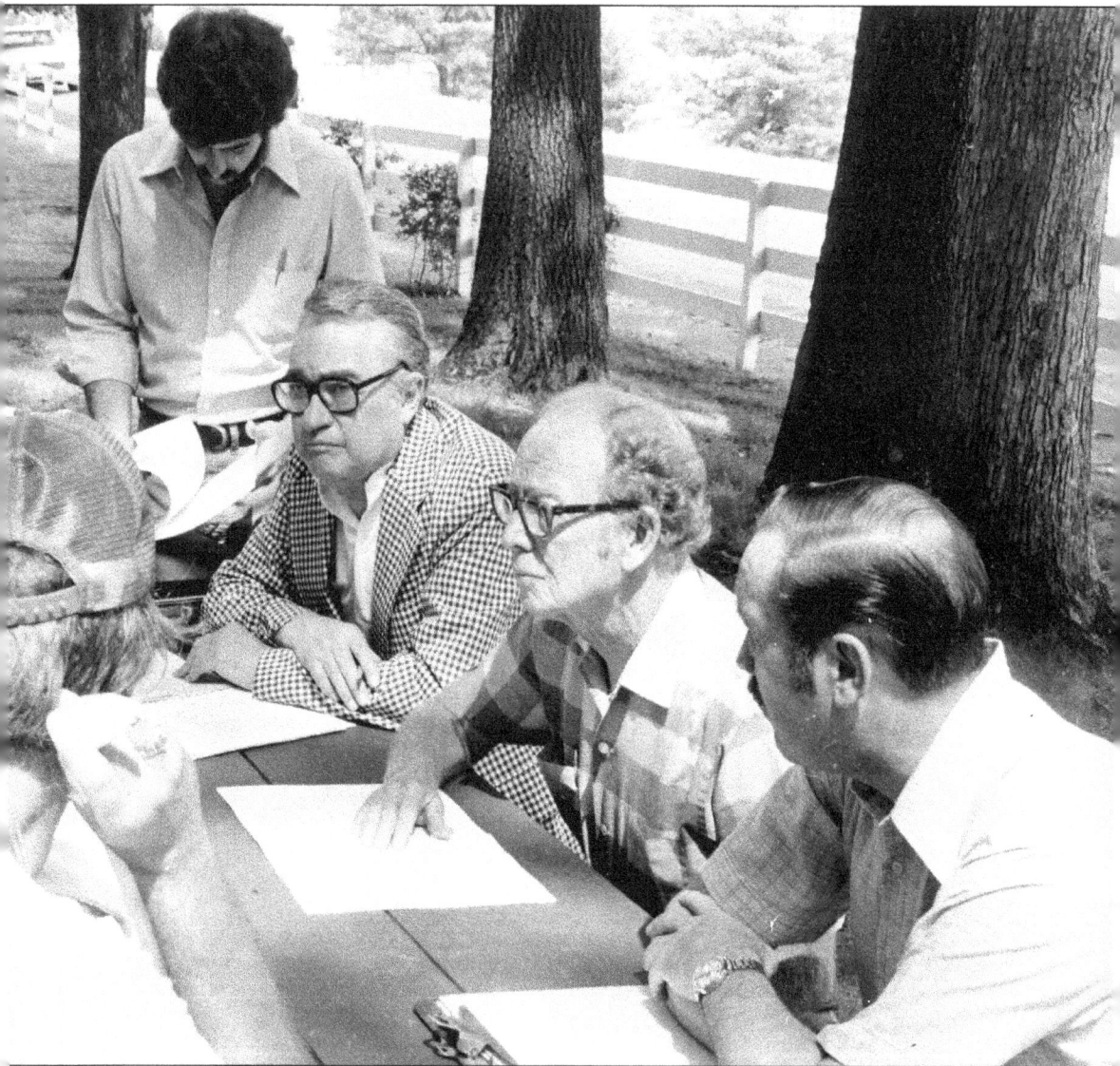

Mel Allen (left center) and Red Barber (right center) set up a casual conference area outside International Grove at the 1979 Little League World Series. In 1978, Allen (longtime voice of the New York Yankees) and Barber (who broadcast the Brooklyn Dodgers games) were inducted into the broadcasting wing of the National Baseball Hall of Fame. Allen was master of ceremonies for the Little League World Series in 1954 and 1976. In 1953, Barber aired the series on CBS.

Two players on the 1980 Belmont Heights team from Tampa, Florida, went on to become stars in the Major Leagues. Derek Bell (shown here) and Gary Sheffield were key players in Belmont Heights's run to the final game. The team was toppled by Long Koung, Taiwan, 4-3.

Gary Sheffield runs past first base during the 1980 Little League World Series. Although Belmont Heights never won the championship, it participated in the World Series four times in the nine-year period beginning in 1973.

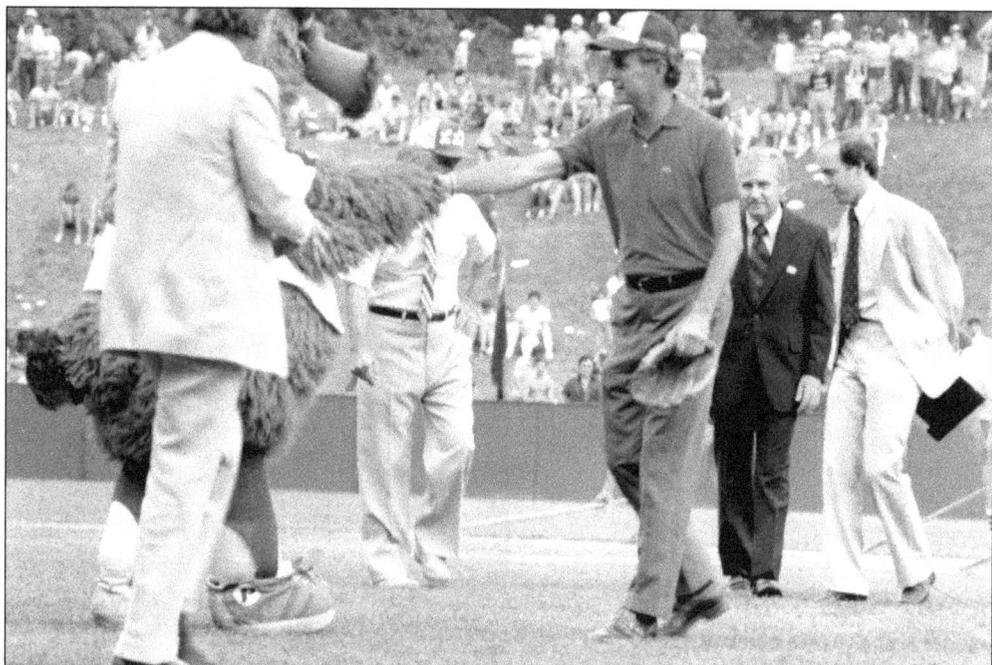

Three months before being elected vice president, former Little League coach George Bush (right foreground) throws out the first pitch for the 1980 World Series championship game. His son, Pres. George W. Bush, attended the series 21 years later, also to toss the first pitch.

In 1980, Junior League Baseball was created for 13-year-olds. Future Major Leaguers Dwight Gooden, Floyd Youmans, and Vance Lovelace played for the Belmont Heights team in the Senior League Baseball World Series in Gary, Indiana.

This Canadian runner (center) is safe, sliding into third base during a prechampionship game of the 1981 Little League World Series. Once again, Belmont Heights fell to Taiwan as Tai-Ping claimed the series 4-2.

35th ANNUAL
LITTLE LEAGUE BASEBALL
1981 WORLD SERIES
WILLIAMSPORT, PENNSYLVANIA

Another future Major Leaguer, Dan Wilson, played for Barrington (Illinois) Little League in the 1981 Little League World Series. Derek Bell returned with Belmont Heights in 1981, becoming the first Major League player to have played in two Little League World Series.

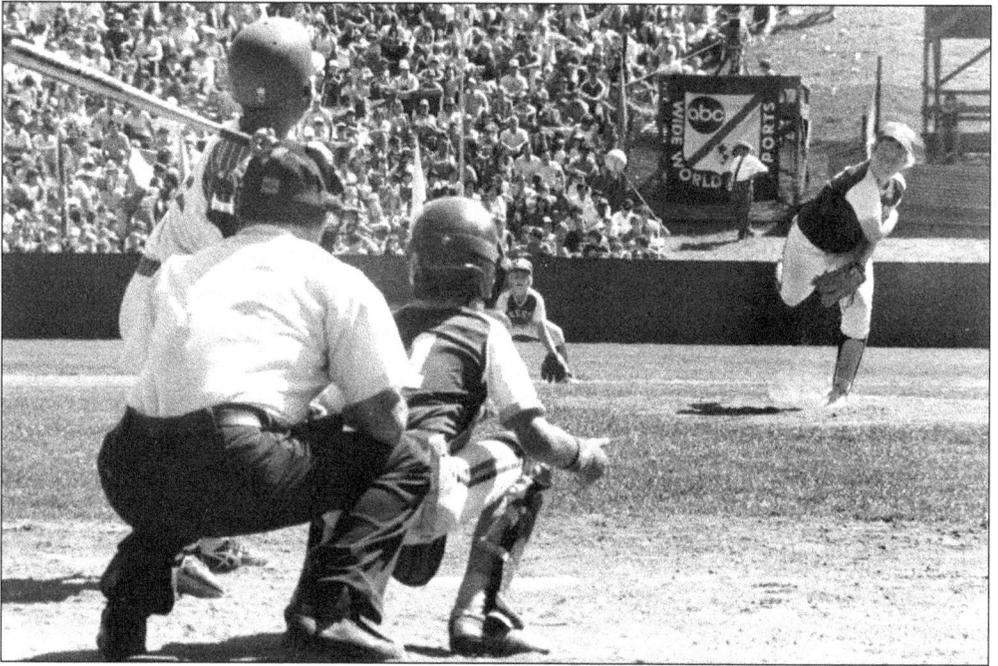

Before a record-setting crowd of 40,000, Cody Webster (right) tossed a two-hitter in the final game of the 1982 Little League World Series. Kirkland, Washington, upset Pu-tzu Town, Taiwan, 6-0.

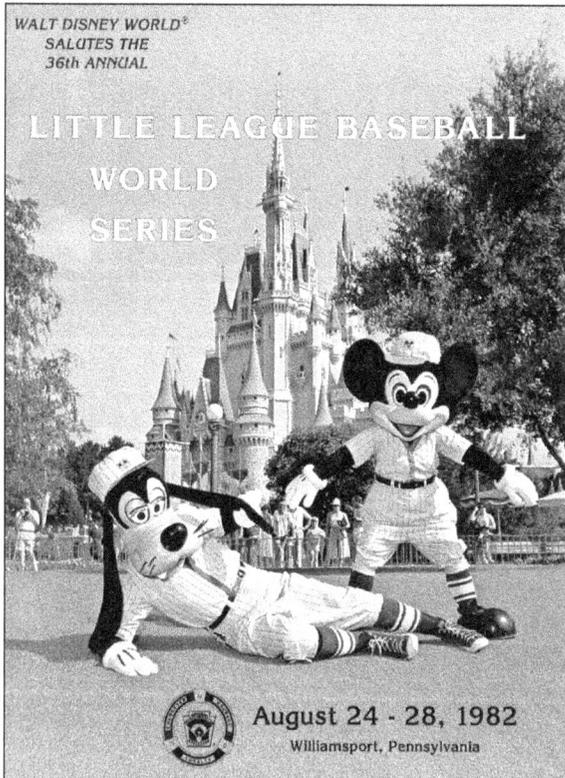

WALT DISNEY WORLD®
SALUTES THE
36th ANNUAL

LITTLE LEAGUE BASEBALL
WORLD
SERIES

August 24 - 28, 1982
Williamsport, Pennsylvania

The Peter J. McGovern Little League Museum opened in 1982 at the Little League international headquarters complex. Future Major Leaguer Wilson Alvarez played for the Maracaibo, Venezuela team in the series.

East Marietta (Georgia) National Little League won the 1983 Little League World Series 3-1, routing Liquito Hernandez of the Dominican Republic. In this photograph, manager Richard Hilton joyfully hugs his pitcher, future Major Leaguer Marc Pisciotta.

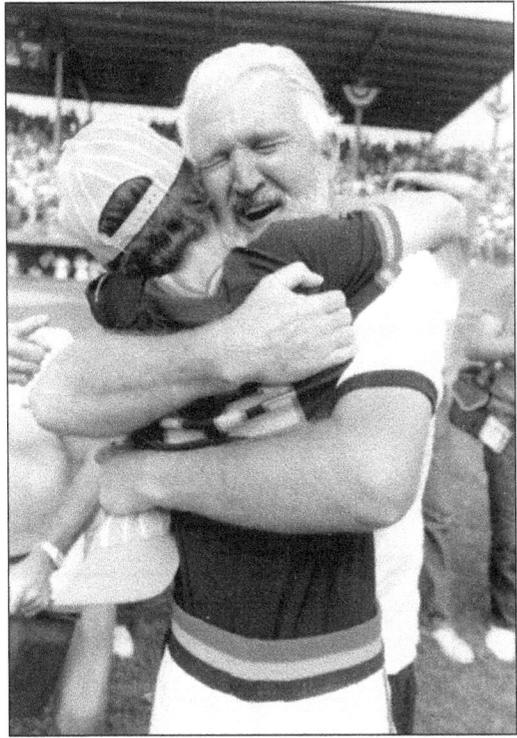

WORLD SERIES 1983 37th ANNUAL LITTLE LEAGUE BASEBALL.

AUGUST 23 - 27, 1983 Williamsport, Penna.

Baseball commissioner Bowie Kuhn threw the ceremonial first pitch for the 1983 Little League World Series championship game, and music star Chuck Mangione provided entertainment, playing the national anthem of the Dominican Republic. Pictured here in the center is the president of Little League Baseball, Dr. Creighton J. Hale.

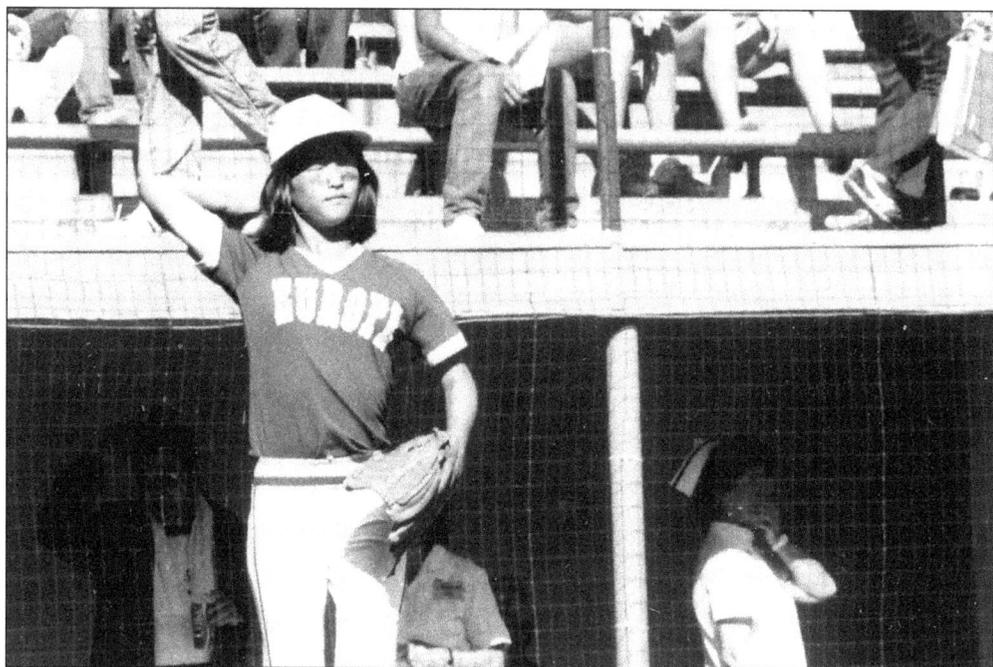

American Victoria Roche paved the road to Williamsport for other girls in baseball, playing for the 1984 European entry from Brussels, Belgium. Only seven other girls have played in the World Series since then, with more than 392,000 annually preferring to play in the softball program.

38th ANNUAL

LITTLE LEAGUE BASEBALL®
WORLD SERIES
1984

PETER J. McGOVERN
1900 — 1984
The first full-time president of Little League Baseball

"HE TAUGHT US ALL TO DREAM"

WILLIAMSPORT, PENNSYLVANIA AUGUST 21-25, 1984

Seoul, Korea, won that country's first Little League World Series championship, defeating Altamonte Springs, Florida, 6-2 in 1984. One Altamonte Springs player was Jason Varitek, who went on to play in the majors. Peter J. McGovern, Little League board of directors chairman for more than 30 years, died on June 30, 1984.

For the first time in baseball history, ABC mounted a miniature camera on the mask of the home plate umpire, Frank Rizzo, a member of every World Series championship umpire team. The 1985 series marked his 25th year behind the plate. The series was won by National of Seoul, South Korea. The team beat Mexicali of Baja Cal, Mexico, 7-1.

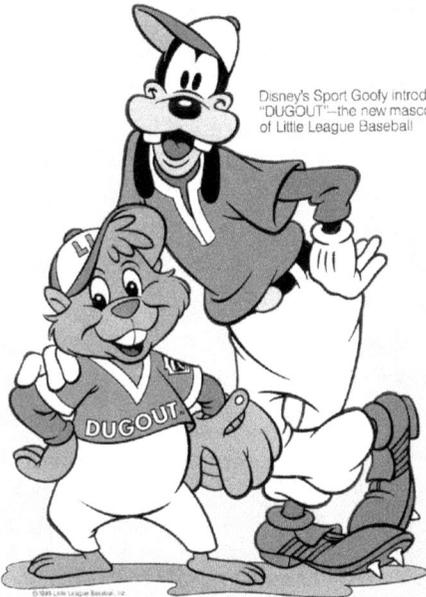

39th Annual Little League Baseball
WORLD SERIES 1985

Disney's Sport Goofy introduces "DUGOUT"—the new mascot of Little League Baseball

DUGOUT

August 20-24, 1985, · Williamsport, Pennsylvania

ABC carried the Little League World Series championship game live, and Little League's official mascot, Dugout, was introduced in 1985. Designed by Disney, the cartoon figure had to be a "a positive thinking character." Inspirations for Dugout were the gopher in *Winnie the Pooh* and the beaver in *The Lady and the Tramp*.

Latin American players greet girls at the fence surrounding International Grove during the 1986 Little League World Series. Tainan Park, Taiwan, won the series 12-0 over International of Tucson, Arizona.

OFFICIAL SOUVENIR PROGRAM

LITTLE LEAGUE BASEBALL

WORLD SERIES

August 19-23, 1986
Williamsport, PA

LITTLE LEAGUE SALUTES "THE LADY"

Peter Ueberroth, baseball commissioner, made his first visit to the Little League World Series for the 1986 championship. Bill Shea, president of the Little League Foundation and the namesake of New York's Shea Stadium, threw the ceremonial first pitch.

The pitcher for the West (Northwood Little League of Irvine, California) could not compete against Hua Lian, Chinese Taipei, as the Taiwanese racked up 21 runs to win the 1987 Little League World Series 21-1.

OFFICIAL SOUVENIR PROGRAM

LITTLE LEAGUE
BASEBALL®
WORLD
SERIES

1947

40ᵗʰ ANNIVERSARY
LITTLE LEAGUE
1947 1987
WORLD SERIES

WEST

1987

August 25-29, 1987
Williamsport, PA

In celebration of the 40th anniversary of the Little League World Series, the 1947 Little League National Tournament champions, the Maynard Midgets of Williamsport, were reunited on the field before the championship game. ABC broadcast the championship game, marking the silver anniversary of *Wide World of Sports*.

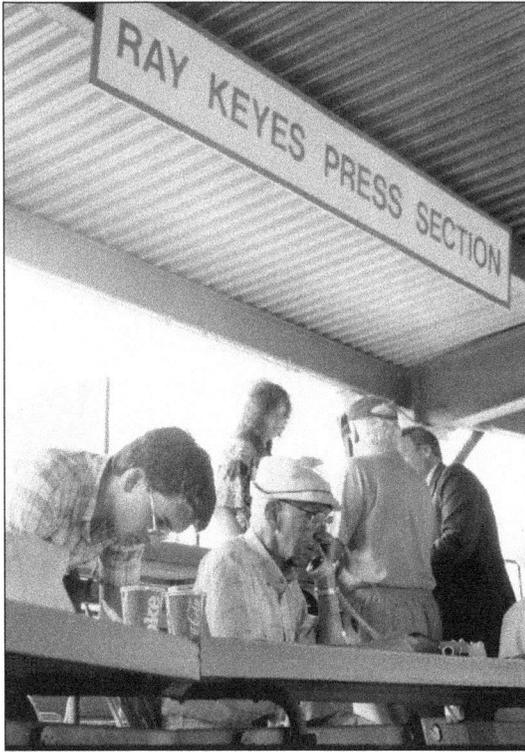

The press section of Howard J. Lamade Stadium was named in honor of Ray Keyes (center), the only sportswriter of his time to cover every Little League World Series. Keyes, sports editor for the *Williamsport Sun-Gazette*, recounted his four decades of coverage in the 1987 series program.

42nd Annual Little League Baseball.
WORLD SERIES 1988
August 23-27, 1988 • Williamsport, Pennsylvania

Ping, Chinese Taipei, won the 1988 Little League World Series 10-0, shutting out Pearl City, Hawaii. Six players on the Hawaiian team went on to play in three more World Series tournaments. Tom Seaver, a graduate of the Spartan Little League in Fresno, California, became the first enshrinee of the Peter J. McGovern Little League Museum Hall of Excellence.

104

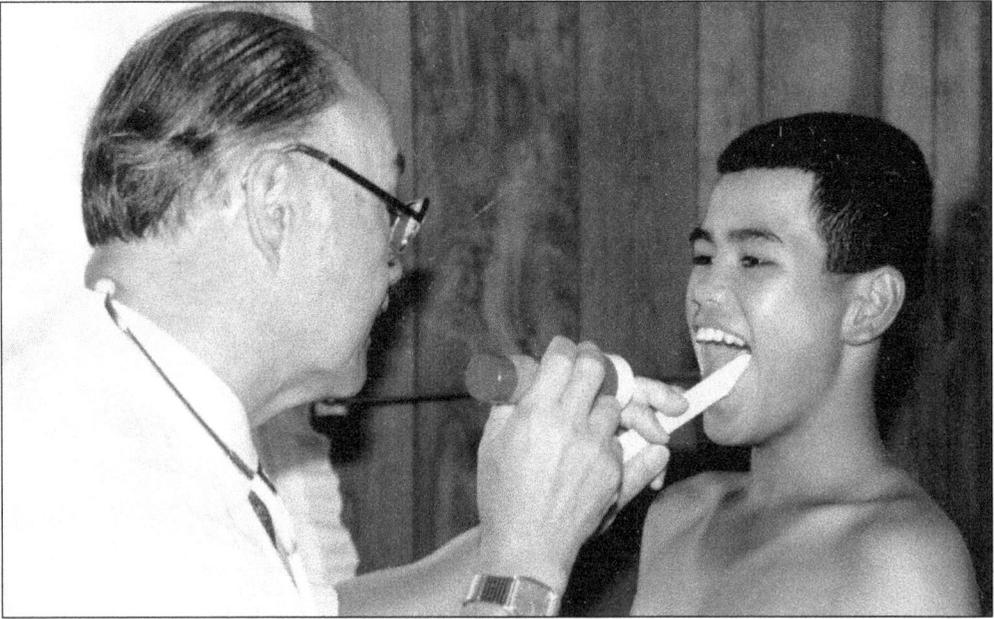

Dr. Robert Yasui, a Williamsport area physician, gives a 1989 Little League World Series participant a physical examination. After morning appointments at his local practice, Yasui headed for the Lamade Stadium for the day's games, helping to ward off medical emergencies and maintain the well-being of the players.

43rd Annual Little League Baseball.

1 9 ★ 8 9

WORLD ★ SERIES

A WHITE HOUSE TRIBUTE TO LITTLE LEAGUE BASEBALL.

LITTLE LEAGUE
50th
Anniversary
1939-1989
BASEBALL

August 22-26, 1989 ★ Williamsport, Pennsylvania

Little League Baseball celebrated its 50th anniversary in 1989, and Poland received four certificates of charter for the first Little League programs in a former Eastern Bloc country. Pres. George Bush, a former Little League coach, delivered the charters. Harlem Little League founders Dwight and Iris Raiford stepped up to the plate. Iris became a trustee of the foundation, and Dwight became chairman of the international board of directors—the first African American to hold that post.

Betty Speziale (left), the first woman umpire in the series, works home plate. Victoria Brucker was the first girl to get a hit in the series. ABC's *Wide World of Sports* carried the Little League World Series live. Before a crowd of 45,000, National of Trumbull, Connecticut, became the first U.S. team to win the World Series since 1983. Future National Hockey League star and Olympian Chris Drury was the winning pitcher in the victory over Kang-Tu, Chinese Taipei, 5-2.

Jim Palmer (right), an announcer with ABC and regular attendee of the Little League World Series, accepts the William Shea Award at the 1990 Little League World Series. To the left is Stephen D. Keener, future president and chief executive officer of Little League Baseball, the first former Little Leaguer to hold that position.

44th ANNUAL
LITTLE LEAGUE
BASEBALL
WORLD SERIES

'TEAM DUGOUT'
TEAM PICTURE

AUGUST 21-25, 1990
WILLIAMSPORT, PENNSYLVANIA

Another young girl, Kelly Craig of British Columbia Trail Little League, Canada, played at the 1990 Little League World Series. San-Hua, Taiwan, regained the championship with a 9-0 victory over Shippensburg, Pennsylvania. Little League Baseball launched the first full season of the Challenger Division for mentally and physically disabled children, and Little League Baseball spread to 39 countries.

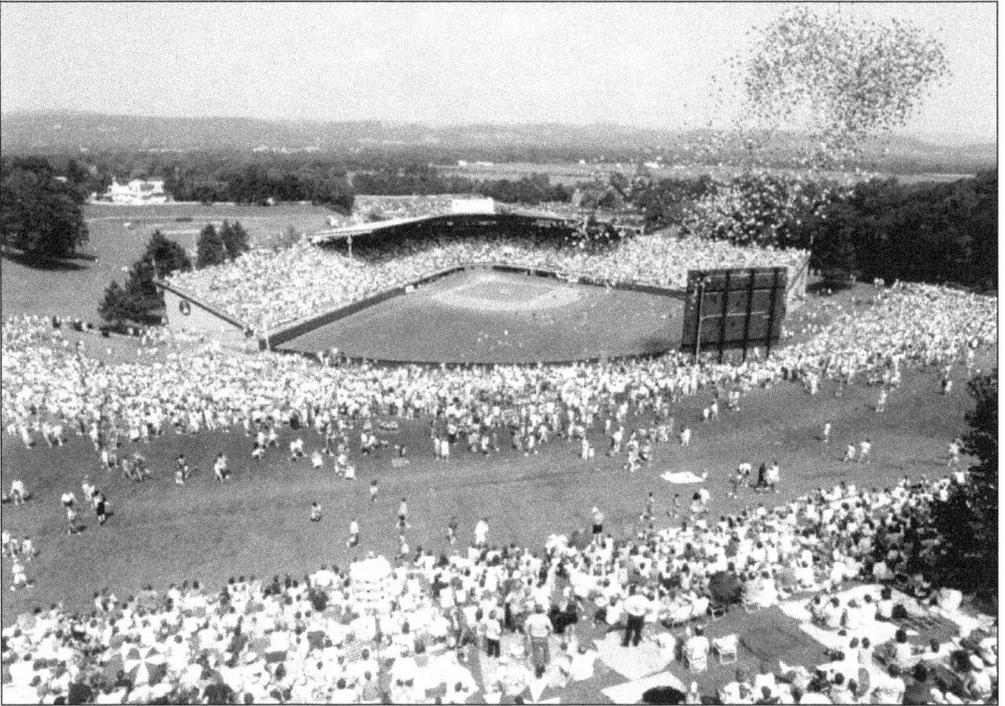

Pregame ceremonies during the 1991 Little League World Series featured a balloon release.

Hsi Nan League of Tai Chung, Taiwan, defeated San Ramon of Danville, California, 11-0 in the final game of the 1991 Little League World Series. Giselle Hardy of the 1991 European team representing Saudi Arabia played in the 1991 series.

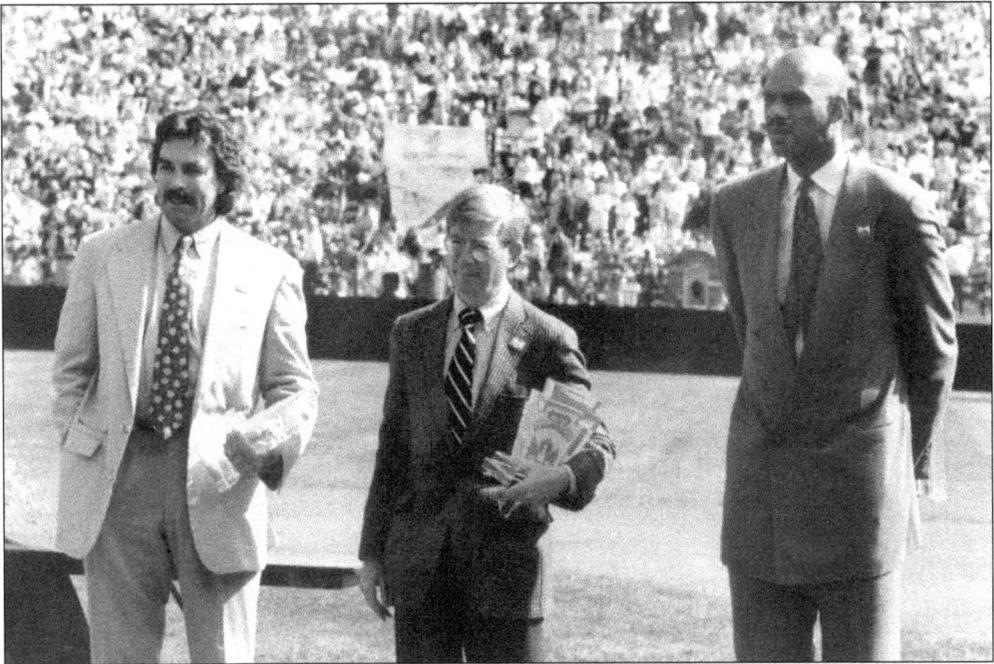

Three men are enshrined in the Peter J. McGovern Little League Museum Hall of Excellence at the 1992 Little League World Series, from left to right, actor Tom Selleck, columnist George Will, and former basketball player Kareem Abdul-Jabbar. When Carl Stotz died on June 4, 1992, thousands of local people reeled with the implication—the founder of Little League Baseball would never be reunited with the program he had created in 1939.

After a state-of-the-art lighting system was installed at Howard J. Lamade Stadium, the first Little League World Series night game is played in 1992. The same year, the Little League World Series adopted a "pool" assuring that each of the entered teams would play a minimum of three meaningful games in the World Series.

Vice Pres. Dan Quayle (left) visits the 1992 Little League World Series and signs autographs for the ball players in International Grove. Quayle, enshrined into the Peter J. McGovern Little League Museum Hall of Excellence, was the first sitting vice president to visit the series.

Allegations were made that the Far East champion team from Zamboanga City, Philippines, used ineligible players. Without time to investigate, however, the games went on as scheduled. The Philippine team won 15-4 against Long Beach, California, in the 1992 Little League World Series final.

The Long Beach, California team was proclaimed the winner of the 1992 Little League World Series after an investigation proved that the Philippines used eight players living outside the league's boundaries. The Little League International Tournament Committee stripped the Zamboanga City team of its title.

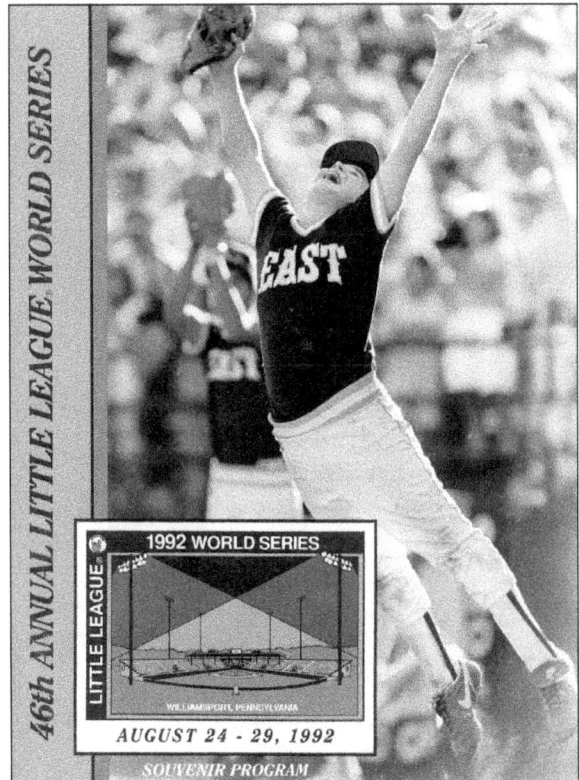

All-star pitcher Chris Drury—future National Hockey League star and 2002 Olympian from Trumbull, Connecticut—who helped defeat the Far East champions, Kang-Tu, in the 1989 series is featured on the cover of the 1992 Little League World Series program.

46th ANNUAL LITTLE LEAGUE WORLD SERIES

1992 WORLD SERIES

LITTLE LEAGUE

WILLIAMSPORT, PENNSYLVANIA

AUGUST 24 - 29, 1992

SOUVENIR PROGRAM

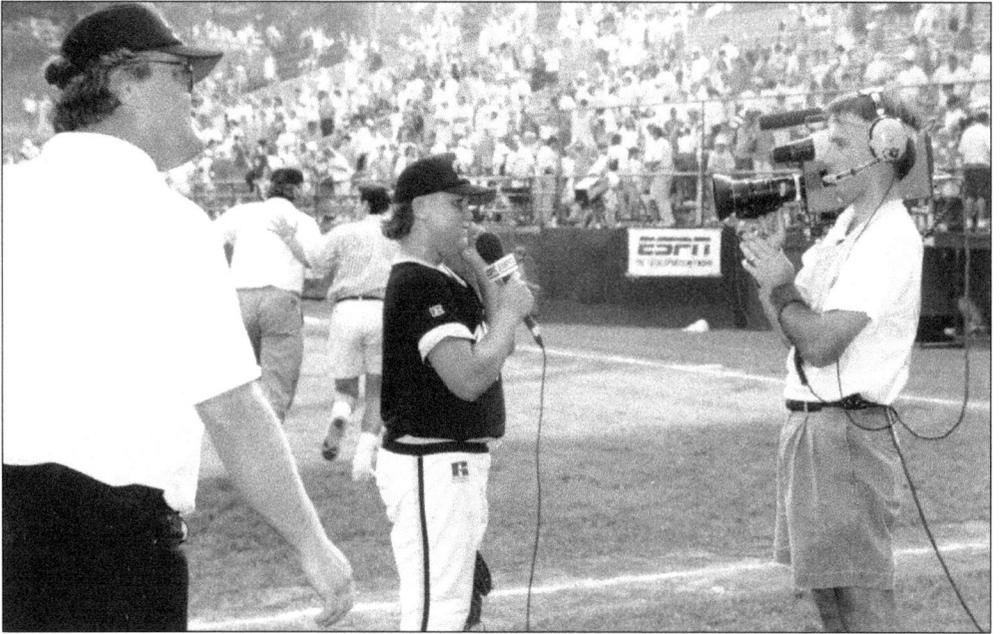

ABC interviews Sean Burroughs (center), son of former Major League player Jeff Burroughs (left), before a game at the 1993 Little League World Series. Sean Burroughs was a first-round draft choice of the San Diego Padres in 1998 and also played for Team USA, winning the gold medal in the 2000 Olympics.

In 1993, Long Beach, California, became the first American team in history to win consecutive Little League Baseball World Series titles. The team won a thrilling 3-2 victory against Chiriqui, Panama.

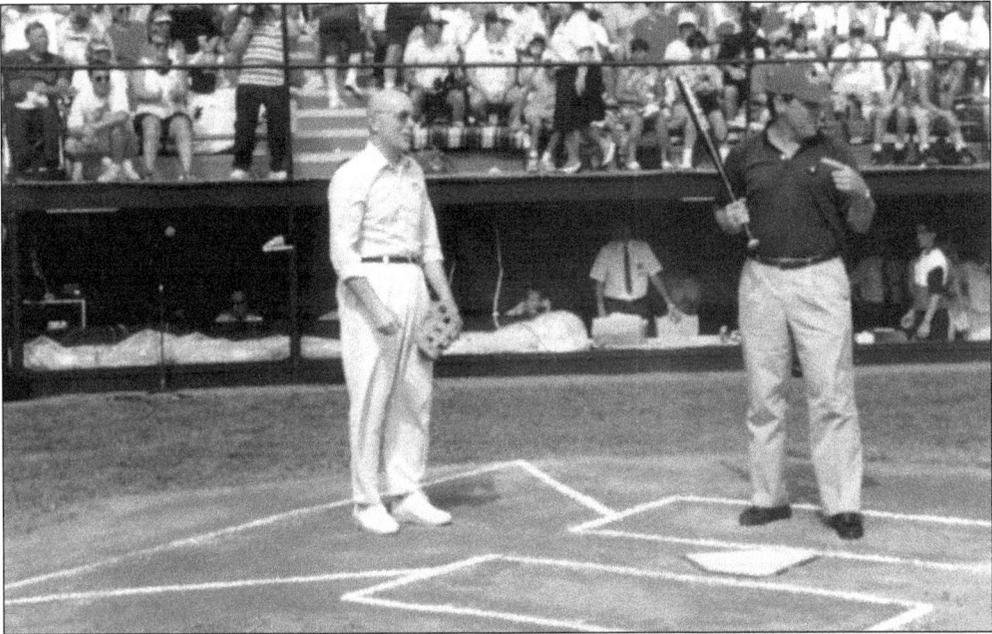

Catching the first pitch at the 1994 Little League World Series is NASA astronaut and Little League graduate Story Musgrave (left), the scientist who repaired the Hubble telescope in a daring space walk. During his six space flights, Musgrave spent a total of 1,281 hours, 59 minutes, and 22 seconds in space. The batter is Hall of Fame pitcher Tom Seaver.

After a record three-hour rain delay, Coquivacoa Little League of Maracaibo, Venezuela, became the first Latin American team to win the Little League World Series since 1958, defeating Northridge, California, 4-3. Also in 1994, Stephen D. Keener became the first Little League graduate to be named president of Little League Baseball, succeeding Dr. Creighton J. Hale.

113

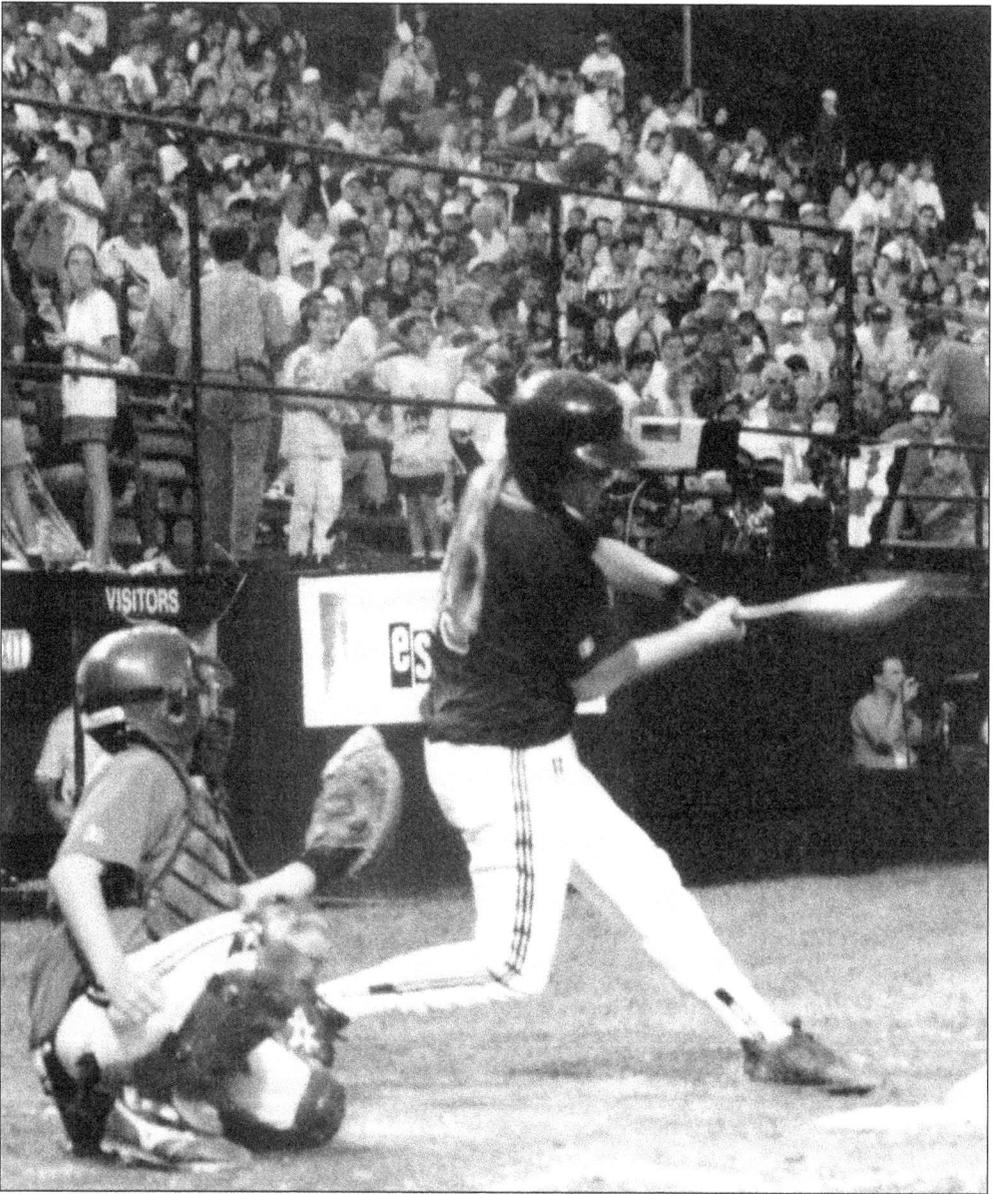

Krissy Wendell, catcher for Brooklyn Center, Minnesota, and future Olympic hockey player, puts the ball in play at the 1994 Little League World Series.

Baseball fans participate in a bubble-blowing contest during a lull in the action at the 1995 Little League World Series. After a three-year drought, Taiwan regained the world championship when Shan-Hua of Tainan, Chinese Taipei, defeated Spring, Texas, 17-3.

Hall of Famer Stan Musial threw out the ceremonial first pitch for the 1995 Little League World Series. The Pennsylvania Historic Museum Commission recognized the significance of the Original League ballpark (birthplace of Little League Baseball and site of the first 12 Little League World Series tournaments) with a historic site marker. Substantial grants enabled Original League volunteers to forge ahead with $200,000 in improvements.

Len Coleman was inducted into the Peter J. McGovern Little League Museum Hall of Excellence during the 1996 World Series. Coleman was the president of the National League of Professional Baseball Clubs and played Little League in Montclair, New Jersey.

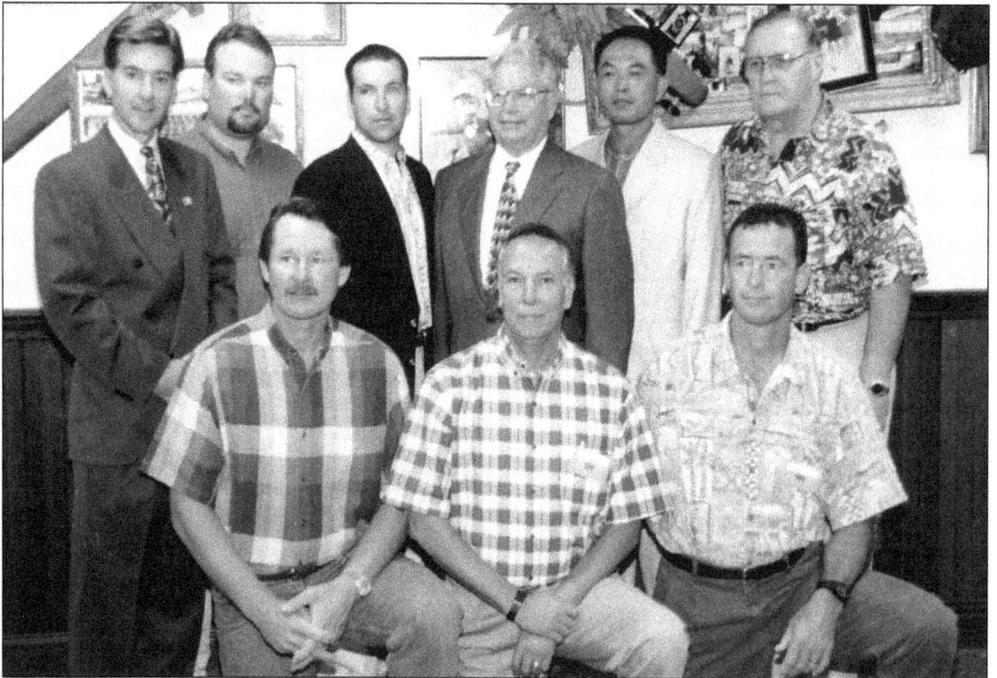

Members of the 50th anniversary World Series commemorative team join Little League officials at the 1996 World Series. From left to right (with their year of participation or their title) are the following: (front row) Carney Lansford (1969), Angel Macias (1957), and Brian Sipe (1961); (back row) Stephen D. Keener (Little League president), Cody Webster (1982), Don Cohick (1969), Dr. Creighton Hale (chief executive officer of Little League), Tsai Ching-Fong (1969), and Jack Losch (1947).

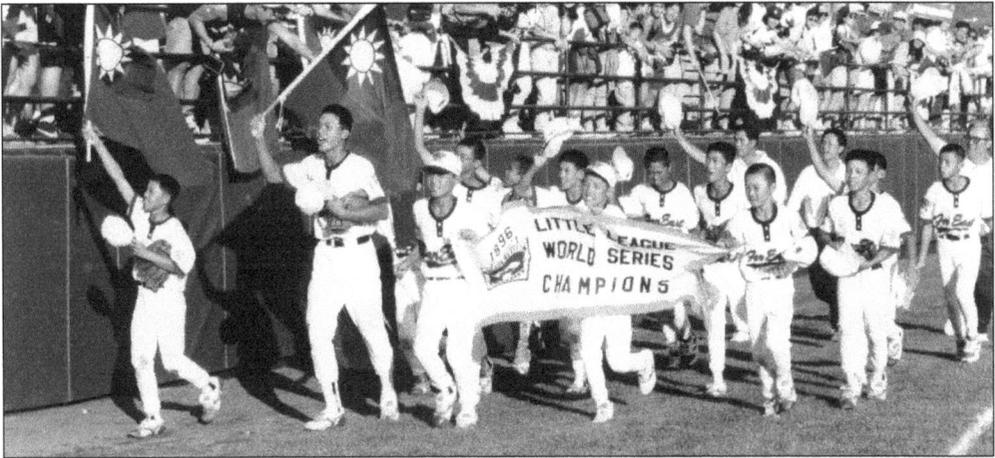

The Taiwan team celebrates its 17th Little League Baseball World Series title during a victory lap in 1996. Fu-Hsing, Kao-Hsuing, defeated Western of Cranston, Rhode Island, 13-3.

Little League celebrated its 50th World Series in 1996 and launched the Little League Child Protection Program, which seeks to educate local Little League volunteers and children in ways to protect themselves against pedophiles through pamphlets, videos, trading cards, and printed guidelines in the Little League operating manual.

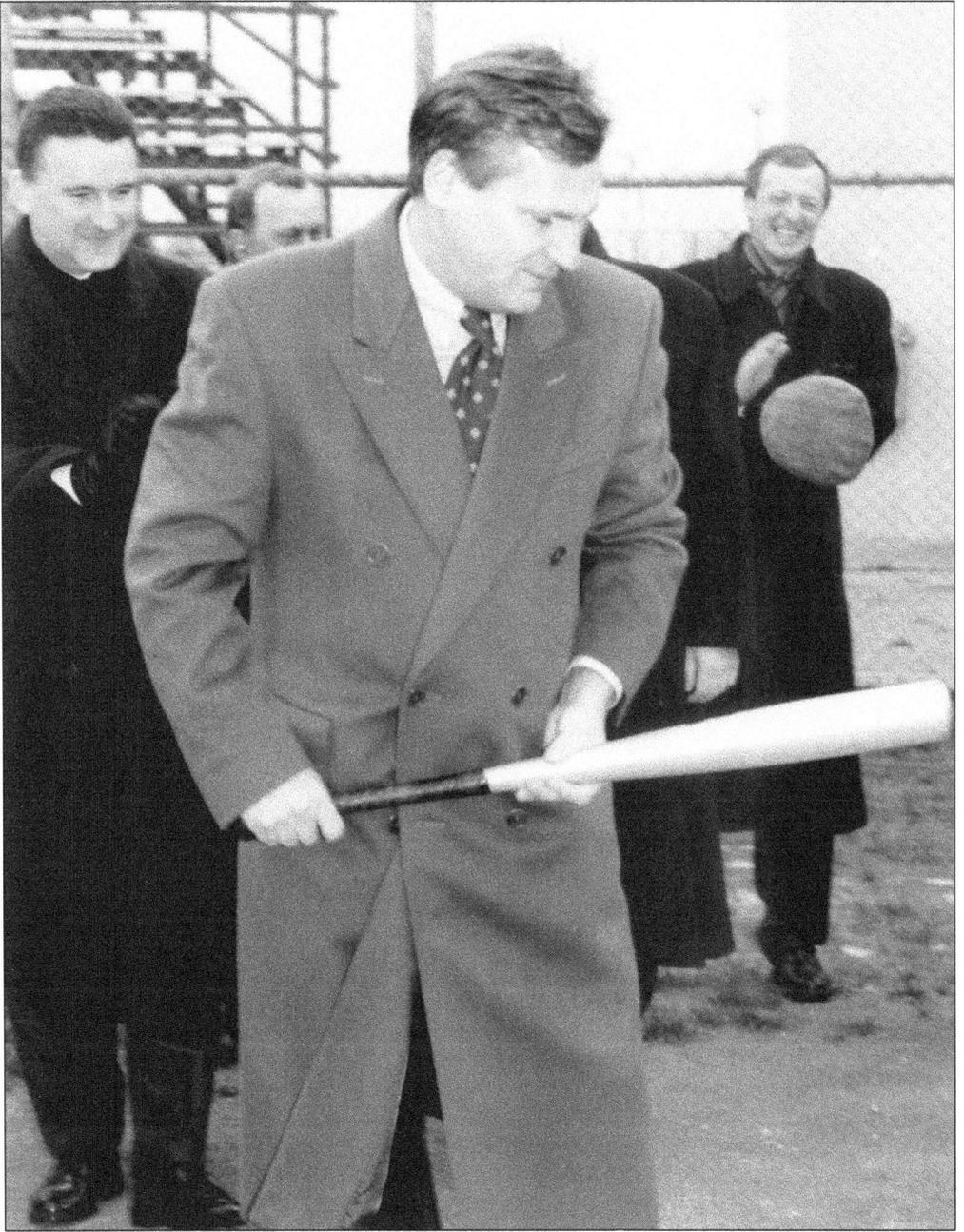

Little League's first full-service regional headquarters outside the United States was opened in Kutno, Poland, in 1996. Aleksander Kwasniewski (center), Poland's president, was on hand to dedicate the facility. The winners of the annual European Regional Tournaments in Kutno advance to the various World Series in baseball and softball.

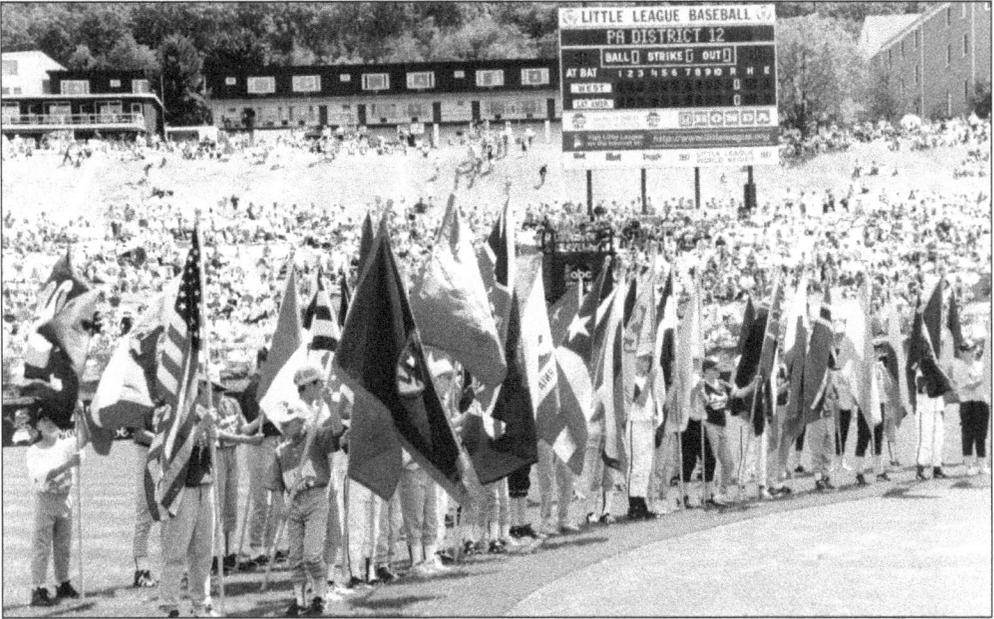

Carrying flags onto the field in the 1997 pregame ceremonies are Little Leaguers from the Williamsport area. The Parade of Champions (formerly the Cavalcade of Champions) and a parade of flags from every nation with a Little League presence are part of the opening ceremonies for each Little League World Series. Sharon Robinson, daughter of Jackie Robinson, was a guest at the 1997 series.

After 12 championships in 23 years, Taiwan ended its relationship with Little League Baseball. The Chinese Taipei Baseball Association decided it could not comply with boundary regulations and joined Pony Baseball and other organizations. Linda Vista Little League of Guadalupe, Mexico, won the 1997 Little League World Series 5-4 after a four-run rally in the last inning against South Mission Viejo, California.

Sayaka Tsushima was the sixth girl to play in the Little League World Series and the starting center fielder for her team, Kashima, Japan, in 1998.

Toms River (New Jersey) East American Little League won the 1998 Little League World Series, defeating Kashima, Japan, 12-9 in the championship game. The game featured 11 home runs and 41,200 fans at Lamade Stadium. The team, invited to the White House after their victory, is pictured with Vice Pres. Al Gore (front row, second from left).

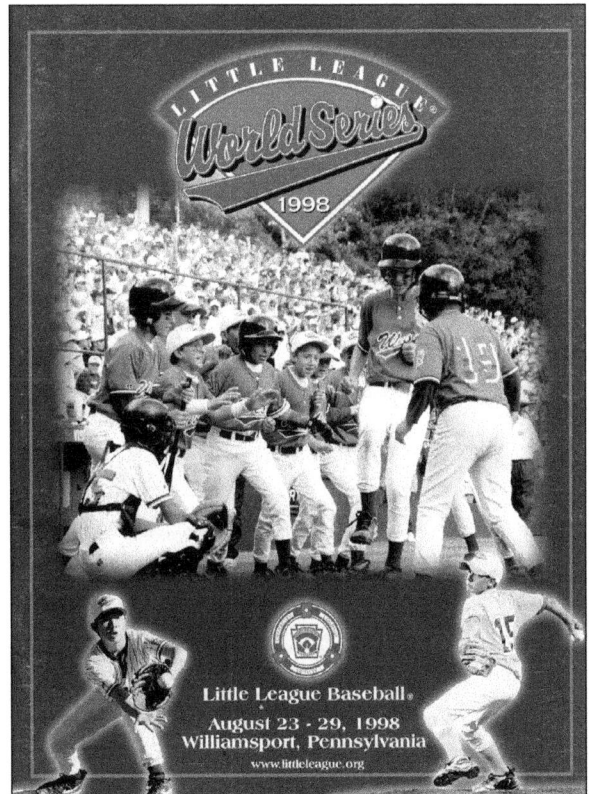

Little League expanded to include 95 countries in 1998, and it was announced that the Little League World Series would expand from 8 teams to 16 in 2001. A second stadium would be built for the extra games and the series would be lengthened by several days.

The South Williamsport Area High School Marching Band performs at the pregame ceremony of the 1999 Little League World Series. Little League Baseball founder Carl Stotz, at the request of his nephews Major and Jimmy Gehron, began the tradition of inviting bands to Little League games.

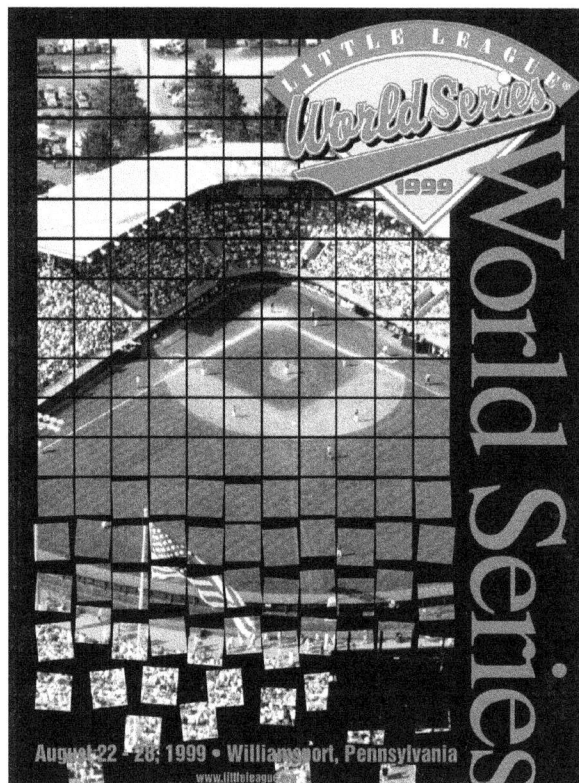

August 22 - 28, 1999 • Williamsport, Pennsylvania
www.littleleague...

Hirakata of Osaka, Japan, won that nation's first World Series title since 1976, defeating Phenix City, Alabama, 5-0 in 1999. The number of countries with Little League programs climbed to 100 for the first time when Burkina-Faso chartered a league. Little League's first international capital campaign was initiated with a goal of $20 million.

Dugout, Little League's official mascot, lightens spirits and entertains the crowd at the 1999 Little League World Series by dancing with players from the South and Far East teams prior to the championship game.

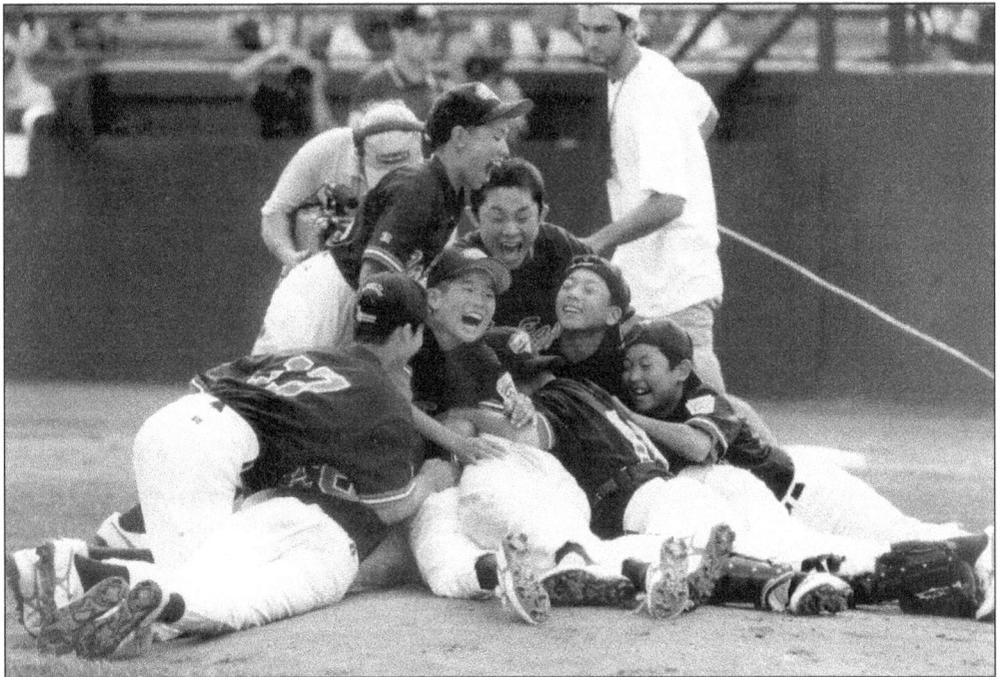

Thrilled to have won the 1999 Little League World Series, players for the Far East (Hirakata of Osaka, Japan) pile on each other in center field. Cameramen for ABC close in to capture the moment.

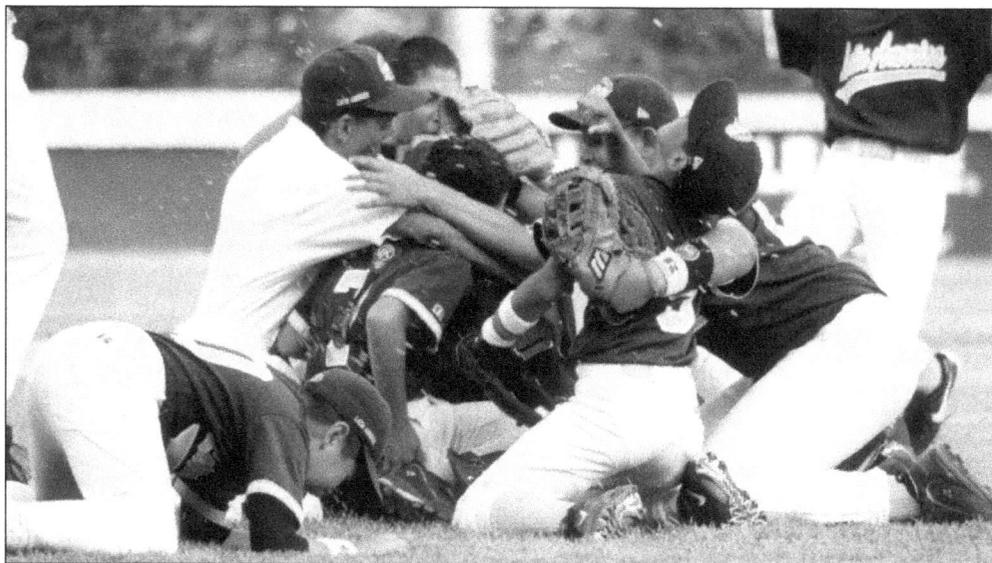

Players and coaches for Sierra Maestra of Maracaibo, Venezuela, hug each other after defeating Bellaire, Texas, 3-2 in the 2000 Little League Baseball World Series final.

Construction began on a second stadium in preparation for expansion of the 2001 Little League World Series from 8 to 16 teams. George W. Bush became the first Little League graduate to be elected to the highest U.S. office. Bush played for four years in the Midland (Texas) Central Little League and was a catcher.

Two baseball legends, one real and one fictitious, enjoy themselves at the 2001 edition of the Little League World Series. Former Major Leaguer Orel Hersheiser (left) jokes with actor Kevin Costner, whose movie *Field of Dreams* became a classic in the baseball genre. That year, Costner, Billy Hunter, and Dr. Robert Stratta were enshrined into the Peter J. McGovern Little League Museum Hall of Excellence.

A stake marks the pitching mound as construction begins on the new stadium in 2001. Once finished, Pool Play Round games were held at Howard J. Lamade Stadium (rated by *Sports Illustrated* in 1999 as one of the top 20 places in the world to watch a sporting event) and at the newly constructed Little League Volunteer Stadium. Single elimination games and the final are held at Howard J. Lamade Stadium.

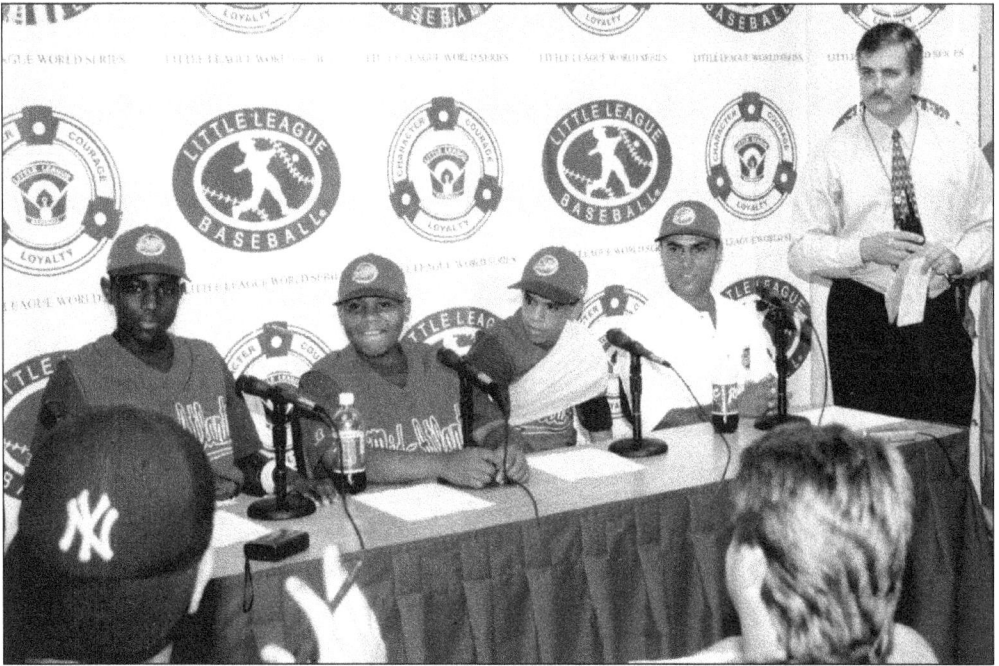

Members of the Rolando Paulino (Bronx, New York) World Series team are interviewed by reporters after a perfect game pitched by Danny Almonte. After the 2001 series, it was revealed that Almonte was ineligible, and all of his team's games were forfeited. Rolando Paulino, president of the New York league, and Felipe Almonte, Danny's father, were banned from Little League for life.

The road to Williamsport is tough. More than 7,000 teams begin the tournament in the Little League Baseball division. More than 6,500 are eliminated in the first three weeks of play. The final level of tournament play is the World Series. There are eight World Series tournaments played in the Little League program: Little League Baseball, Junior League Baseball, Senior League Baseball, Big League Baseball, Little League Softball, Junior League Softball, Senior League Softball, and Big League Softball.

126

August 17-26, 2001
Williamsport, Pennsylvania
www.littleleague.org

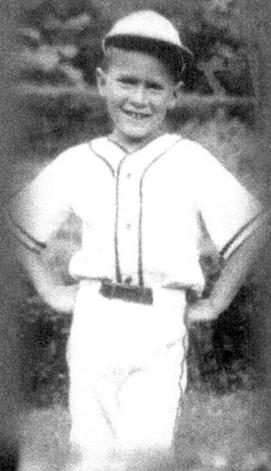

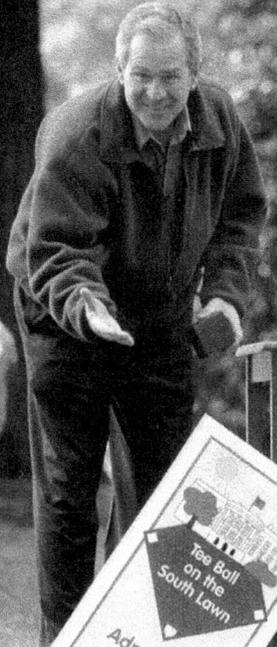

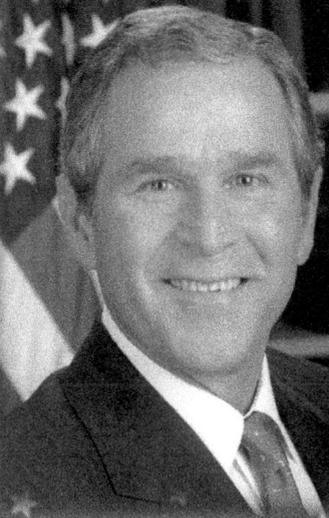

LITTLE LEAGUE
World Series
2001

George W. Bush, the first
Little League graduate elected
President of the United States

Tee Ball
on the
South Lawn

Admit One

Tokyo Kitasuna, Japan, won the 2001 Little League World Series, defeating National of Apopka, Florida, 2-1. In the stands were bestselling author John Grisham and his daughter, Shea, as well as film director Hugh Wilson. Also visiting during the final game was Pres. George W. Bush, the first time a sitting president has attended a series game.

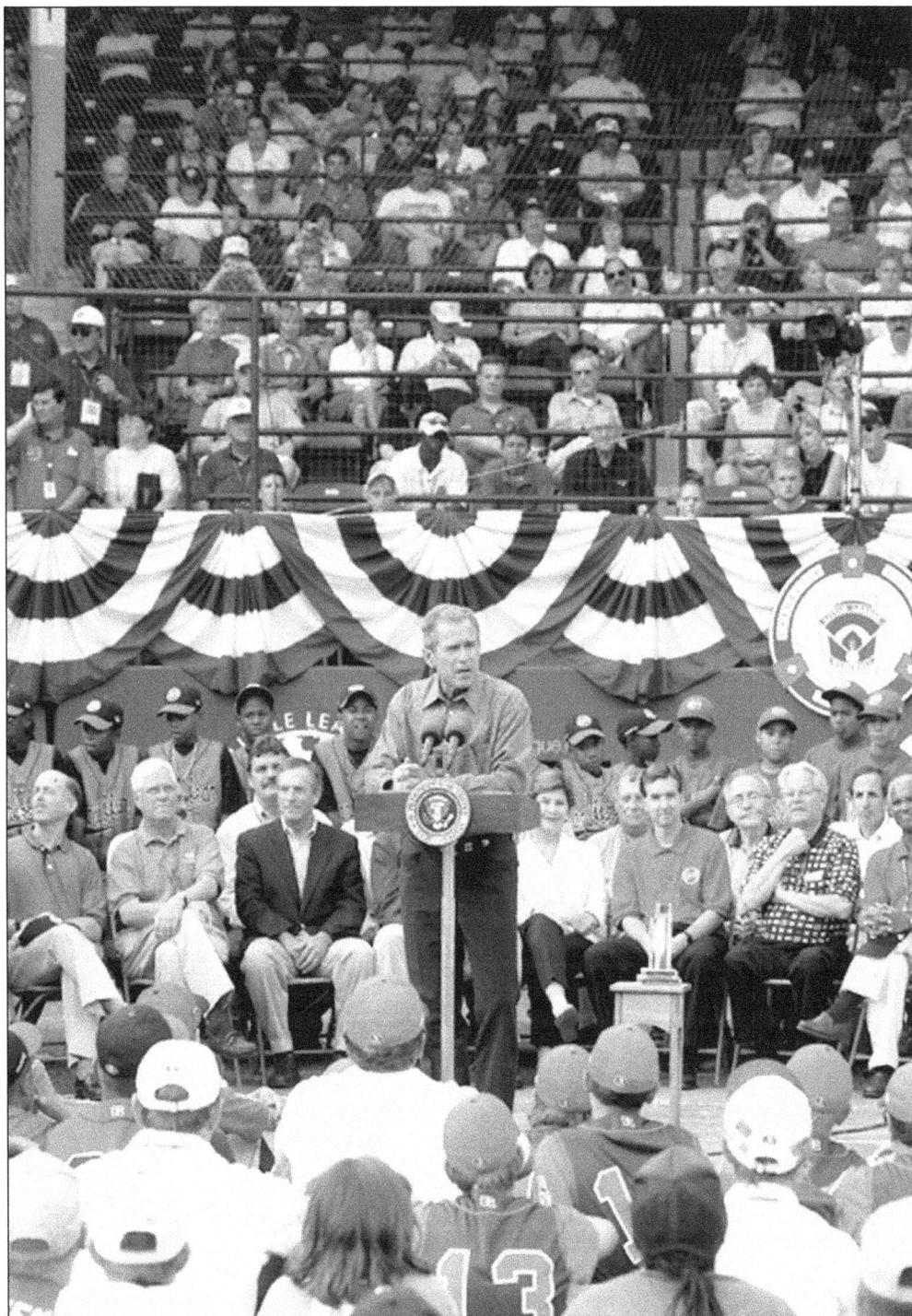

Pres. George W. Bush delivers a stirring speech to the participants of the 2001 Little League World Series before tossing the ceremonial first pitch. Bush, a former Little Leaguer in Texas, has a soft spot for the program and regularly invites children to play Little League Tee Ball games at the White House.